Italian Panel Painting of the Early Renaissance

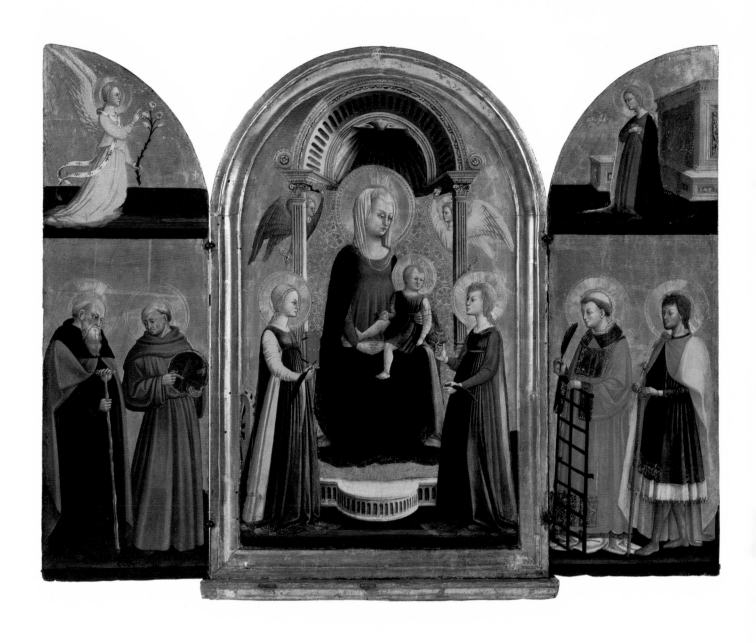

LOS ANGELES COUNTY MUSEUM OF ART *in association with the University of Washington Press*

Italian Panel Painting
of the Early Renaissance

IN THE COLLECTION OF THE LOS ANGELES COUNTY MUSEUM OF ART

Susan L. Caroselli

with contributions by Joseph Fronek
and members of the Conservation Center

This book was published in conjunction with an exhibition organized by the Los Angeles County Museum of Art and held there December 22, 1994–March 12, 1995.

Distributed by the University of Washington Press, P.O. Box 50096, Seattle, Washington 98145-5096

Support for the exhibition was generously provided by the Ahmanson Foundation, the Samuel H. Kress Foundation, Mrs. Rosa Liebman, the Getty Grant Program, the National Endowment for the Arts, and the Andrew W. Mellon Curatorial Support Endowment Fund. Transportation for the exhibition was provided by Alitalia Airlines.

Library of Congress Catalog Card Number: 94-79755
ISBN: 0-295-97434-6

Chris Keledjian
EDITOR

Pamela Patrusky
DESIGNER

Peter Brenner, Barbara Lyter, Jay McNally, Steve Oliver
PHOTOGRAPHERS

Typeset in Monotype Fournier and Adobe Univers with Monotype Van Dijck display type. Printed by Hull Printing Company, Incorporated, Meriden, Connecticut.

FRONT COVER:
Detail of Luca di Tommè, *Virgin and Child Enthroned with Saints Nicholas and Paul*, c. 1367/70.
CAT. NO. 8

BACK COVER:
Bartolo di Fredi, *The Angel of the Annuciation*, c. 1383/88.
CAT. NO. 1

FRONTISPIECE:
Neri di Bicci, *Virgin and Child Enthroned with Saints and the Annuciation*, c. 1440/50.
CAT. NO. 13

NOTE TO THE READER
A slash between two dates—for example 1383/88—indicates that something happened (an artist was born or died, an artist's activity began or ceased, a work was produced) at an indeterminable time between the first and second date.

Dimensions are given in both centimeters and inches. Height precedes width.

In the Catalogue section (pp. 87–123), entries are arranged alphabetically by artist. Conservation Notes were written by Joseph Fronek, Virginia Rasmussen, and Shelley Svoboda.

Exhibitions and bibliographical references are indicated in the text by a short form consisting of the city and date of the exhibition in the former case and the author's name and date of publication in the latter. Complete citations can be found in the Bibliography (pp. 124–31).

Contents

Foreword

The fourteenth and fifteenth centuries in Italy saw enormous activity in what we now call the fine arts. We have come to identify this period as the early Renaissance—"rebirth"—because, although we now acknowledge the important continuity of much that came from the Middle Ages, there was to be sure a shift in attitude that affected much of the culture. While still placing God at the center of the universe, humankind grew in self-esteem, seeing in itself the image of its Creator, with a will to act and a self-imposed obligation to adhere to moral standards. Human accomplishments, particularly those of ancient Greece and Rome, were rediscovered and prized. The height of a man became the module for exquisitely proportioned buildings; saints were transformed from icons to men and women whose sanctified lives could be emulated; ancient gods and goddesses and long-dead heroes and heroines of antiquity were given form and made to serve the causes of both edification and delight.

Italian Panel Painting of the Early Renaissance combines the work of curator and conservator, making use of Renaissance documentation and modern technical achievements in conservation to study and present the panels from the period 1300–1500 in the museum's collection. In preparing this volume Susan L. Caroselli, formerly associate curator in the department of European Painting and Sculpture and currently visiting assistant professor of Religion and the Arts at Yale Divinity School, enlisted the help of Joseph Fronek, senior paintings conservator, and many members of the museum's Conservation Center. Historical and technical introductions provide a context for a detailed study of two altarpieces in the collection, encompassing the art of fourteenth-century Siena and fifteenth-century Florence as well as representing the gifts of two of our most generous donors, the Ahmanson Foundation and the Samuel H. Kress Foundation. This is followed by a catalogue of the early Renaissance panels in the museum's collection, in subject both sacred and secular, from many of the important centers of Renaissance art. I wish to thank the authors for their careful and insightful work and to add my thanks to our supporters, donors, and the other individuals mentioned in the acknowledgments for helping to shed a brighter light on these valuable images from another age.

STEPHANIE BARRON
Coordinator of Curatorial Affairs
Los Angeles County Museum of Art

Acknowledgments

We wish first to thank the organizations and individuals whose generosity made possible the various aspects of this project: the considerable work of conservation of the panel paintings was supported by the Samuel H. Kress Foundation, Mrs. Rosa Liebman, and the Getty Grant Program; the Ahmanson Foundation funded the making of a documentary film on the conservation work; Alitalia and the National Endowment for the Arts contributed to the organizational costs of the exhibition; and the Kress Foundation subsidized the production of this volume.

Much of the research on the panel paintings acquired by the Los Angeles County Museum of Art before 1970 was carried out by Burton Fredericksen, at that time a member of the museum's curatorial staff and now the director of the Provenance Index of the J. Paul Getty Art History Information Program. His thorough and insightful work and his graciousness in allowing his considerable findings to be available to all scholars and students interested in the museum's collection are greatly appreciated.

We are thankful to museum curators and collectors who allowed us access to works of art under their care: Luisa Morozzi, Palazzo Venezia, Rome; Lino Pasquali, Florence; Nicholas Penny, National Gallery, London; Jane Munro, Fitzwilliam Museum, Cambridge; Renata Hedjuk, Yale University Art Gallery, New Haven; Gretchen Hirshauer, National Gallery of Art, Washington, D.C.; Sona Johnston, Baltimore Museum of Art; Joaneath Spicer, Walters Art Gallery, Baltimore; and especially Carl Brandon Strehlke, Philadelphia Museum of Art. A number of scholars and conservators in Florence were of immense help: Oriana Sartiani and Anna Maria Massinelli provided valuable advice and arranged visits to sites in Tuscany; Lisa Venturini, Nicoletta Pons, and Jonathan Nelson were particularly generous with their time, information, and advice.

At the Los Angeles County Museum of Art, Philip Conisbee and J. Patrice Marandel, successive curators of the department of European Painting and Sculpture, encouraged us in our work on this project, and associate curator Mary L. Levkoff proved once again a most supportive and resourceful colleague. Susan Wiggins, departmental secretary, was of great assistance, especially in the acquisition of photographic images. Jennifer Wood, a graduate student in the Museum Studies Program at the University of Southern California, was a valued ally as research assistant for the project; she updated the information provided by Burton Fredericksen, assiduously researched the provenance, literature, and exhibition history of works of art acquired after 1970, and checked details of bibliography.

Tom Jacobson, head, grants and foundation giving, and Talbot A. Welles, former grants coordinator, of the Development Office were responsible for successful grant applications and other sources of funding; Mark Mitchell, budget manager, of the Business Office handled financial matters; John Passi, head, Exhibition Programs, attended to the many details of exhibition arrangements and scheduling; and Tamra Yost, associate registrar, was responsible for the details of the loan of a panel by Marco Zoppo.

Warmest thanks go to the conservators and conservation scientists at the Los Angeles County Museum of Art who devoted several years of their considerable skill and expertise to the examination, cleaning, and restoration of the Italian panel paintings in the museum's collection and greatly contributed to the content of this book by sharing their findings: senior conservation chemist John Twilley, who provided answers to our many technical questions; associate conservator Virginia Rasmussen and assistant conservator Shelley Svoboda, who both worked tirelessly on many of the panels and helped with attributions; conservation technician Neil Rhodes, for his work on frames; and visiting conservators Oriana Sartiani and Barbara Schleicher from Florence, whose participation was made possible by grants from the J. Paul Getty Trust and Rosa Liebman. Ms. Liebman also provided funds for the restoration of the panel support of the *cassone* by Rosselli; Andrea Rothe and Mark Leonard, of the Getty Museum, arranged for treatment of the panel support at the Getty and also identified specialists in Italy; the Getty generously allowed Giovanni Marussich from Florence to work on the Roselli panel while he was a consultant at the Getty; and the Kress Foundation provided funds allowing consultation with specialists Mario Modestini and Dianne Dwyer of New York City.

We are very grateful to Bernard Kester, whose elegant design for the gallery provided a new environment for the panel paintings. We wish also to thank Art Owens and the Technical Services staff for their careful installation of the works.

Chris Keledjian was an able and gracious editor, and Pamela Patrusky provided the beautiful design for the book and the installation graphics. Marcia Tucker created the book's index. Peter Brenner, supervising photographer, and his staff are responsible for the excellent images of the museum's panel paintings.

Finally, we wish to thank a group of individuals who provided extraordinary assistance, hospitality, and support during this project: Patrick Anderson, Los Angeles and Rome; Pierre Riandet, Berlin; Debbie and Chris Winchell, Los Angeles; Brigitte and Wolfgang Wolters, Berlin; and Ruby and Joseph Caroselli, Boston.

SUSAN L. CAROSELLI
Visiting Assistant Professor of Religion and the Arts
Yale Institute of Sacred Music, Worship and the Arts/Yale Divinity School

JOSEPH FRONEK
Senior Paintings Conservator
Los Angeles County Museum of Art

Introduction to Italian Panel Painting of the Early Renaissance

Historical Introduction

SUSAN L. CAROSELLI

Early History The artists of antiquity painted on wood panels, but there is little left to tell us of these early works. Not one panel survives from ancient Greece, nothing of the work of the legendary masters from Cimon of Cleonae in the sixth century B.C., through Polygnotus, Micon, and Apollodoros, to Nicias and the incomparable Appelles two centuries later. Of their panel-painting technique we know almost nothing, although we may gather infor-

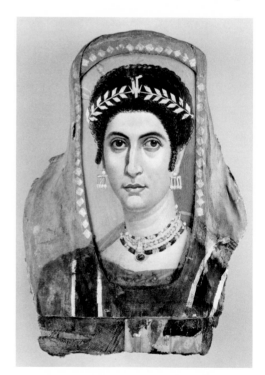

mation about stylistic development from vase painting of the same period and, later, from wall paintings and mosaics. Almost all the painted remains of the Etruscan and Roman civilizations are ceramics or mural decorations of tombs or villas. The richest cache of painted panels comes from Roman-controlled Egypt in the first through the fourth centuries A.D., when exquisite portraits of the deceased were painted on thin boards and bound into their mummies (FIG. 1).

In the early Christian, Byzantine, and medieval periods wood panels were rarely used as supports. Large-scale paintings were executed on walls or transformed into mosaics; small-scale works were painted on skin, vellum, parchment, or, later, paper, most usually bound into manuscripts. The exceptions were portable icons, devotional images for personal use painted on wood in workshops in Byzantine monasteries and palaces during the sixth and seventh centuries and again, after the banning of religious imagery in the Iconoclastic period, from the ninth century onward.

The earliest painted panels in western Europe after antiquity were either small religious images and scenes that served as a focus for devotions (FIG. 2)—a western version, in a sense, of the Byzantine icon—or less expensive substitutes for liturgical objects or church furniture normally executed in precious materials too costly for a patron's purse. The technical advantages to painting on panels, however, must have soon made them more attractive to a wide range of patrons and artists. The panels could replicate the brilliant palette of colors and minute detail of illuminated manuscripts; they were more durable than individual illuminated sheets and more physically accessible than the images in a bound manuscript. The available range of colors and the potential for stylistic subtlety in panel painting gave it an advantage over techniques of metalwork, enameling, and fresco painting. Indeed, in contrast to fresco artists, panel

FIGURE 1

Attributed to the Isidora Master (Romano-Egyptian, second century A.D.), *Mummy Portrait of a Woman*, c. 100–125, tempera on panel, J. Paul Getty Museum, Malibu.

10

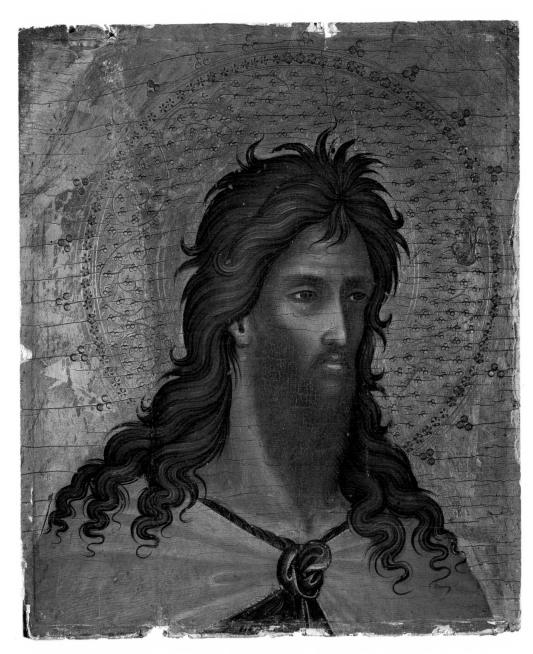

painters could work at their own pace, unaffected by the rate of drying plaster, and could make changes without the necessity of chipping off a wall surface and beginning again. Once craftsmen began to join wood panels together to form large surfaces, panel painting gradually became the chosen technique for nearly all but major campaigns of architectural decoration, which continued to be executed in fresco.

Until the thirteenth century a priest stood behind the altar to celebrate mass, facing the congregation. The altar was decorated where it was the most visible, that is, the front lower panel, the antependium or frontal. This might be of carved stone or carved or painted wood, or, if a church was wealthy, such as Sant'Ambrogio in Milan or San Marco in Venice, of gold or silver set with jewels. When the doctrine of transubstantiation was formally promulgated by the fourth Lateran Council in Rome in 1215, the "mystery" of

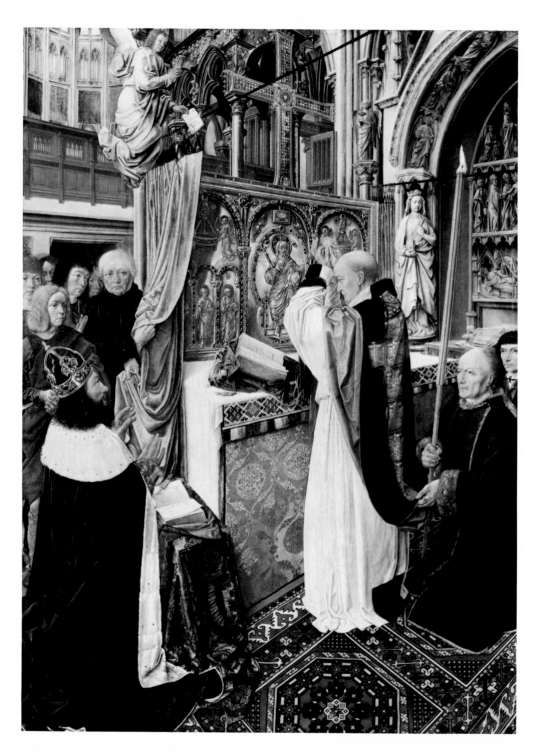

FIGURE 3
Master of Saint Giles (France,
active 1490–1510), *The Mass of
Saint Giles*, c. 1500, oil on panel,
the National Gallery, London.

the transformation of bread and wine into the body and blood of Christ was heightened by the priest turning his back to obscure the elements of the Eucharist and to conceal his words and gestures (FIG. 3). Since antependia were no longer visible during much of the mass, and since they often hindered the priests from approaching the table as closely as was necessary, some of them were removed, many to be replaced by altar cloths. It was not unusual during this transitional period for frontals to be reused as altarpieces, placed on or behind the altar to give a focus for the liturgy. (A few extant frontals recycled in this way, such as the

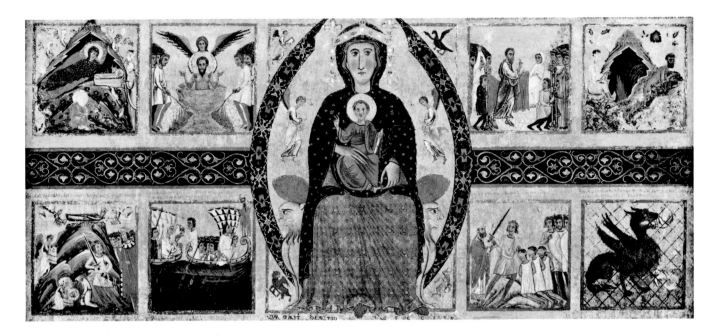

FIGURE 4

Margarito da Arezzo (Tuscany,
active second and third quarters
of the thirteenth century),
*The Virgin and Child Enthroned,
with Scenes of the Nativity and
the Lives of Saints*, 1260s,
tempera on panel, the National
Gallery, London.

Majestas Domini of 1215 in the Pinacoteca Nazionale of Siena, display scuff marks and damage from the priests' toes.)

The earliest painted altarpieces in Italy, being either reused antependia or influenced by them, were rectangular, wider than they were tall, although sometimes with a raised central section. An exception to this was an early image especially prevalent in Pisa and Lucca, the large crucifix suspended over the high altar or in the choir of a church, painted on a panel constructed in the shape of a cross. Both types of panels, however, featured a large central

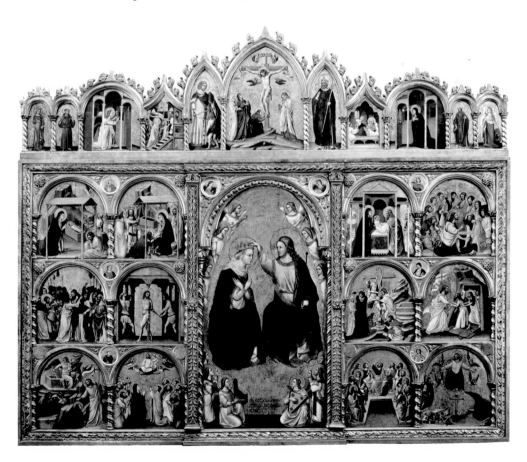

FIGURE 5

Guariento di Arpo (Venice,
c. 1310–1370), *The Coronation of
the Virgin Altarpiece*, 1344,
tempera on panel, Norton Simon
Art Foundation, Pasadena.

13 HISTORICAL INTRODUCTION

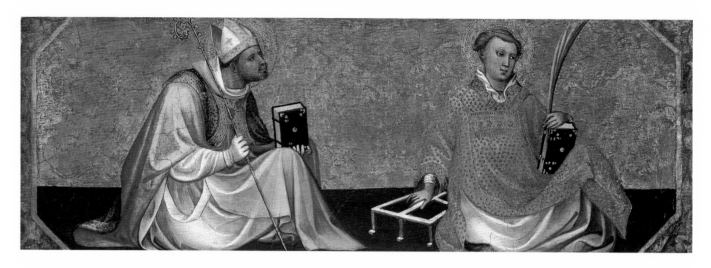

FIGURE 6
Gherardo di Jacopo di Neri
Starnina (probably Master of
the Bambino Vispo; Florence,
active 1378–1409/13), *A Bishop
Saint and Saint Lawrence*
(predella panel), c. 1404/7,
tempera on panel, Los Angeles
County Museum of Art, gift of
Dr. Ernest Tross (47.23).
CAT. NO. 16

FIGURE 7
Neri di Bicci (Florence,
1419–1492), *Virgin and Child
Enthroned with Saints and the
Annunciation* (triptych) with
closed wings, c. 1440/50,
tempera on panel, Los Angeles
County Museum of Art, gift
of Varya and Hans Cohn in
honor of the museum's twenty-
fifth anniversary (M.91.15).
See fig. 17 for the open triptych.
CAT. NO. 13

FIGURE 8 *(facing page)*
Francesco di Stefano (called
Pesellino; Florence, 1422–1457),
finished in the workshop of
Filippo Lippi, *The Trinity with
Saints Mamas, James the Great,
Zeno, and Jerome*, 1455–60,
tempera on panel, the National
Gallery, London.

figure with small narrative scenes arranged on the sides (FIG. 4). Vertically oriented rectangular or gabled-top panels were the next development, but the simplicity of this format gradually gave way to a division of the panel by its frame. The frames, often of a piece with the panels themselves and usually gilded, became increasingly elaborate until they evolved into architectural fantasies of arches, spandrels, and pinnacles (FIGS. 5, 38). This kind of compartmentalization had been used to separate scenes on early Christian sarcophagi and medieval reliquary caskets, but it was even more ideally suited to the hierarchy of the individual figures and scenes that now developed in panel painting. A substantial base was needed to support these works; it was called a *predella*, or altar step, and it too was divided by its structure and framing elements into fields that were often decorated with subsidiary figures and scenes (FIG. 6), coats of arms, or inscriptions. It was not unusual for panels to be

painted on both sides, especially large altarpieces in monastic churches, where the monks sat in the choir behind the high altar, or small, freestanding diptychs or triptychs with hinged wings that could be closed and thus provided another surface for decoration (FIG. 7). With the increase of the influence of classical Greek and Roman art, the preferred shape of altarpieces of the later fifteenth century became once again simple rectangles, with frames equally simple in shape decorated with elegant and subtle motifs taken from ancient architecture. The lower horizontal element of the frame was often retained as a predella and decorated with related scenes or figures (FIG. 8).

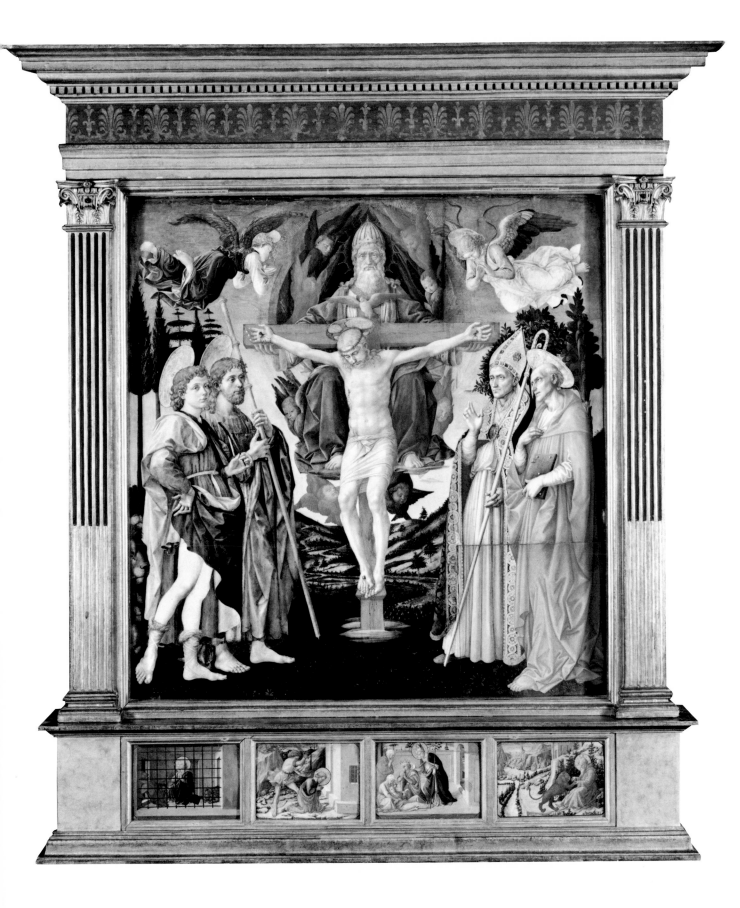

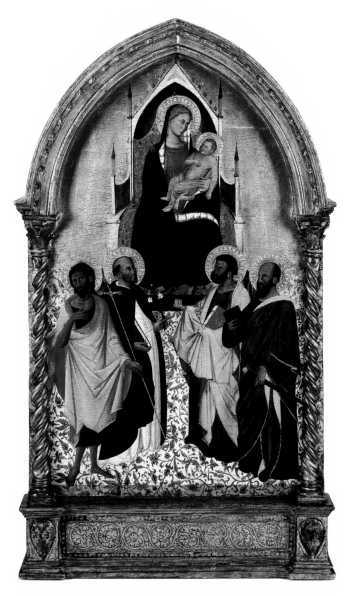

Patronage Most panel paintings, like most other forms of art in medieval and Renaissance Italy, were executed on commission, especially altarpieces and other large works. Due to the status of artists as craftsmen—a status that was not to change for the majority of artists until well into the sixteenth century—the patron had control of almost every detail of the painting. The artist was frequently provided with a prepared panel, often with an integral frame already in place, into which he was expected to fit the requested composition (FIG. 9). Most contracts detailed the patron's wishes as to the subject to be painted, the arrangement of the figures and other elements of the composition, the amount and quality (gauged by cost) of gold and expensive pigments that were to be used, the time period in which the work was to be executed, and the manner of payment; other written agreements referred to previous discussions or attached sketches that provided the same information. Patrons and their agents kept an eye on the progress of the painting, complaining if it was not done quickly enough and demanding changes if the results were not pleasing to them. In documents of the period it is the patron who receives the credit for the finished work; if the artist's name is mentioned at all, it is usually in order to give the patron praise for commissioning him. The patronage of art and architecture in the fifteenth century was seen not as the fulfillment of any aesthetically motivated desire but as an act of piety or civic duty, the expiation for sin (especially usury, which affected any citizen involved in banking or commerce), or a guarantee of present glory and a measure of immortality.

FIGURE 9
Niccolò di Pietro Gerini (Florence, active 1368–1415/16), *Virgin and Child with Saints John the Baptist, Dominic, Peter, and Paul*, 1375/85, tempera on panel, Los Angeles County Museum of Art, gift of Alexander M. and Florence E. Bing (48.1).
CAT. NO. 5

FIGURE 10 *(facing page)*
Dario di Giovanni (called Dario da Treviso; Veneto, c. 1420– before 1498), *Saint Bernardino of Siena*, c. 1470, tempera on panel, Los Angeles County Museum of Art, gift of Dr. Rudolph Heinemann (48.6).
CAT. NO. 4

Patrons could be corporate or individual, from the state itself to one of its humblest citizens. Civic governments, fond of grandiose decorative schemes frescoed in the rooms of their municipal headquarters, did not often commission panel paintings, although they sometimes presented a church with an altarpiece or contributed to the costs of an expensive commission: Pietro Lorenzetti's *Carmelite Madonna* (Pinacoteca Nazionale, Siena), painted in 1329 for the church of San Niccolò and subsidized by the Consiglio Generale of Siena, is an example. The powerful and wealthy merchant and craft guilds ordered large panel paintings for the chapels or altars they had endowed in local churches, as did the lay confraternities that were the charitable arms of these same guilds or the support groups formed by the ecclesiastical or monastic authorities. The guilds and confraternities also commissioned works for their headquarters and meeting rooms.

While the interior walls of churches were often decorated with frescoes commissioned either by the church authorities or devout donors, there were dozens of panel paintings

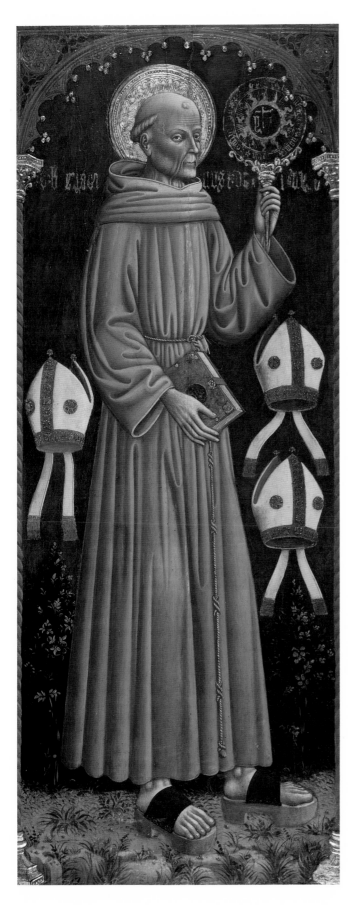

executed for even the smallest of churches, from the high altar, usually paid for by the bishop or monastic order to whom the church belonged, to altarpieces in the sacristy and subsidiary chapels commissioned by the family or organization that endowed them. Endowed chapels were a source of income to the church, and when these spaces ran out, new donors were sometimes allowed (even encouraged) to erect small altars against walls or even against the columns separating the nave from the side aisles, providing both a new source of funds for the church and a need for more altarpieces. Religious paintings were also required for altars set up in chapels and oratories in monasteries and hospitals, government and guild buildings, and private palaces.

Secular Commissions Corporate and family patronage, directed largely toward the decoration of spaces for religious use, was almost never associated with secular subject matter. Even the paintings commissioned for civic buildings were usually directly or indirectly religious in theme: a city's patron saints (FIG. 10), allegories extolling the "Christian" virtues, or scenes of military victories achieved by the grace of God (and often attended by celestial participants or observers). It was patronage by individuals that led to the proliferation of secular imagery.

Panel paintings were commissioned by private patrons of all degrees, princes of the state and of the church, the nobility and the patriciate, merchants and bankers, scholars and monastics, and men and women of quite humble means. While some of the commissioned works were religious in nature—particularly small panels and portable altarpieces for private devotions (FIG. 11)—the rediscovery of and renewed interest in the literature and history of ancient Greece and Rome provided many themes appropriate for the decoration of domestic or secular civic spaces. There were morally edifying episodes to demonstrate the nobility of the human race, complicated allegories to challenge the mind, and scenes of grace and beauty to delight and stimulate the senses and emotions. Twentieth-century scholarship has often succeeded in demonstrating that some of the most overtly "pagan" or frivolous of the secular works of the early Renaissance have an underlying religious

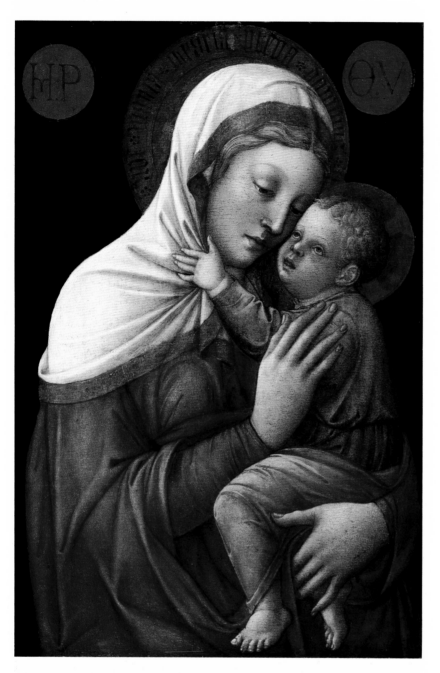

or at least moral significance; it would thus be unwise to consider these paintings as a body of work unrelated to the contemporary production of religious art. In the same way, it is a mistake to think of the desire for the acquisition of secular art as an impulse at odds with personal piety. A new interest in observation of the natural world and a new regard for the place of humankind at the center of that world was certainly inspired by the learning and accomplishments of the ancients, but in appreciating creation the people of the Renaissance revered the creator and in themselves they saw the image of God.

Not surprisingly, in the light of a new self-confidence in the men and women of the Renaissance, the art of portraiture developed into an independent genre to which the panel was ideally suited. Increasingly lifelike figures of donors appeared at the sides of altarpieces (FIG. 12), and local notables could be recognized among crowds present at episodes from the life of Christ or the saints, such as the luminaries of the papal court on the walls of the Sistine Chapel in Rome (c. 1482) or the prominent citizens of Florence in the fresco cycles of Domenico Ghirlandaio in Santa Trinità (1483–86) and Santa Maria Novella (1485–90). Occasionally a saint would be given the clearly recognizable features of a contemporary of the artist, as in Giovanni Bellini's portrait of the Dominican monk Fra Teodoro da Urbino as Saint Dominic (1515; National Gallery, London). Panels recording the lineaments of a single individual were used at first for gifts and presentations, to celebrate a betrothal or as a diplomatic courtesy, but soon patrons were commissioning portraits of themselves for themselves (FIG. 13). In the early part of the fifteenth century many sitters preferred a profile portrait, in imitation of ancient coins, which most accurately captured their likeness; later in the century they were represented in a three-quarters view that more vividly communicated the essence of their character.

Secular panels had at first a largely decorative function, just as secular frescoes had first been employed as substitutes for leather and tapestry wall coverings. The panels were

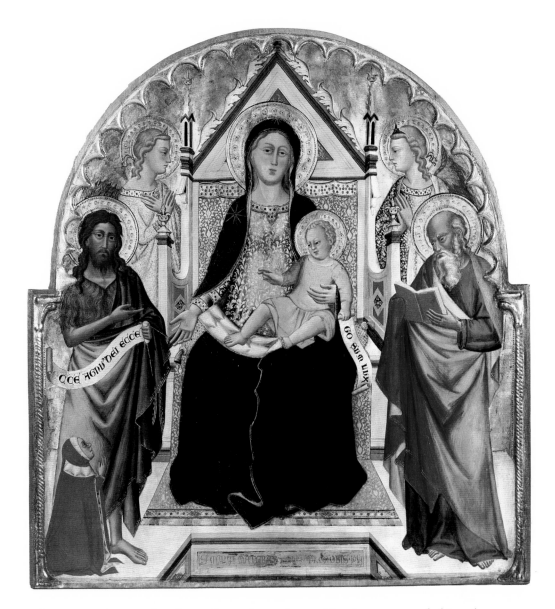

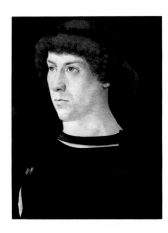

often mounted in wood wall paneling or large pieces of furniture or were fashioned as objects in themselves, such as trays or shields, for presentation or display rather than use. Even some of the largest and most famous of the fifteenth-century panel paintings were conceived as decoration: Paolo Uccello's three panels of the *Battle of San Romano* (now divided between the National Gallery, London; the Galleria degli Uffizi, Florence; and the Musée du Louvre, Paris) were painted about 1445 for the end wall of a bedroom in the Palazzo Medici in Florence, and Sandro Botticelli's exquisite *Primavera, Pallas and the Centaur*, and possibly the *Birth of Venus* (all arguably painted around 1482 or shortly thereafter and now in the Uffizi) were in the private apartments of Lorenzo di Pierfrancesco de' Medici, second cousin of Lorenzo the Magnificent.

Many of the paintings executed for inclusion in wall panels or furniture confirm the survival of the popular tradition of storytelling into the Renaissance. Some of the tales come from medieval chivalric literature and local legends, others from ancient history. The scenes and stories chosen for illustration usually feature an elaborate ceremony— a banquet, procession (FIG. 14), wedding, tournament—that reflected activities in which the patron was often involved. The panels were displayed in the public rooms of private palaces

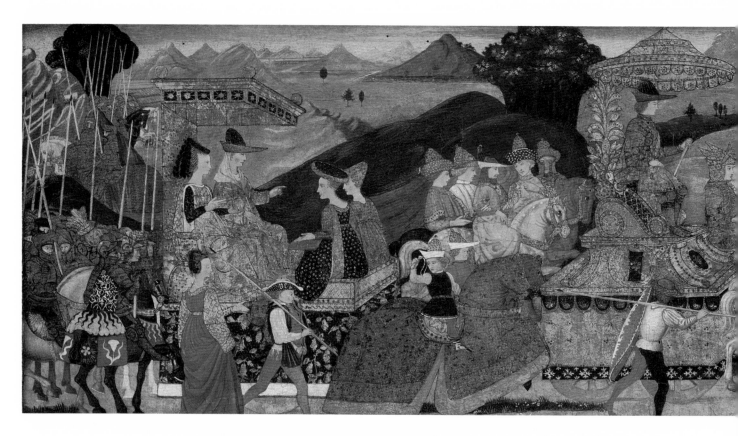

as *spalliere*, mounted in the wall paneling or in the frame of a bed (even the bedroom was often a public space, doubling as a reception room), or as the sides of *cassoni*, large carved and painted chests commissioned at the time of a betrothal, in which a bride would carry her possessions to her new household and which then served the double purpose of storage and adornment (FIG. 15). The themes chosen for these panels were suitably appropriate—stories of filial piety, paragons of female and male virtue, episodes of family glory—but they seem more often to have been selected for their potential for splendor, variety, and richness, deliberately incorporating battle scenes, triumphal entries, and social events. Single scenes were filled with crowds of figures and animals, colorful textiles and armor (a good excuse for a great deal of gold and silver), and elaborate architectural or landscape backgrounds. Narrative panels incorporated as many episodes as possible, the composition arranged in architectural stage sets to enhance the clarity of the progression of the tale.

Ready-Made Art An artist in the early Renaissance rarely executed a panel without a commission, but there were exceptions. Ready-made secular images were available on panels to be included in pieces of furniture or to serve as wall decoration or *deschi da parto*, "birth

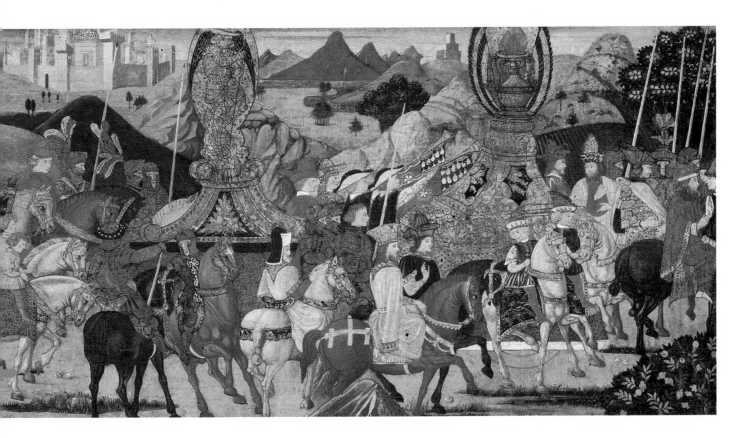

trays," on which refreshment was presented to a woman after she had delivered a child; these panels could be customized with coats of arms or mottoes. Such panels did not require a large outlay of material or time on the part of the makers, who were usually not among the leading masters (although some of the panels did issue from major workshops, having been executed, we assume, by assistants).

The relatively few religious paintings produced for a mass market were small images of the Virgin and Child (FIG. 16) or, less commonly, the Crucifixion, Adoration, or Annunciation, to be used for personal devotions. Some of these were versions of or details copied from well-known images, occasionally in the workshop of the master who had painted the original. Contemporary sources mention the mediocre *madonnieri* (literally, madonna makers), who specialized in such painting; they could count on these works to give them a steady income, especially from citizens who could not afford to commission a devotional image.

Iconography Such imagery was essential because nearly every citizen had a saint or group of saints to whom he or she owed devotion. The concept of intercession suggested that mortals, unworthy to address God in their sinful state, required advocates to plead for them. This was often the Virgin Mary, but some supplicants dared to approach her only through a lesser saint; others invoked the Virgin and many more saints for insurance. Many people lost sight of the intercessor as a channel to God and concentrated their devotion on that intercessor, whose specific image became the focus of great piety and veneration. Some supplicants, in need of something they could see and touch, veered over the fine line separating veneration from idolatry, worshiping particular images, some of them associated with relics of a saint. Although hundreds of images of the Virgin and Child were available

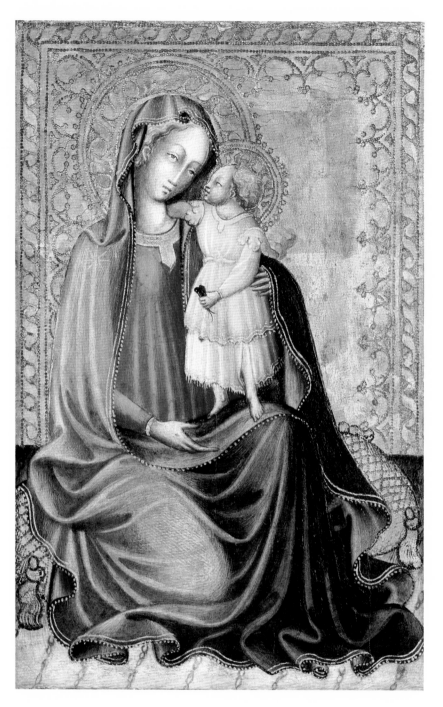

FIGURE 16
Master of the Bargello *Judgment of Paris* (also called the Master of the Carrand Tondo; Florence, active early fifteenth century), *Virgin of Humility*, c. 1425, tempera on panel, Los Angeles County Museum of Art, gift of Robert Lehman (47.11.1).
CAT. NO. 11

to the residents of any large city, it was not unusual for them to travel a great distance to pray before an ancient image of the Virgin that had a proven record of healing or other answered prayer. A fourteenth-century fresco of the Annunciation in the church of the Santissima Annunziata in Florence was (and still is) a goal for many, and pilgrims from all over Europe have been journeying to Lucca since the eleventh century to venerate the *Volto Santo*, a wooden crucifix once believed to have been carved by an eyewitness to the Crucifixion (see pp. 64–65 and FIGS. 46–47).

By the very conditions of their existence, individuals would enlist a whole company of saints in their defense (FIG. 17). For example, Florentine banker Piero de' Medici, the father of Lorenzo the Magnificent, had a name saint (Peter), family saints (Cosmas and Damian, who were doctors, or *medici*), his guild's patron (Matthew, who was a tax collector, and thus the bankers' saint), his confraternity's patrons (the Three Kings, for the Compagnia dei Magi), the saint to whom his parish church was dedicated (Lawrence), and the protector of his city (John the Baptist), not to mention the myriad saints to be appealed to in the specific crises and events of life, such as childbirth (Margaret of Antioch), plague (Roch and Sebastian), and travel (Christopher and Raphael).

Thus the choice of even one saint to accompany the Virgin and Child in a painting was a matter for serious consideration and signifies the existence of a patron who had made that decision. The selection of saints was conditioned by the eventual purpose to which the work would be put: an image to be hung in a bedchamber might incorporate only the patron's name saint, while an altarpiece conspicuously displayed in the family chapel in a large church might comprise everyone up to and including the patron saint of the city.

Narrative scenes drawn from the life of Christ, the Virgin Mary, or the saints (FIG. 18) were as popular as individual or grouped figures of saints in attendance on Christ and his

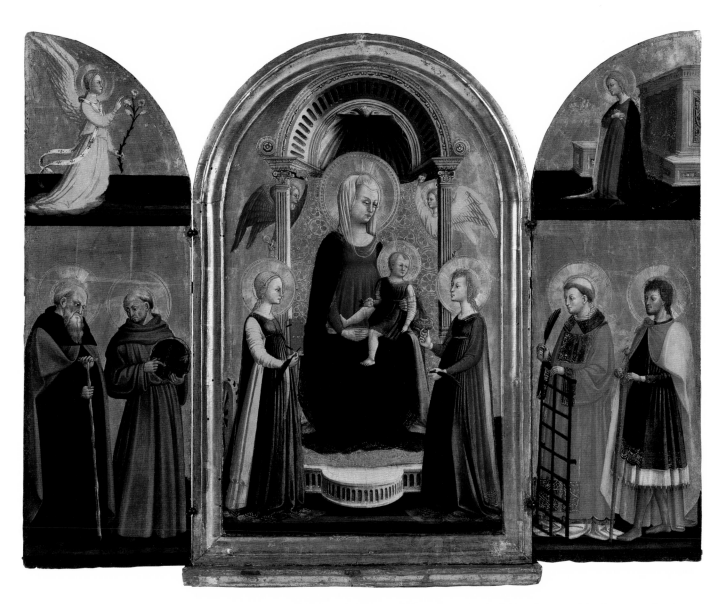

FIGURE 17
Neri di Bicci (Florence, 1419–
1492), *Virgin and Child Enthroned
with Saints and the Annunciation*
(triptych), c. 1440/50,
tempera on panel, Los Angeles
County Museum of Art, gift of
Varya and Hans Cohn in honor
of the museum's twenty-fifth
anniversary (M.91.15).
CAT. NO. 13

mother. A story with a large number of episodes was ideal for a fresco cycle, for example, the extensive early-fourteenth-century series of scenes from the life of Saint Francis in the upper church of San Francesco in Assisi (once attributed to Giotto but now believed to be the work of three unidentified artists, two of whom may have been Roman) or Vincenzo Foppa's life of Saint Peter Martyr, painted in the late fifteenth century in the Portinari Chapel, Sant'Eustorgio, Milan. Such an elaborate program, however, could rarely be accommodated on all but the largest altarpieces. One scene would usually be the primary subject of an altarpiece (FIG. 19), and a small group of scenes could serve as subsidiary decoration on a predella, wings, or pinnacles. Such scenes not only educated the faithful and presented models for personal piety, they satisfied a craving for entertainment—the delight in storytelling evinced by the entire population. It should be remembered that many of these stories were immediately recognizable to most of the populace, who had grown up in the midst of an immense amount of similar visual imagery. One episode in a predella would not only identify the corresponding saint in the main panel above but would recall to the viewer the whole narrative of that saint's life, works, and miracles.

A love of narrative was also responsible for much of the secular subject matter in paintings of the early Renaissance, a great deal of which was drawn from the literature of antiquity, from Homer's *Iliad* and *Odyssey* and Virgil's *Aeneid* to the biographies of notable Greeks and Romans by Plutarch and Suetonius. The tone could be moralizing or frivolous, depending on the whim of the patron and the purpose for which the painting was executed. The depiction of a series of illustrious men and women of antiquity (both biblical and classical) and the Middle Ages, extolling their exemplary character and accomplishments, proved a popular and edifying theme: King David, Judith, Queen Esther, Alexander the Great, Queen Tomyris, and the Roman general Scipio Africanus became nearly as recognizable as the saints. Myths and legends were mixed with local history in a fairy-tale blend that charmed and delighted. The more refined the patron, the greater the desire to infuse the subject with symbolism and hidden meaning. Such *invenzioni*, which required learning and intellectual cunning to unravel, were a serious and engrossing pastime for the patrons and their resident scholars or humanist advisors. Unfortunately and intriguingly, some of the layers of meaning of such works—Botticelli's *Primavera*, for example—have been irretrievably lost over the centuries, and in the absence of documentary evidence there is no way to discern which of several conflicting modern interpretations is correct.

FIGURE 18
Lorenzo Monaco (Florence, 1370–1425), *Martyrdom of Pope Caius*, c. 1394/95, tempera on panel, Santa Barbara Museum of Art, museum purchase.

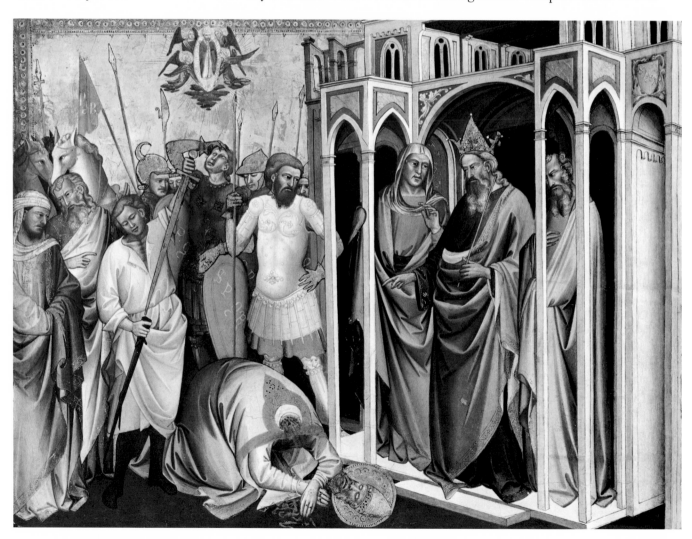

Fragments Many of the early Renaissance panel paintings in the world's museums are segments of larger works that were disassembled and dispersed. Central panels of large altarpieces have been separated from their wings, predellas, pinnacles (FIG. 20), or spandrels and are now often divided by a continent or more, if they have survived at all. Such altarpieces, once occupying a position of honor on a church's main altar, were gradually moved to side altars and then to sacristies or storage areas so that they could be replaced by works in a newer style. Primarily in the eighteenth and nineteenth centuries the less important elements and occasionally whole altarpieces were cut up and sold—sometimes legally, more often not—either to provide extra income for a church (or a member of its clergy) or when a church was suppressed, that is, officially closed and deconsecrated. Occasionally,

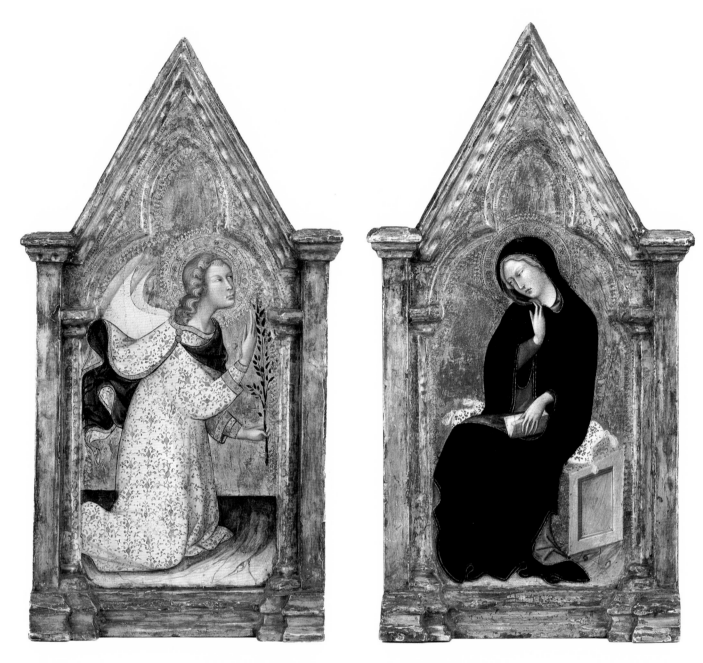

written or visual evidence, such as documents from church archives or old engravings, allows us to discover the origin of a detached panel and the location of other segments of the same altarpiece or monument, such as Duccio's immense *Maestà* (1308–11), whose central panel and many subsidiary scenes still fortunately remain in Siena (Museo dell'Opera del Duomo), or Ugolino di Nerio's high altar of about 1325 for the great Franciscan church of Santa Croce in Florence, some of whose major sections, including the central image of the Virgin and Child, are lost (FIG. 21; see CAT. NO. 17).

Secular art did not escape this fate. *Cassone* panels and *spalliere* especially were often sawn or pried out of their furniture surrounds and cut into as many pieces as the composition would allow (FIGS. 22–23), in order to maximize the seller's profits, just as other vendors would for the same purpose separate pendant paintings, break up a set of objects, or tear the illustrations out of an illuminated manuscript or printed book.

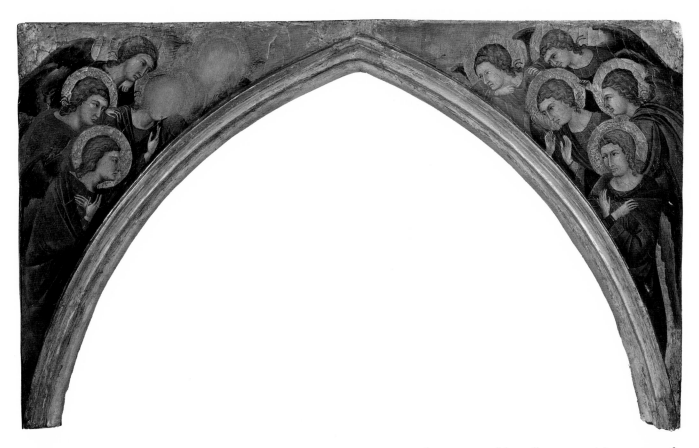

The Artists of the Early Renaissance The concept of the collector acquiring art out of admiration for its beauty and the artist's talent was only in its nascent stage at the very end of the fifteenth century. Isabella d'Este, the marchioness of Mantua, sent her agents after many paintings, but the force behind her acquisitive frenzy was the desire to have a work by every possible eminent artist; the painting itself seems to have been of secondary importance: she was unconcerned about the artist's style, and while she initially dictated explicit details of iconography, she was happy to settle for a different subject altogether. This was in contrast to her son, Federigo, first duke of Mantua, who was not concerned with the identity of the artist as long as the erotic content of the painting was pronounced.

Federigo's attitude, rather than his mother's, characterized most of the patrons of the early Renaissance, who perceived artists as servants, as producers of commodities, or as commodities themselves. As we have seen, the artist's task was largely subject to the patron's desires. The depiction of specific subject matter was constrained both by the patron's demands and by convention, and the elements and arrangement of the composition were strictly dictated by church authorities, court scholars, or erudite "advisors." Some themes, particularly religious subjects for public display, required a traditional iconography accessible to all; contracts often specified that a painting be executed in "*modo et forma*," that is, in the manner and form of an earlier work. Other themes were complex, highly personal, and newly invented or reinvented for the delectation of the cultural elite. Either way there was little latitude for innovation. It required all the inventive powers of an artist to produce a composition that was not simply a more recent version of a well-known image;

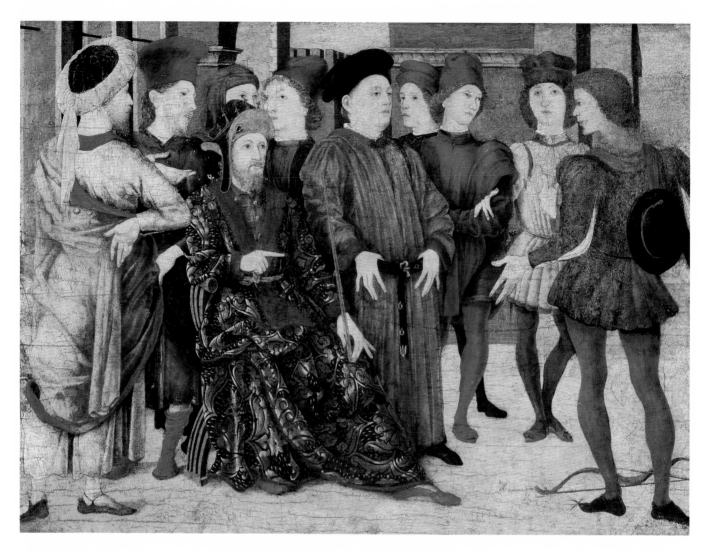

many lesser artists did not even make the effort to do so. The most leeway was accorded in matters of style, but even here the effect of tradition may be seen. The central panel of a large altarpiece, for example, was usually a manifestation of an artist's style at its most conservative, while the predella provided an opportunity for experimentation and now gives us a better idea of the painter's unfettered interests and abilities, unless, as sometimes happened, these subsidiary elements were assigned to an assistant of lesser talent.

The typical bottega (workshop) of an early Renaissance artist was full of assistants, some of minimal talent. There were journeymen (fully trained artists hired as assistants), one or more apprentices sent to learn art as a trade, and helpers of all sorts; occasionally more than one master would share space and personnel. The terms of a contract and the amount of the payment determined the degree of participation of the master: for a high price he would execute the work himself, although his assistants would prepare the panel and colors and would perhaps do some background painting; at the bottom of the fee scale he would merely invent the composition and supervise the work of a shop assistant. It is thus not unusual for paintings of this period to show the hand of more than one artist (FIG. 24).

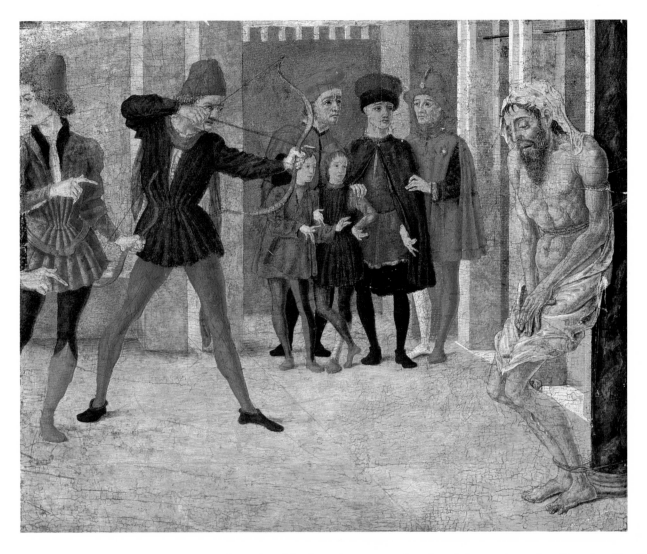

FIGURE 23
Marco Zoppo (Bologna and
Venice, 1433–1478), fragment of
Shooting at Father's Corpse,
c. 1462, tempera on panel,
Florence, private collection.
See CAT. NO. 18

The artist with a large bottega produced work in a variety of media; a few, like Francesco
di Giorgio in Siena, Leonardo da Vinci in Milan, and Andrea Verrocchio and Botticelli in
Florence, turned out panel paintings, frescoes, sculpture in various media, goldsmiths'
work, illuminated manuscripts, decorated leather, and designs for embroidery and intarsia
(wood mosaic), not to mention architecture and engines of warfare. Some shops included
resident carpenters and carvers who could make panels, frames, and even pieces of furniture
into which the panels were set.

In some cities—Siena, for example—painters were compelled to join guilds with strict
regulations about practices and even materials; in other cities they were a loose federation.
But the structure of a bottega was organized along the lines of a family, literally and figura-
tively. As in all ranks of society at that time, children were expected to enter the family
business, unless they went into the church or showed a talent for another career that would
elevate the status of their family or provide an economic advantage. Those in whom artistic
ability was somewhat lacking, even after years of training, could function in other capacities
for the workshop—preparing grounds, mixing colors, or outside the bottega as buyers,
agents, even notaries. The family structure extended also to those who came to the shop as

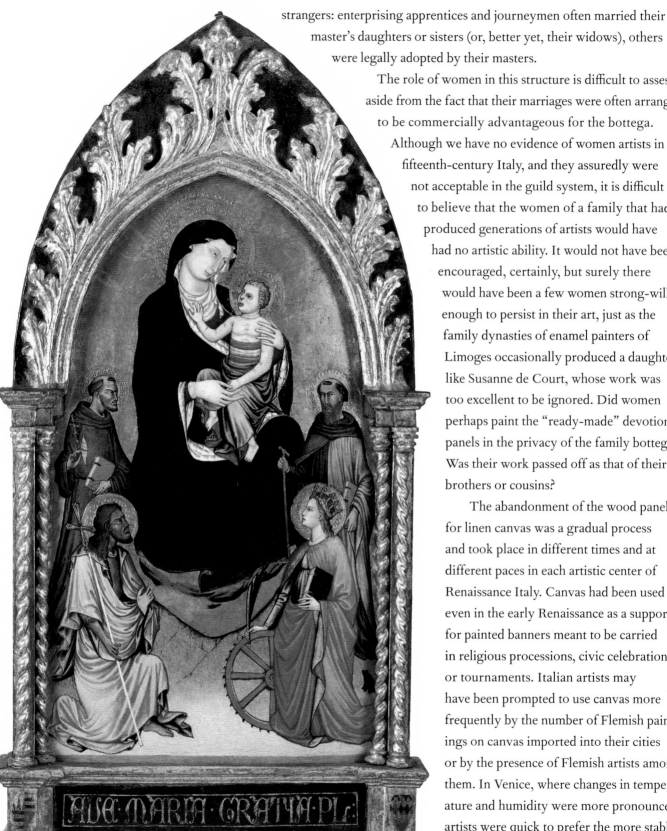

strangers: enterprising apprentices and journeymen often married their master's daughters or sisters (or, better yet, their widows), others were legally adopted by their masters.

The role of women in this structure is difficult to assess, aside from the fact that their marriages were often arranged to be commercially advantageous for the bottega. Although we have no evidence of women artists in fifteenth-century Italy, and they assuredly were not acceptable in the guild system, it is difficult to believe that the women of a family that had produced generations of artists would have had no artistic ability. It would not have been encouraged, certainly, but surely there would have been a few women strong-willed enough to persist in their art, just as the family dynasties of enamel painters of Limoges occasionally produced a daughter, like Susanne de Court, whose work was too excellent to be ignored. Did women perhaps paint the "ready-made" devotional panels in the privacy of the family bottega? Was their work passed off as that of their brothers or cousins?

The abandonment of the wood panel for linen canvas was a gradual process and took place in different times and at different paces in each artistic center of Renaissance Italy. Canvas had been used even in the early Renaissance as a support for painted banners meant to be carried in religious processions, civic celebrations, or tournaments. Italian artists may have been prompted to use canvas more frequently by the number of Flemish paintings on canvas imported into their cities or by the presence of Flemish artists among them. In Venice, where changes in temperature and humidity were more pronounced, artists were quick to prefer the more stable stretched and primed canvas to wood that would expand and contract, to the detri-

ment of the paint layer, or to a plaster wall that would hold the damp and flake. The change of support seems to have been a choice governed by the size of the painting, its intended use or placement, the wishes of the patron, or the preference of the artist.

BIBLIOGRAPHICAL NOTE For an excellent introduction to the many aspects of Renaissance panel painting, see especially David Bomford, Jill Dunkerton, Dillian Gordon, and Ashok Roy, *Art in the Making: Italian Painting before 1400*, exh. cat. (London: National Gallery Publications, 1989); Jill Dunkerton, Susan Foister, Dillian Gordon, and Nicholas Penny, *Giotto to Dürer: Early Renaissance Painting in the National Gallery* (New Haven: Yale University Press; London: National Gallery Publications, 1991); and Henk van Os, *Sienese Altarpieces, 1215–1460: Form, Content, Function*, 2 vols. (Groningen: Bouma's Boekhuis/Egbert Forsten, 1984/1990), all of which have extensive bibliographies.

FIGURE 24
Follower of Mariotto di Nardo
(Florence, active 1394–1424),
*Virgin and Child with Saints
Francis, John the Baptist,
Catherine of Alexandria, and
Anthony Abbot*, c. 1420, tempera
on panel, Los Angeles County
Museum of Art, William
Randolph Hearst Collection
(48.5.7).
CAT. NO. 9

Technical Introduction

JOSEPH FRONEK

Much of our knowledge regarding early Italian painting comes from a relatively well-known treatise written by the artist Cennino d'Andrea Cennini. Though he wrote his manuscript *Il libro dell' arte* in about 1400, he described techniques that had been in use for more than a century.[1] Other fifteenth-century manuscripts about the making of paintings survive, but these are either more like recipe books, of which the so-called Bolognese manuscript is an example, or not so complete as Cennini, of which the Strasburg manuscript originating in northern Europe is an example.[2] Cennini, however, wrote for young apprentices and instructed them in everything from grinding pigments to preparing the panel to applying colors.[3]

In recent years scientific analysis of Italian paintings of the fourteenth and fifteenth centuries has added to our understanding of the materials and techniques used by artists of the time.[4] Pigments and media have been identified for many paintings from this period, and the actual layer sequence of ground and paint layers has now been proven. The results of

the analysis of these materials and techniques generally support Cennini's writing of more than five hundred years ago.

Most of the paintings that have come down to us from the fourteenth and fifteenth centuries are on wood panels. There were paintings on canvas, but it was not until the sixteenth century that fabric became a widespread support for altar paintings. Cennini gives little space to paintings on canvas, but he does mention something that helps to explain why they eventually became popular: canvas paintings could be folded or rolled without harming the gold or paint. Thus, they could be transported much more easily.

FIGURE 25

Stages in the making of a panel painting (illustration by Virginia Rasmussen): *far left*, gesso, bole, and some gold leaf applied; *middle*, gold burnished, punchwork begun, first layers of paint applied; *far right*, flesh still to be completed.

In format the smaller paintings in this volume are of two types: the single-panel devotional painting, such as the *Virgin and Child with Saints Francis, John the Baptist, Catherine of Alexandria, and Anthony Abbot*, by a follower of Mariotto di Nardo (see FIG. 24), and the portable triptych, such as that by Neri di Bicci (see FIG. 17), with a central image of the Virgin and Child and wings depicting saints. The wings would be closed to protect the precious images, and with the wings closed (see FIG. 7) the triptych converts into a compact object that could be easily transported.

Some of the smaller panels were originally components of multipaneled altarpieces called polyptychs. The more sophisticated polyptychs usually have a central vertical image flanked by two or more panels with a lower horizontal series of images called the predella and an upper series called the pinnacles. The two Bartolo di Fredi panels depicting *The Angel of the Annunciation* and *The Virgin Annunciate* (see FIG. 20) were once pinnacles from

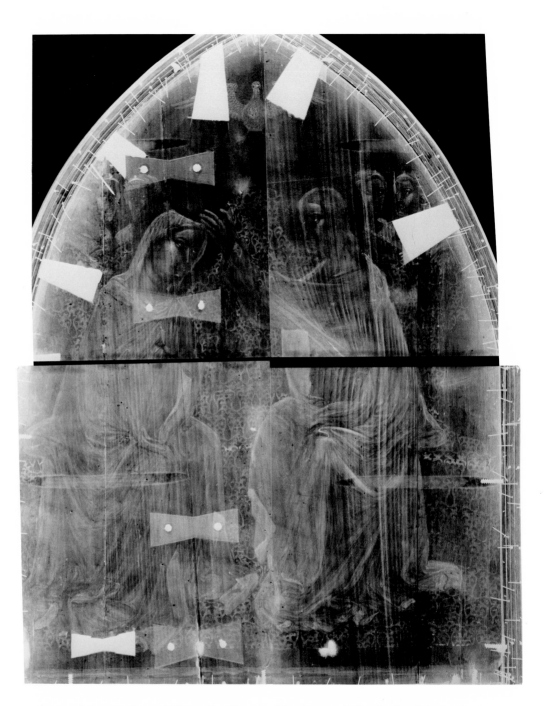

a dispersed large polyptych from the Chapel of the Annunciation in the church of San
Francesco in Montalcino outside Siena.

It is thought that the little narrow panel of *A Bishop Saint and Saint Lawrence* (see FIG. 6)
by Gherardo di Jacopo di Neri Starnina once formed part of a predella. Recent studies have
found that predella images were painted on one continuous piece of wood.[5] As was the fate
of the Starnina in this collection, many predellas were cut up to be made into several indi-
vidual pictures for the art market.

The Luca di Tommè *Virgin and Child Enthroned with Saints Nicholas and Paul* (see
FIG. 35) appears always to have been a single-panel altar painting. A single rectangular
painting devoid of any supplementary imagery is relatively uncommon in fourteenth-cen-
tury Italian religious art; however, by the fifteenth century this type of painting became the
norm. The altarpiece by the Master of the Fiesole *Epiphany*, *Christ on the Cross with Saints*

Vincent Ferrer, John the Baptist, Mark, and Antoninus (see FIG. 45), is an example. Such a work, with one unified image, has a tabernacle frame, which is like a window through which the painting is viewed.[6] Such paintings could have predellas, but whether or not this was true for either of the museum's paintings will only be determined if more documents about the paintings come to light.

Secular art is represented here by two panels, *The Triumph of Alexander the Great* by Bernardo Rosselli (see FIG. 14) and *Scene of Judgment* by Marco Zoppo (see FIG. 22). Once proportionally longer like the Rosselli, the Zoppo has been cut in half (see FIG. 23). Each of these panels would have decorated the fronts of chests, or *cassoni*, which would have been used for storage. Though utilitarian, these pieces of furniture were also highly prized decorative objects.

The Supports Italian panels are almost always made of poplar, a tree common in Italy. Small upright panels consist of a single plank of wood set vertically. Large panels, as one would expect, are composed of several planks. The panel for Luca di Tommè's *Virgin and Child Enthroned with Saints Nicholas and Paul*, for example, is made up of three vertical planks probably glued together and held tightly with wooden "butterflies." The latter reinforcements, which are set flush into the planks, show up in X-radiographs of the painting (FIG. 39). Dowels were also commonly used to join wooden planks of a panel, and X-radiographs will often expose these as well (FIG. 26).

Battens across the reverse gave additional support to composite panels and helped to keep them flat. Though Rosso Fiorentino's *Allegory of Salvation with the Virgin, the Christ Child, Saint Elizabeth, the Young Saint John, and Two Angels*, c. 1521, in the Los Angeles County Museum of Art, is beyond the scope of this volume, it provides an excellent example here because the reverse of the panel has remained completely intact. Metal braces have been added later across some of the joins; however, the rough backs of the planks, with marks of planing, and the heavy battens crossing the top and bottom of the panel, have not been altered in any other way (FIG. 27). It is very rare to find a panel in this original state. Why this is true will be discussed toward the end of this essay.

The way in which the panel for Luca's *Virgin and Child Enthroned with Saints Nicholas and Paul* was put together suggests that it was crafted with a particular composition in mind. The joins are aligned on either side of the Virgin, between the Virgin and saints.

Since joins may come apart or open with age, they were obviously placed between the figures so as not to deface them if and when they did open.

Fourteenth-century paintings, such as the two Bartolo di Fredi panels of the Annunciation, often have engaged frames, referred to as such when a frame molding was attached to the edges of the panel before any preparation for painting began.[7] Additional molding was usually added to the polyptych once painting was completed. This type of framing continued into the fifteenth century (the Neri di Bicci triptych of c. 1440/50 [see FIG. 17] being one example) even when frames began to be made completely separate from the panel (as in the case of the altarpiece by the Master of the Fiesole *Epiphany*).

Panels were prepared by a carpenter, and panels for larger, more expensive commissions were made to order. We know this from surviving contracts for such projects. The expense of the carpenter could even be as much as that of the artist, for the woodworker not only made the panel but also had to carve moldings and attach them to the edges of the panel.[8]

Panel Preparation Preparation of a panel for painting required several steps that were usually completed in the artist's studio. The goal of preparation was to achieve a very smooth, white surface with just enough roughness, or tooth, and absorption to create a good bond with the paint. Any holes or knots had to be filled and smoothed, then the panel was sized with glue. In order to further stabilize and even out the surface, thin linen was sometimes attached with glue over the face of the panel. The linen can sometimes be detected in X-radiographs of Italian panels. (FIG. 28).

The next step was the application of the ground, which in this case was composed of numerous coats of gesso, a mixture of gypsum and animal-skin glue. Cennini gives elaborate directions for the preparation and application of gesso, beginning with the coarser first layers and then following with the finer later layers. Each application of gesso was carefully rubbed and smoothed. Cross sections of the paint and ground layers from Luca's *Virgin and Child Enthroned with Saints Nicholas and Paul* actually show the layers of preparation as described by Cennini (FIG. 29).

Underdrawing From Cennini's treatise we learn that the design of the painting should first be drawn out with charcoal on the gesso and then, using diluted ink or paint, worked up with some indications of drapery folds. The growing transparency over time of paint films

FIGURE 28
X-radiograph detail (upper left) of Niccolò di Pietro Gerini, *Virgin and Child with Saints John the Baptist, Dominic, Peter, and Paul*, 1375/85.
CAT. NO. 5

FIGURE 29
Cross section of Luca di Tommè, *Virgin and Child Enthroned with Saints Nicholas and Paul*, c. 1367/70, magnification of 250X, showing paint layers and ground in the area of Saint Paul's pink robe.
CAT. NO. 8

has made some of these drawings visible to the unaided eye. The *Coronation of the Virgin* by Martino di Bartolomeo (see FIG. 19) is one such example. Here we see the drawn outlines of forms and indications of folds in many areas of the picture. When the drawing was completed, these outlines were inscribed with a pointed object wherever the forms abut areas that were to be gilded. The panels by Luca and Martino exhibit this last feature quite clearly.

An infrared photograph (see FIG. 54) of the altarpiece by the Master of the Fiesole *Epiphany* reveals the underdrawing especially clearly in the figures of Saints John the Baptist and Mark because the red paints used for the drapery are penetrated by the infrared rays. There are, however, no inscribed lines. In the introduction of Giorgio Vasari's *Lives of the Artists*, first published in 1550, the author included technical treatises on painting, sculpture, and architecture. Vasari described how an artist could transfer a design done on paper to the ground, but he did not adhere to Cennini's system. According to Vasari the sketch was done on paper initially so that it could be reworked according to the inspiration of the artist. (This was an important development as well: Vasari saw the artist as an inspired, creative person rather than the craftsman that Cennini emphasized.) The reverse of the paper was rubbed with charcoal, and by the use of a sharp instrument the design was transferred to the white ground.[9] Rosso Fiorentino in his *Allegory of Salvation* sketched out the design on the ground with charcoal. Whether or not the designs of this panel and that by the Master of the Fiesole *Epiphany* were first transferred to the ground from a cartoon as Vasari describes cannot be determined for certain.

Gilding Once the design was set, the next step for a gold-ground painting was the gilding. Gold acts as a continuous, ethereal backdrop for the holy figures in fourteenth- and early-fifteenth-century Italian panels. Gold leaf is gold beaten until it is as thin as paper. When it is applied and burnished properly, it acquires a hard, reflective surface. Punching, which indents the gold so that it reflects light at different angles, provides the decorative details of halos and borders.

The surface that best allows for burnishing and punching is a natural clay called *bole*. This usually reddish material imparts a rich, warm color to the thin metal leaf. The bole is mixed with size or egg and applied in several layers where the gold is to be applied.

Transferring the thin, crinkly gold leaf onto the bole, which is wetted just before gilding, is no easy task. It requires some skill, and Cennini gives careful instructions concerning the process. Before the bole has become too dry, the gold is burnished with a hard stone such as agate. The stone must be perfectly smooth, and it must be rubbed over the gold with steady but not too great pressure so as not to break the fragile gold leaf. The transformation of the gold from a crinkled appearance to one of a hard, solid surface is remarkable.

Again, before the bole has had time to become too dry the gold is inscribed with sharp compasses to mark out halos and stamped to give decorative designs to halos and borders. Stamping is "one of our most delightful branches," according to Cennini,[10] and is accomplished with metal tools of various shapes called punches. A punch is tapped with a hammer

into the gold ground, thus stamping the design of the punch into the surface. Bole, being a soft and pliable material, allows the indentation to take place without breaking the gold if it is skillfully done.

Though many different designs of punches are found on Renaissance panels, each studio would generally reuse the same punches in panel after panel. In Luca's painting of the *Virgin and Child Enthroned with Saints Nicholas and Paul* the various punches include quatrefoil, oval, and circular designs (FIG. 30). The sparkling effect between the larger punch marks was created with a tiny pointed punch repeatedly hammered into the gold.

FIGURE 30
Detail of Luca di Tommè,
*Virgin and Child Enthroned with
Saints Nicholas and Paul*,
c. 1367/70, showing punchwork
and incised lines in the area of
the Virgin's halo.

Cennini refers to this overall broken-up effect of the tiny pointed stamp, saying that the tiny punch marks "sparkle like millet grains."[11]

Niccolò di Pietro Gerini's *Virgin and Child with Saints John the Baptist, Dominic, Peter, and Paul* (see FIG. 9) is decorated not only with incised lines and punchwork but also with *sgraffito* (from the Italian *sgraffio* meaning "scratch" or "abrasion"), which involves laying paint over the gold and then scratching off the paint to create a design. In the Gerini panel the exposed gold was then punched with tiny pointed punches to create the appearance of a very rich textile woven with designs of golden figures and foliage (FIG. 31).

During the fifteenth century gold grounds came to be replaced with more naturalistic backdrops. In the *Christ on the Cross* by the Master of the Fiesole *Epiphany*, instead of a solid background of gold, there is a blue sky with receding clouds. Gold did not fall out of use, however; it was used in different ways, such as ornamental details of halos, clothing, and hair. There is no better example than the gold striations illuminating the space behind Christ in this panel. The gold is set on top of the paint, and it is slightly raised. Cennini explains this technique, known as *mordant gilding*, in some detail, and it is found on a number of panels in this collection (FIG. 32). (Mordant gilding should not be confused with shell gold, which is gold beaten to a powder and suspended in a medium such as egg white so that it can be applied as a paint.)

The striations in the *Christ on the Cross* were first painted with a mordant or adhesive, probably a resin-type material. A sheet of gold leaf was then applied over the mordant. Once the adhesive set, the unattached gold was brushed away, leaving the intended gold design. Mordant gilding was also used to decorate the hems of many of the garments in this fifteenth-century painting.

Pigments and Paint All of the panels represented in this volume were painted in a very similar way using similar materials and techniques. Once again, Cennini explains the process in some detail, from selecting and grinding pigments, even fashioning brushes and tempering the colors, to applying them to the design.

The palettes used by medieval panel painters were limited compared with today's. Pigments such as terre verte were prepared from naturally occurring minerals, while a few inorganic pigments could be artificially prepared. For example, verdigris, a green pigment,

could be made by exposing copper to some form of vinegar followed by additional steps to refine the green corrosion products. Another important group of pigments was prepared from dyes. Coloring matter extracted from plants, such as indigo, or insect secretions, such as lac, could be deposited on a colorless substrate, such as aluminum hydrate, to form what is called a lake pigment.[12] The standard pigments were obtained from *speziali* (spice dealers), while the more precious ones were obtained from other sources. Ultramarine, for example, was so expensive, more expensive even than pure gold, that if it was to be used, the contract between the artist and patron stipulated the extent of its use, and the patron would often obtain the pigment himself.[13]

The medieval artist actually had a remarkable amount of information available to him about the various pigments. For example, vermilion, the bright orange-red color found in many of our panels, should be bought in lump form, according to the streetwise Cennini, who knew that if the artist bought the pigment already ground, he would also be paying for additives or extenders, a problem that has plagued artists even to the present day. Cennini, who discusses the art of grinding pigments, says of vermilion, "Grind it with clear water as much as ever you can; for if you were to grind it every day for twenty years, it would still be better and more perfect."[14] He could also relate something about the deterioration of this opaque red, for artists of his day looked at their own "Old Masters" to learn how pigments would weather or age. Vermilion, they found, could turn black when exposed to air. One painting in the Los Angeles County Museum of Art has been afflicted in this way, though not too seriously: the vermilion of the frame arch of Gerini's *Virgin and Child with Saints John the Baptist, Dominic, Peter, and Paul* has discolored in a number of areas. Because of this possible instability of vermilion, Cennini recommends that artists use this pigment for panel painting, where it would be bound in medium and probably varnished, but not for fresco on the wall, where it would be more exposed.[15]

The commonly used violet red, a lake, was best if prepared from the secretion of the larvae of the lac insect, according to Cennini.[16] Since it is a relatively translucent pigment, it can produce rich glazes, which are evident in the dress of Saint Mark in the *Christ on the Cross*. Mixed with white, it is the cool pink of Saint Paul's drapery in Luca's *Virgin and Child Enthroned with Saints Nicholas and Paul*.

Valued for its violet blue shade, ultramarine was the most precious of pigments. Ultramarine is the mineral lazurite in the semiprecious stone lapis lazuli. It must be separated from the other minerals in the stone, such as calcite: the stone is powdered and then mixed into a paste of pine rosin, gum mastic, and wax in a weak lye solution. The lazurite will be given up, while the paste retains much of the gray or colorless material.[17] Ultramarine was used quite extensively in the *Christ on the Cross*. Mixed with white, it is the color for the sky and for the blue garments of the angels. This must have been very expensive, and it may only have been possible because the monastery of San Marco, for which it was painted, probably served as a major supplier of ultramarine.[18]

Azurite, the other important blue pigment, also exists naturally. Cennini tells his readers to grind it "very moderately and lightly" otherwise it will lose some of its tinting

strength.[19] While azurite is fairly stable in its natural state, it does not always fare so well as a paint. This condition could be exemplified by several paintings in the museum's collection, but one example will suffice here: the azurite robe of the Virgin in the large altarpiece by Luca di Tommè is now almost totally black. It is hard to imagine that it was once a regal blue, but that is the case. A tiny sample of paint taken from the robe and examined under high magnification reveals that the paint film is composed of rough particles of azurite that still retain their original blue color (see FIG. 42). But why does the paint appear black under normal viewing conditions? The answer seems to be that the medium surrounding the pigment particles, as well as successive layers of varnish that have penetrated the paint film, have discolored, not the pigment itself.

FIGURE 31
Detail of Niccolò di Pietro Gerini, *Virgin and Child with Saints John the Baptist, Dominic, Peter, and Paul*, 1375/85, showing sgraffito in drape over the throne.

FIGURE 32
Detail of Saint Lawrence's dalmatic from Neri di Bicci, *Virgin and Child Enthroned with Saints and the Annunciation* (triptych), c. 1440/50, showing mordant gilding. In some areas the gold has worn off revealing the brown discolored mordant.

The most pervasive use of green in our panels is for the underpainting of the flesh. Cennini describes how flesh is built up beginning with a terre-verte underpainting. The color can be seen in most of the panels; note especially the Virgin's face in Luca's panel. Terre verte, when it is of very good quality, can be a fairly intense green, though this is rare. The Master of the Fiesole *Epiphany* obviously had a source for a very good terre verte, because the bright greens in the landscape are largely painted with that pigment.[20]

The actual preparation, mixing, and application of pigments followed strict rules. Pigments were first ground in water. Then, at the time of painting, they were mixed or tempered with the yolk of an egg. Because egg tempera dries very quickly, it cannot be blended as oil paint can. Instead, the various tones of a color—dark, middle, and light—had to be mixed separately. Each tone was applied in stroke after stroke, one next to the other, with a round brush. One sees these strokes in most of the paintings. The tones were "blended" by hatching one tone over the other at their junction.

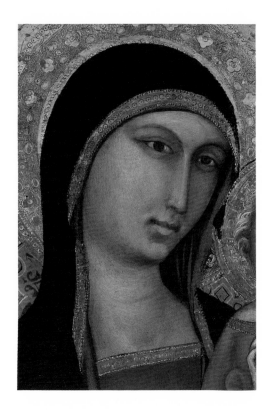

FIGURE 33
Detail of the Virgin's face in
Luca di Tommè, *Virgin and
Child Enthroned with Saints
Nicholas and Paul*, c. 1367/70.

Cennini describes how to paint various images: a youthful face, a dead man, different types of drapery, to name but a few. For the building up of a form with tempera paint, let us take the pink robe of Saint Paul in the *Virgin and Child Enthroned with Saints Nicholas and Paul* by Luca. Cennini uses the painting of a drape with lac as an example in his treatise, and it is this color, in fact, that we see in Paul's mantle. The darkest of the mixed colors is applied to the shadows of the folds. The middle color is used to bring the color out of the shadow, and then the light colors are painted. These colors were applied again and again until the form was covered and well blended. Finally, a lighter color was applied to the brightest areas, and at last pure lead white was used to create the strongest reliefs. The darkest shadows were painted with pure lac.

The system that Cennini describes for painting flesh really does succeed in creating lifelike effects—witness Luca's Virgin in the *Virgin and Child Enthroned with Saints Nicholas and Paul* (FIG. 33). The cheeks are flushed with vermilion. The terre-verte underpainting aids in creating shadows, and a brown-colored mixture called *verdaccio* contributes depth and some translucency to the dark colors. Between the rosy cheeks and the green-brown shadows lies the middle flesh tone, probably a mixture of vermilion, lead white, and ocher.

How and when oil paints entered the picture is still being disputed. Vasari in his *Lives of the Artists* tells how Antonello da Messina introduced the technique to Italy, having learned it from the Flemish painter Jan van Eyck.[21] This is, of course, an oversimplification and highly unlikely. Van Eyck died in 1441 and Antonello was active only from 1456. Also there is no conclusive evidence that Antonello visited the Netherlands.[22] It is more likely that painting with oils became the dominant technique in Western painting in a much less dramatic fashion, and while there seems to be a stronger tradition for the use of oils in the North, there was certainly an exchange between the artists of the two areas.

Painting in oil had been known for some time, and Cennini briefly describes the preparation and use of oil. It was used in numerous areas of Italy in the fifteenth century, but it was employed in different ways by different artists. How it was used and to what extent also varies with the location. While some artists glazed a tempera underpainting with oil, others mixed it with the egg tempera, and still others used it for almost the entire painting.[23] The figures in the *Christ on the Cross*, for example, appear to have been painted primarily with egg tempera, created with the traditional strokes. The sky, however, is a thick layer of paint that stands out from the tempera. This layer could be oil or oil mixed with egg.

Since oil dries more slowly than egg tempera, it can be blended. Hence, more subtle modeling can be achieved than one finds in egg tempera paintings. With oil, true glazes are possible, and deeper, richer colors can be attained. The *Virgin and Child* by the Venetian artist Jacopo Bellini (see FIG. 11) must have been painted using oil glazes to achieve a more naturalistic effect.

Traditionally, paintings were coated with varnish to saturate and protect the colors. There has been some disagreement regarding varnishing when it comes to Italian panels, with one school believing that they were varnished and another believing they were not or only very lightly. Be that as it may, Cennini does devote a short section to the varnishing of panels, stating that a painting should be well dried before any varnishing can take place. He goes on to advise the reader to place the panel in the sun prior to applying varnish. This, of course, would warm the painting so that the varnish could be more easily spread over the surface of the panel.[24]

Changes and Deterioration We should not be surprised that paintings of such age, no matter how well crafted, have suffered changes, whether through natural deterioration or by acts of man. Understanding these changes helps in our own appreciation of these precious objects.

Some panels, such as the Neri di Bicci triptych, have remained largely intact. Fortunately, this small devotional painting has not been dismembered. Conversely, many of the pieces in the collection come from large polyptychs dismantled years ago. As mentioned above, the two small panels by Bartolo di Fredi are pinnacles from a large polyptych. The Ugolino di Nerio spandrels of *Worshiping Angels* (see FIG. 21) were cut out of a well-documented large polyptych from the high altar of Santa Croce in Florence. The other panels from this large altarpiece are scattered around the world, with London and Berlin holding the largest number; to add to the sad fate of the polyptych, several of its panels have been destroyed or lost.

We find that the paintings themselves have often been cut down. The head of Saint John the Baptist by Paolo Veneziano (see FIG. 2) is only a fragment of a larger panel. It may have been that the rest of the panel was damaged and only the well-preserved area was salvaged.

The large altarpiece by Luca di Tommè has been trimmed on all but one side, the top, which retains the edge of the panel where the frame was engaged. Along the upper border one still sees the punchwork in the gold that would have followed the edge of the frame. This same motif would surely have decorated the edge of the gold on the left and right sides as well. One can think of a number of reasons to explain such paring down of a picture. There may have simply been the desire to remove the engaged frame, or it may have been an attempt to remove damaged edges. In the past, Italian panels have been cut down for the art market in an attempt to formulate dimensions and compositions that would suit the collectors of the time (or even to fit a particular frame!). It was also quite popular to dismantle *cassoni* to create easel pictures from their painted sides. Zoppo's *Scene of Judgment* (see FIG. 22) is actually half of a *cassone* panel, the other half being in a private collection in Florence. Why this image, which really does not make sense unless seen in its entirety, was cut in half is difficult to imagine.

Many of the wood supports themselves have gone through excessive treatments in an attempt to correct years of deterioration. Two of the major causes of past disintegration of wood panels are insect infestation and strong fluctuations in relative humidity and temperature. The larvae of woodworm tunnel through wood and weaken it, culminating with exit

holes for the adult beetles to escape; the holes are often visible on the paint surface. Poplar, being a soft wood, responds readily to changes in relative humidity and temperature. Such responses cause splitting, opening of joins, and bowing.

In the past the most common treatment for deteriorated panels was cradling. The first step of the treatment was that of thinning the bowed panel so that it could be flattened with pressure. Then a cradle was attached. A cradle is composed of vertical wood members glued to the reverse of the panel with slots for horizontal members (see FIG. 41). Theoretically, the horizontal beams are supposed to move or slide, allowing the panel to react to changes in the atmosphere. Unfortunately, the system often does not work so well. The sliding members become stuck or frozen, and the panel cannot naturally expand and contract. Consequently, more damage to the painting may take place because of the treatment.

Some panels were apparently so weakened by woodworm or rot that transferring was thought to be necessary. In this operation the paint and some of the ground layers are pulled away from the wood support and attached to a new backing. Correggio's *Holy Family with the Infant Saint John*, c. 1515, in the museum's collection, was transferred from wood to canvas. This is a drastic treatment that is rarely performed today because the process, we now fortunately realize, dramatically changes the appearance of the painting. Less-invasive treatments are usually available.

Some of the changes that have taken place in the paints themselves have already been discussed. One of the most prevalent changes, the darkening of the azurite-containing paint films, as we have learned, can be the result of natural aging of the paint medium. But much of the deterioration of paint films is the result of improper care. For example, an almost universal affliction is abrasion from poor cleaning methods of earlier times. Though egg tempera makes a very tough paint film, it can be damaged by harsh substances that may have been used in early, nonprofessional cleanings. One victim of such a cleaning is the cloth of honor in the background of Luca di Tommè's *Virgin and Child Enthroned with Saints Nicholas and Paul*. This richly decorated cloth once had semitranslucent shading indicating folds and undulations of the cloth. Remnants of this deep reddish color can still be seen along the upper edges of the cloth. Probably a lake, the red shading may also have been affected by light, for lakes are often susceptible to fading.

Gilding, whether by water or mordant, is very fragile. That is why it was so surprising to see the good state of the mordant gilding in the *Christ on the Cross* panel. In spite of the numerous ways paintings can be harmed, many have come down to us in remarkable states. Though this panel had been "lost" for years and uncared for, beneath its layers of old varnish and grime the paints and gold remain in miraculous condition.

Notes

1 Cennini 1960.

2 Merrifield 1849, vol. 2, 325–600, and Strasburg 1966.

3 Would-be painters learned the profession through apprenticeship. Cennini admonishes the beginner to submit himself "to the direction of a master for instruction as early as you can; and do not leave the master until you have to" (Cennini 1960, 3). Rules for apprenticeships—dealing with such things as duration, compensation, and who could take apprentices and how many—were controlled by the guilds. The guilds also controlled quality and materials. For a concise explanation of training and guilds, see *Giotto to Dürer* 1991, 126.

4 Magnification with the binocular microscope or the polarized-light microscope helps to reveal information about ground, paint, and coatings. The more powerful microscope can usefully magnify paint samples up to 400x, so pigments can be identified and paint and coating layers distinguished. Even more sophisticated equipment such as X-ray diffraction is used for pigment analysis. Other analytical techniques such as X-radiography, infrared photography and reflectography, and ultraviolet fluorescence can each add to our knowledge about a work of art. The use of these techniques and the results will be referred to throughout this text. For one of the most complete technical analyses of fourteenth-century painting, see London 1989.

5 Ibid., 78.

6 Gardner von Teuffel 1983, 324–27.

7 This is certainly true of panels made in Tuscany. In Venice gessoing of the panel was finished before frame elements were applied; see New York 1990, 19.

8 London 1989, 16.

9 Vasari 1960, 212–15.

10 Cennini 1960, 86.

11 Ibid., 85.

12 Thompson 1956, 74–189.

13 Wackernagel 1981, 327.

14 Cennini 1960, 24.

15 Ibid.

16 Ibid., 26–27; see also Gettens/Stout 1966, 123.

17 Gettens/Stout 1966, 165–66.

18 Verbal communication from Mario Modestini and Dianne Dwyer.

19 Cennini 1960, 36.

20 According to the analysis by John Twilley using X-ray diffraction.

21 Vasari 1966–84, vol. 3, 301–8.

22 *Giotto to Dürer* 1991, 197–204.

23 Ibid.

24 Cennini 1960, 98–100.

Two Altarpieces of the
Early Renaissance

*I*n 1931 the merchant prince and collector Samuel H. Kress presented a large altarpiece, a panel representing the *Virgin and Child Enthroned with Saints Nicholas and Paul* by the fourteenth-century Sienese artist Luca di Tommè, to what was then the Los Angeles Museum of History, Science, and Art. This donation was greeted with much attention, for, as one headline proclaimed ("The Renaissance Begins in Los Angeles"), the Luca and a *Madonna and Child* later attributed to Mariotto di Nardo, the gift of Axel and Jacob A. Beskow a few months earlier, were the first Italian Renaissance paintings to be acquired by the young museum.[1] Shortly thereafter Kress sent out an exhibition of a personally selected group of Italian paintings to travel through America on a twenty-four city tour from 1932 to 1935, at the height of the Great Depression (it was on view in Los Angeles from February 28 to April 15, 1934). The highly successful tour was responsible for creating a taste for Italian art and an understanding of its development among people who had no access to those few museums with comprehensive collections. At the same time Kress began an extraordinary program of donations, continued after his death in 1955 by the Kress Foundation administered by his brother Rush Kress, which enriched the collections of dozens of American regional and university museums, as well as the National Gallery, not only with paintings but with sculpture, furniture, tapestries, and other objects.

More recently in the history of the Los Angeles County Museum of Art, the generosity of the Ahmanson Foundation has made possible the acquisition of fifty-four masterpieces of European painting and sculpture from the fifteenth to the nineteenth century.[2] Three of the eight Italian Renaissance paintings in this group are panel paintings from before 1500, and one of those presents a striking contrast to the altarpiece by Luca di Tommè. In style and iconography *Christ on the Cross with Saints Vincent Ferrer, John the Baptist, Mark, and Antoninus*, attributed to the Master of the Fiesole *Epiphany*, is as Florentine as Luca's work is Sienese, and, besides the differences inherent in their geographical origins, more than a century of artistic development separates them. Yet there are similarities beyond the obvious superficial facts that both are tabernacle altarpieces representing a holy figure flanked

by saints. They both reflect earlier images of the spiritual guardians of their respective cities: the Virgin Mary was the acknowledged queen of Siena, just as Christ was, quite literally, the king of Florence—he had been elected to that honor in 1342 after the expulsion of the tyrannical duke of Athens so that no man could ever assume that title in authority over the city.

In one case we know the artist but nothing of the early provenance of the altarpiece; in the other we have extensive contemporary documentary evidence of the early history of the painting, but we cannot yet identify the artist. Each panel demands an examination of the culture that produced it, and, in return for our efforts, each offers us further insights into those cultures. Thus, to consider together the earliest and the most recently acquired Renaissance altarpieces in the collection of the Los Angeles County Museum of Art is to address many of the facets of panel painting in the early Renaissance.

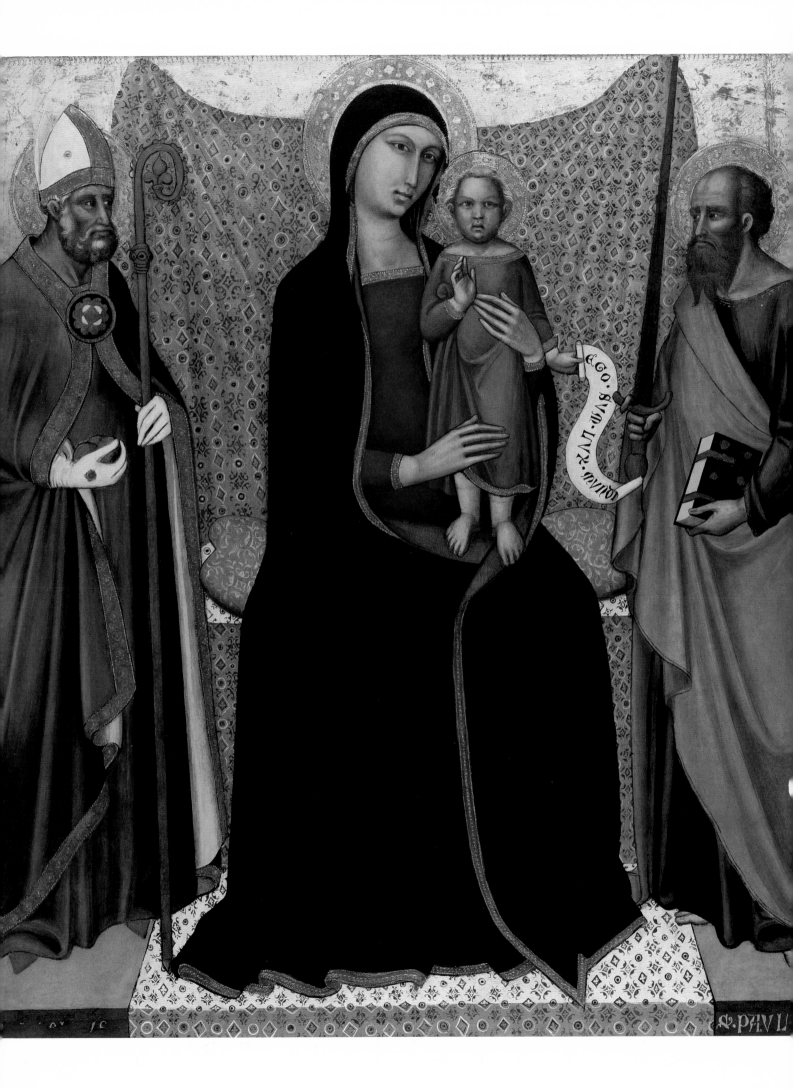

Luca di Tommè

Virgin and Child Enthroned with Saints Nicholas and Paul

On September 3, 1260, the citizens of Siena dedicated their city to the Virgin Mary; the next day they defeated the Florentines at the battle of Montaperti. Understandably, the thanksgiving generated by this perceived cause-and-effect led to an increased veneration of the Virgin and to the proliferation of her image in Siena. To be sure, the Virgin Mary is the most frequently depicted figure in Italian medieval and Renaissance art (indeed, in Christian art in general), but in Siena the amount and variety of Marian imagery is truly staggering. The image addressed by the citizens on the eve of the battle can still be seen in the Museo dell'Opera del Duomo: it is an early-thirteenth-century rectangular antependium known as the *Madonna degli occhi grossi* (Madonna with the bulging eyes; FIG. 34).[3] In a visual tradition derived from Byzantine art, Mary sits on a cushioned bench in a strict frontal pose softened only by the decorative drapery folds of her skirt. In her lap sits her son, steadied by her hands beneath his foot and on his shoulder; his right hand is raised in blessing and his left hand clutches a scroll. The basic elements of this image were to be repeated for centuries; of most interest to us is the fact that they are repeated in Luca di Tommè's *Virgin and Child Enthroned with Saints Nicholas and Paul* (FIG. 35).

Luca was one of the Sienese painters who came to prominence in the second half of the fourteenth century, after the epidemic of bubonic plague of 1347–50 had decimated Europe. These artists will always dwell in the shadow of the elegant Simone Martini, who died in 1344, and the endlessly inventive Lorenzetti brothers, Ambrogio and Pietro, who probably fell victim to the plague, but it is unwarranted to say that the success of the later painters came about simply because the "great" artists of Siena were dead. The generation that emerged after mid-century had talent enough of their own and continued the proud tradition of Sienese art. A general attitude of fear and despondency, after the terror of the Black Death, pervaded every aspect of life, however, including artistic style and iconography, which became more conservative and orthodox. If the art is taken out of its context, it may seem as if the artists of the second half of the fourteenth century had regressed and negated the accomplishments of what has come to be regarded as a "golden age" of Sienese painting.

The earliest recorded mention of Luca di Tommè is in 1356, when he was the third member to be enrolled in the painters' guild of Siena.[4] We know nothing of his formation. Giorgio Vasari's claim in 1550 that Luca was trained by Barna da Siena,[5] although

disputed by many, is not as unlikely as it seems: his early works display in their grace, substance, and composition the stylistic influence of both Barna and Pietro Lorenzetti. Indeed, in 1357 Luca was commissioned to restore a fresco of the Virgin originally painted by Pietro over the portal of the cathedral, which would suggest a knowledge of that master's style.

Luca worked for a time, about 1362–66, with Niccolò di Ser Sozzo, and the hands of the two artists are sometimes difficult to distinguish in the works attributed to them. By the later 1360s Luca had developed an individual style and had reached a level of fame in his native city and elsewhere, judging by the importance of the commissions with which he was entrusted. He served as a city councillor in the 1370s and held other civic positions in the 1380s. The last mention of him is in 1389, when he received a payment for an altarpiece for the cathedral in Siena, which he was painting with Bartolo di Fredi and the latter's son, Andrea di Bartolo. Paintings commissioned from Luca for other cities in Tuscany were influential on the style of local artists, especially in Lucca, Orvieto, and Pisa.[6]

In the center of Luca's rectangular panel is a large figure of the Virgin, turned slightly to her left, seated on a cushioned bench in front of an elaborately patterned cloth of honor that covers both the bench and the dais on which it is placed. Standing on her lap, supported by her hands, is the Christ Child, raising his right hand in blessing and grasping in his left hand the end of an unfurling scroll that reads *Ego sum lux mundi* (John 8:12: "I am the light of the world"). To the left is Saint Nicholas of Myra wearing a bishop's miter and cope and holding a crozier and three balls; to the right is Saint Paul with a sword and bound book.

The Los Angeles panel was first attributed to Luca by F. Mason Perkins when it was in the collection of Charles Fairfax Murray in Florence; Perkins identified it as a work of Luca's "middle period."[7] This attribution was later reinforced by Roberto Longhi, Giuseppe Fiocco, Wilhelm Suida, and Adolfo Venturi.[8] Longhi believed it to be one of the artist's most notable works, an opinion shared more recently by Licia Bertolini Campetti, and later called it one of the museum's most important Italian paintings.[9]

While Luca's early style was characterized by delicate poses, full modeling, and expressive charm (FIG. 36), this panel is typical of his manner after 1366, after he ceased painting with Niccolò di Ser Sozzo and found his own expression, embodied by monumental, hieratic figures of enthroned Virgins and standing saints. He simplified, even schematized, poses and forms. His faces became solemn, often devoid of emotion, possibly to create the effect of iconic majesty in the large-scale works and polyptychs he was now commissioned to produce. The scale of the figures in the Los Angeles painting is typical of the later phase of Luca's work: they fully occupy the space of the panel. They are not as three-dimensional as those in his earlier paintings, but the lines and poses are graceful, reminiscent of the earlier, calligraphic contours of the work of Simone Martini and his followers—we have only to trace the meandering edge of Saint Paul's mantle. The tilt of the Virgin's head and the raising of her left shoulder to accommodate the child's weight, creating a diagonal of the neck of her tunic, lead our eyes to the child; these are distinctive features of Luca's Virgins.

Although the Virgin's azurite blue mantle has darkened with time and was covered at a later date by a thin layer of black paint, clearly incised lines suggest the fluid, graceful modeling that Luca built up by the application of different values of blue paint. It is unusual for an artist of this time to incise the surface of a panel with anything other than the most general contour lines, but Luca used this device for internal modeling in the robes of a number of his Virgins, including a small, earlier panel also in the collection of the Los Angeles County Museum of Art (FIG. 36).[10] Interestingly, the early-fourteenth-century technical manual by Cennino Cennini advises this procedure of incising for any area of a fresco to be covered with solid blue.[11] According to Vasari's account (see note 5), Luca had knowledge and experience of fresco techniques; the artist may have used incised lines in fresco work and adopted the practice for his panel paintings.

The difference in scale between the Virgin and the two saints, her idealized, more broadly painted face, and the rectangular format suggest that Luca deliberately sought to evoke the holy images of earlier representations. This is reinforced by his inclusion of the saints on the panel with the Virgin and Child, a practice that goes back to the earliest Christian art in both the eastern and western Church. Only in late medieval art were saints relegated to separate, flanking panels.

In Luca's painting the Virgin is both the *Regina Coeli*, the Queen of Heaven, by virtue of her throne, and the *Theotokos*, the God-bearer, in both senses of that term, as she bears the son she has borne. Profusely patterned cloths, like that behind her, appear in many of Luca's works and recall (although do not duplicate) the luxury silks both of the east and of local centers such as nearby Lucca. The scroll inscribed with this particular verse from the Gospel of John appears in the hands of six of Luca's infant Christs, beginning with a signed and dated altarpiece of 1362, painted with Niccolò di Ser Sozzo.[12]

Saint Nicholas was misidentified as Augustine by Roberto Longhi while the painting was still in the possession of Samuel Kress (1929) and later (1936) as Martin of Tours by Giuseppe Fiocco; both saints are often represented in bishop's robes.[13] Although the inscription below the figure is almost completely lost, it is clear from the three golden balls in his hand that this is Nicholas. In one of the most charming stories surrounding the life of this popular saint, Nicholas saved the three daughters of an impoverished nobleman from a life of prostitution by anonymously throwing three golden balls (some variants say three purses of gold) through their window so that the girls would have dowries that allowed them to be honorably and suitably married.[14] It has been suggested that this story of gift giving is largely responsible for the conflation of Nicholas (whose feast day is December 6) and the Magi bringing gifts to the infant Jesus (January 6) into the familiar Christmas figure we know as Santa Claus.[15]

Saint Paul is more easily recognizable: he had been depicted as the same physical type, dark-haired and balding, since the earliest Christian art, and he is never without a sword,

FIGURE 36
Luca di Tommè (Siena, active 1356–89), *Virgin and Child Enthroned with Saints Louis of Toulouse and Michael and Angels*, c. 1356/61, tempera on panel, Los Angeles County Museum of Art, given anonymously (57.68).
CAT. NO. 7

the instrument of his martyrdom and the "sword of the Spirit," as he referred to the word of God (Ephesians 6:17). The presence of Paul prompted a speculation by Paul Wescher that this panel was the *"tavola"* (panel) mentioned in a document of 1373 that recorded a payment to Luca by the Consiglio Generale (General council) of Siena.[16] The painting he executed commemorated the victory of Sienese forces in 1363 over a rapacious Breton mercenary company called the Cappellucci (Company of the hat), and the altarpiece was to honor Saint Paul, who had been named the patron of the expedition. That the victory would have waited ten years to be commemorated in this way is curious but not inexplicable. It was common for unemployed bands of soldiers to support themselves during peacetime by ravaging the countryside they had once been paid to protect. For a large enough "ransom," however, they would move off, preferably into the territory of a rival state. Siena—indeed, most small cities without large standing armies—had been in the habit of paying off the troublesome bands unless they threatened the city itself. In 1363 the leader of the Sienese troops, the Roman *condottiere* Ceccola di Giordano degli Orsini, took it upon himself to mount an offensive against the Cappellucci without waiting for permission from the authorities (which he probably knew from past experience would not be forthcoming). His triumph received a mixed reaction: the Sienese were relieved to be rid of the mercenaries but furious that their authority had been flouted; Orsini received both a reward and a reprimand. It is unlikely that the government would have further celebrated the incident; the *tavola* mentioned in the document of 1373, however, was commissioned after a change of government.

The identification of the Los Angeles panel as the so-called Saint Paul altarpiece was acknowledged as a possibility by Fern Rusk Shapley in her catalogue of the Kress Collection and was accepted by Cristina de Benedictis and Enzo Carli.[17] There are, unfortunately, not enough details in the document of 1373 to identify the Los Angeles painting as this work, and speculative evidence exists on both sides. The painting in the document is identified as a *tavola* (panel) rather than a *pala* (an altarpiece made up of several attached elements); the Los Angeles painting is in fact a *tavola*. In an altarpiece honoring Saint Paul, however, we would expect to find him in the place of honor at the Virgin's right hand—that is, unless Nicholas had a more important role.[18] The latter saint might, for example, have been the patron of the unnamed church for which this altarpiece was destined: the Consiglio Generale of Siena had once before (1329) subsidized an altarpiece by Pietro Lorenzetti for the Carmelite church of San Niccolò.[19] The saint might also conceivably have been someone's name saint; although Orsini's name "Ceccola" is most likely a nickname for Francesco, it might also be a dialect corruption of Niccolò. Sherwood Fehm pointed out that the payment of 105 gold florins recorded in the document of 1373 was very high; he suggested that for this large a sum, plus the specific itemization of transportation costs, the Saint Paul altarpiece would have been larger than the Los Angeles panel.[20] It must be noted, however, that Luca was at the height of his popularity at this time and might have commanded a high price; he was also a member of the civic government either before or during the execution of the Saint Paul altarpiece, and a high fee might logically signify anything from a conflict of interest (was he paying himself?) to a demonstration of esteem from his fellow councillors.

Although the circumstantial evidence does not eliminate the possibility, it is unlikely for stylistic reasons (see below) that the Los Angeles panel is the Saint Paul altarpiece; however, Fehm's suggestion that the lost altarpiece is a polyptych of the *Madonna and Child Enthroned with Saints John the Baptist, Peter, Paul, and Apollinaris*, now in the Galleria Nazionale dell'Umbria, Perugia (inv. no. 947), is not convincing.[21]

The rectangular form of the Los Angeles altarpiece is unusual at this early date, but despite the fact that the panel has been cut down slightly on the sides and bottom, there is no indication that it ever had any other shape.[22] Luca's composition clearly was planned to fit in a rectangular format. He may have meant to establish a link to the earliest, much-venerated images like the *Madonna degli occhi grossi*, which, being antependia (that is, for the base of an altar), were rectangular. It is certainly of interest that Pietro Lorenzetti's *Carmelite Madonna*, 1329 (see note 19), is also rectangular, except for slightly canted upper corners. This is only a minor example of several correspondences between the two altarpieces; there are far more substantial reasons to see in Pietro's panel a possible model for Luca. Except for the presence of angels in the earlier painting the composition is the same, and in both works the use of a rectangle allows an expansion of the usually constricted Gothic throne into a spacious bench with a wider-than-usual cloth of honor. Luca's Saint Nicholas is reminiscent of Pietro's and is in the same position. Finally, the depiction of full-length figures of the Virgin and saints was extremely rare in Sienese painting before 1370; Luca's nearly consistent use of full-length figures can be traced back to Pietro's *Carmelite Madonna*.[23]

Although many altarpieces of the time were polyptychs, there is no definite indication, documentary or physical, that this panel had any other elements. Since the saints are included on the same panel as the Virgin and Child, wings were possible but

not likely, given the size of the painting; the presence of a predella was more probable, but if it is extant, it has not been identified. There exist four sections of a predella by Luca illustrating scenes from the life of Saint Paul: *The Conversion of Saint Paul* (FIG. 37), *Saint Paul Preaching*, *Saint Paul Led to His Martyrdom*, and *The Beheading of Saint Paul*.[24] When reconstructed, this predella would be too long a base for the Los Angeles panel. Stylistically, the lively figures, individualized faces, and vivid brushwork suggest a period later than the Los Angeles panel; perhaps it was once the predella of the lost or still unidentified Saint Paul altarpiece.

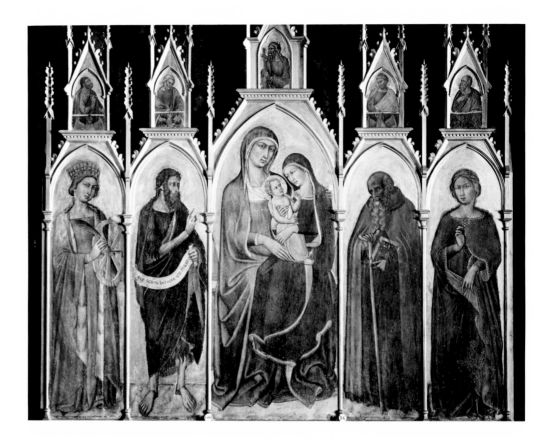

The Los Angeles panel has been dated to a period between 1370 and 1375, partly because a number of art historians believed the painting to be the Saint Paul altarpiece commissioned in 1373.[25] It has also been compared stylistically to a signed and dated polyptych of 1370 from the convent of San Domenico in Rieti, reinforcing a date after 1370.[26] The Los Angeles panel actually has far more affinity with an earlier signed and dated polyptych of 1367 whose central panel depicts the Virgin and Child on the lap of Saint Anne (FIG. 38).[27] The similarities are extremely striking in the scale and poses of the figures, drapery, facial coloring, and painterly treatment of features, hair, and beards of the saints, particularly those in the pinnacles. Though the figures in both the polyptych of 1367 and the Los Angeles panel are static in comparison with Luca's earlier works, the faces especially show a soft and subtle modeling that is far closer to his earlier style. I would thus suggest for the Los Angeles altarpiece a date before 1370 and probably closer to 1367.

There are at least twenty-nine extant enthroned Virgin and Child groups by Luca or his shop, not only from the so-called middle period, 1366–73, but from the years before and after that span.[28] Only four of these include the figures of saints on the panel with the Virgin and Child, and three of these are from Luca's earliest years. The fourth is also the only other rectangular composition of the Virgin and Child extant; it is a smaller panel, vertical rather than horizontal in format, at the Yale University Art Gallery, depicting the enthroned Virgin and Child with two angels and two patron saints of Siena.[29] Although many authorities attribute the Yale panel to Luca, Charles Seymour and Sherwood Fehm believe it is either a collaboration with an assistant or a shop piece;[30] in style, however, it seems to be from the same period as the Los Angeles panel.

Notes

1 The headline appeared on the cover of the *Los Angeles Museum Art News Bulletin* of May 1931. According to the same issue the *Madonna and Child* presented by the Beskows (inv. no. 31.19) was at that time attributed to Giovanni Turini; it is no longer in the collection.

2 Fifty-two of these works are catalogued in Conisbee/ Levkoff/Rand 1991.

3 Van Os 1984, 10, fig. 1; Burckhardt 1988, 43–44, pl. 27.

4 The most complete consideration of the life and art of Luca di Tommè, including transcriptions of contemporary documents, is to be found in Fehm 1986.

5 Vasari 1966–84, vol. 2 (1967), 256.

6 See discussions of Luca's influence in Van Marle 1923–36, vol. 2 (1924), 466, and Pisa 1972, 95.

7 F. Mason Perkins, written communication in the files of the Kress Foundation, New York, and Perkins 1920, 292 n. 12.

8 Written communications in the files of the Kress Foundation.

9 Roberto Longhi, written communication of 1929 in the files of the Kress Foundation; Longhi 1954, 64; Bertolini Campetti in Pisa 1972, 95.

10 Muller 1973, 15–16.

11 Cennini 1960, 54.

12 *Madonna and Child Enthroned with Saints John the Baptist, Thomas, Benedict, and Stephen,* 1362, signed by Luca di Tommè and Niccolò di Ser Sozzo, a polyptych possibly from the convent of San Tommaso degli Umiliati, Siena, now in the Pinacoteca Nazionale of that city (inv. no. 51); see Fehm 1986, cat. nos. 11–13.

13 Roberto Longhi's opinion of 1929 and Giuseppe Fiocco's of 1936 are in the files of the Kress Foundation.

14 This and other incidents from the life of Nicholas were recorded by the Dominican friar, later archbishop of Genoa, Jacopo da Voragine in his *Legenda Aurea* (Golden legend), c. 1275, a compilation of the oral and written traditions of the lives of Christ and the saints. For this story, see Voragine 1969, 17–18.

15 Ferguson 1961, 136. The three golden balls were also appropriated by moneylenders as their symbol (Nicholas was their patron) and are thus used by pawnbrokers to this day.

16 Wescher 1954, 11; the Latin and Italian texts of the document are published in Fehm 1986, 198, docs. 18a–b.

17 Shapley 1966, 60, cat. no. K69; De Benedictis 1979, 87; Carli 1981, 227.

18 In fourteenth-century Siena the Virgin was always the central figure of an altarpiece, even if the altar was dedicated to another saint; see a discussion of the altars in the cathedral in Van Os 1984, 79.

19 Pietro Lorenzetti, *Carmelite Madonna,* now in the Pinacoteca Nazionale, Siena; Van Os 1984, 90–99.

20 Fehm 1970, 138; Fehm 1986, 41.

21 The altarpiece was formerly in the parish church in Forsivo, near Norcia; see Fehm 1986, 41, cat. no. 39.

22 Roberto Longhi (Kress Foundation files) pointed out in 1929 that it was noteworthy that the panel was not conceived as a triptych, even though F. Mason Perkins erroneously called it one in the same year (Perkins 1929, 427). Sherwood Fehm noted that in his later phase Luca experimented with shapes of panels (Fehm 1986, 2).

23 For a discussion of the *Carmelite Madonna,* see Van Os 1984, 91–99.

24 *The Conversion of Saint Paul,* Seattle Art Museum (inv. no. It 37/Sp465.1); *Saint Paul Preaching* and *Saint Paul Led to His Martyrdom,* Pinacoteca Nazionale, Siena (inv. nos. 117–18); and *The Beheading of Saint Paul,* Kereszteny Múzeum, Esztergom, Hungary (inv. no. 55.156); Fehm 1986, cat. nos. 40–42.

25 Roberto Longhi suggested a date of 1375 (written communication of 1929 in the files of the Kress Foundation); Burton Fredericksen felt the work could be earlier and suggested a range of 1370–75 (entry of c. 1970 in the files of the Los Angeles County Museum of Art). For other opinions, see the sources cited in note 17.

26 *Madonna and Child with Saints Dominic, Peter, Paul, and Peter Martyr,* now in the Museo Civico, Rieti (inv. no. 2); Fehm 1986, cat. no. 27.

27 *Madonna and Child with Saint Anne and Saints Catherine of Alexandria, John the Baptist, Anthony Abbot, and Agnes,* probably from the church of Santa Mustiola alla Rosa, Siena, and now in the Pinacoteca Nazionale of that city (inv. no. 109); Fehm 1986, cat. no. 22.

28 Fehm 1986, cat. nos. 1, 9–10, 13–14, 22, 24, 27–28, 30, 32, 34–39, 45, 48–51, 55–57, 62–64, 67.

29 *Madonna and Child Enthroned with Saints Galganus [or Victor] and Ansanus,* Yale University Art Gallery, New Haven (inv. no. 1943.245). The panel has been cut down at the bottom; the figures were originally full-length; Fehm 1986, cat. no. 55.

30 Seymour 1970, 81–82; Fehm 1986, 154 (with a summary of past attributions).

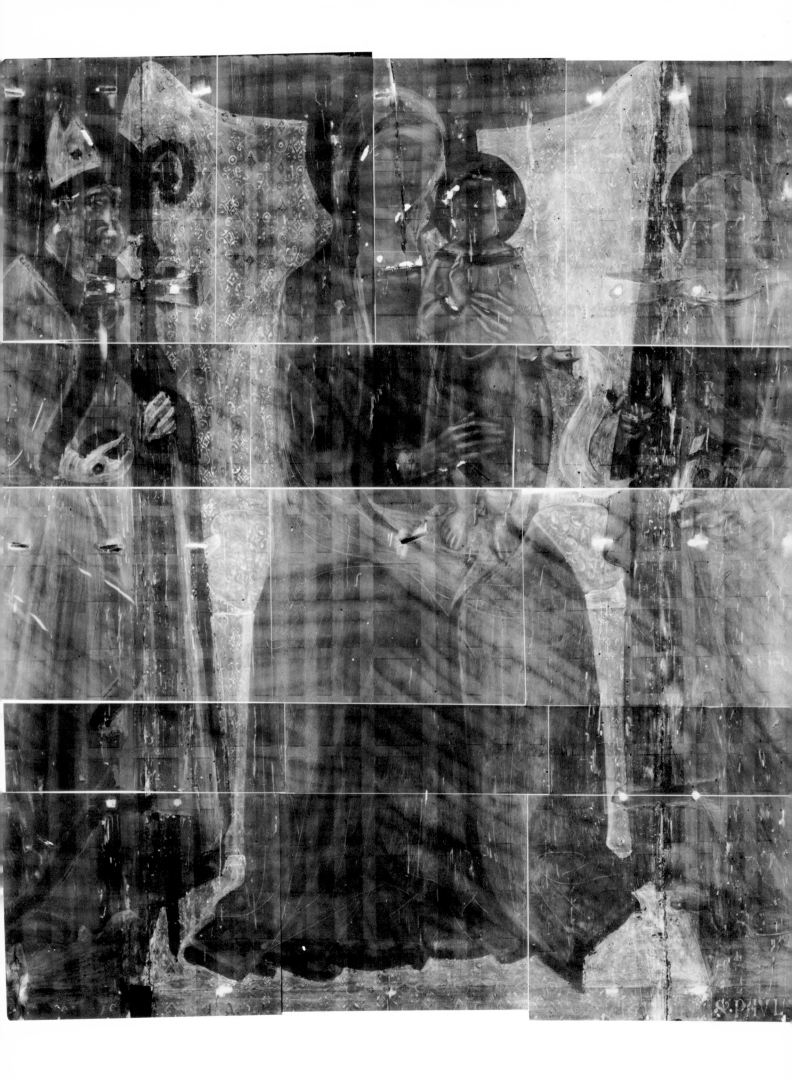

Conservation Report

JOSEPH FRONEK

The support for the painting is a poplar panel composed of three planks set vertically. The central plank is 28¾ inches wide and the side planks are 8¼ inches wide. The three planks are held together by two wooden butterflies at each join. In addition, glue would have been used in the joins. While the butterfly inserts are evident in the X-radiograph, no dowels were detected (FIG. 39).

The top edge of the panel is intact, but the other sides have been cut down. How much has been lost from the edges is difficult to determine with any certainty. The top edge retains the unprimed wood where the engaged frame would have been attached, and punch marks decorate the very edge of the gold ground (FIG. 40). This same punchwork would surely have decorated the edge of the gold on the left and right sides. The unprimed wood is 1 inch wide and the decorative punching is ⅜ of an inch wide.

The panel is now only ¼ of an inch thick. Originally, it may have been as much as an inch or more thick, but at some time in its history it was thinned and cradled. As additional support the painting once had three horizontal battens, one each at the top, bottom, and center. The X-radiograph exposes holes (now filled) where the battens would have been attached to the main panel with nails.

Undoubtedly, dismantling and cradling of the panel was undertaken in order to flatten the planks and mend cracks and joins. One large crack runs from the top of the Virgin's head down to her lap, but numerous smaller cracks exist. All of the damages to the support have caused some paint loss. The panel is also riddled with tunnels made by woodworm. These excavations can be seen in the X-radiograph. The infestation, which we can see was quite extensive, weakened the support considerably.

The wooden butterflies holding the planks together have been sawn through. The reason this was done may be surmised. The joins were coming apart, and the butterfly reinforcements were the only elements holding the panels together. At the same time, the individual planks were bowing, and as a result the front or back of each plank was convex or concave. It would be much easier to thin and flatten each plank separately, especially since each plank of wood was reacting somewhat differently. Consequently, it was necessary to saw through the butterfly inserts to separate the three planks.

The cradle that was attached to support the panel and to keep it flat and in one piece is rather heavy and constricting, minimizing any expansion or contraction of the wood (FIG. 41). It is made

FIGURE 39
X-radiograph of Luca di Tommè,
*Virgin and Child Enthroned
with Saints Nicholas and Paul,*
c. 1367/70.

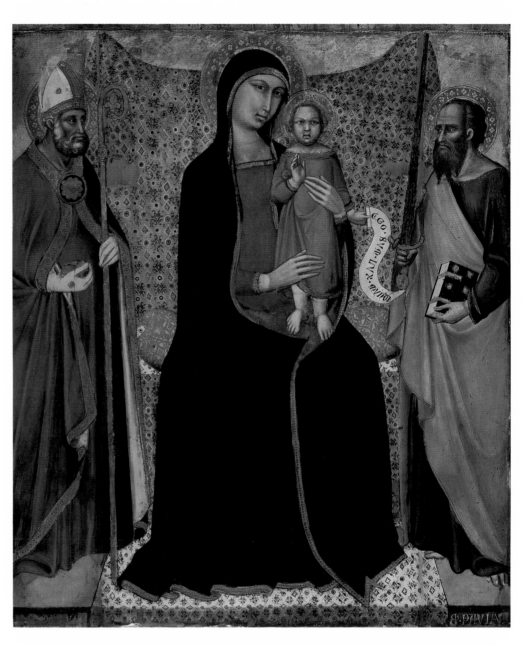

up of vertical members that have been glued to the reverse and horizontal members that slide through openings in the stationary members. Vertical members are clustered over joins and splits.

The panel must have been coated with glue, as Cennini instructs in his treatise; no canvas over the panel could be detected, however. The ground is composed of two distinct layers, a lower, coarser layer corresponding to Cennini's *gesso grosso* and an upper, finer layer, *gesso sottile* (FIG. 42).

The design was indicated with a black color and was subsequently incised. Some of the drawing can be seen with the unaided eye, and infrared photography exposes much more (FIG. 43). The hem of Saint Nicholas's robe was changed during the drawing state. It was first drawn about 1½ inches higher, and in fact two parallel lines, perhaps indicating a gilt border, are particularly visible in the infrared photograph. If one looks carefully even with the unaided eye at the Virgin's hands, slight differences between the drawing and the painting can be detected. For example, the thumb was slightly higher in the drawing than in the painting. The tips of some of the fingers were shortened in the painted stage.

FIGURE 41
Reverse of panel showing cradle.

Incised lines can be easily read in raking light. X-radiographs show the marks quite distinctly. It is useful to compare the X-radiographs of both panels by Luca di Tommè in the

collection (FIGS. 39, 44). The incised lines are very similar, and the Virgin's robes, particularly the proper right side, are closely related in design and stroke.

Gold leaf was applied onto a reddish bole that carefully goes around the imagery along the top of the panel. The garment borders, the sword hilt, and the decoration on Saint Paul's book were laid in with bole before any painting began. The gold background has survived in remarkably good condition, but the gold on various garments and objects is almost entirely missing. It has been suggested that the gilding for the garments was applied with an oil mordant, which would have been slightly darker in tonality, though it could easily have been harmed by strong solvents that were probably used to remove varnish and dirt in the past (this

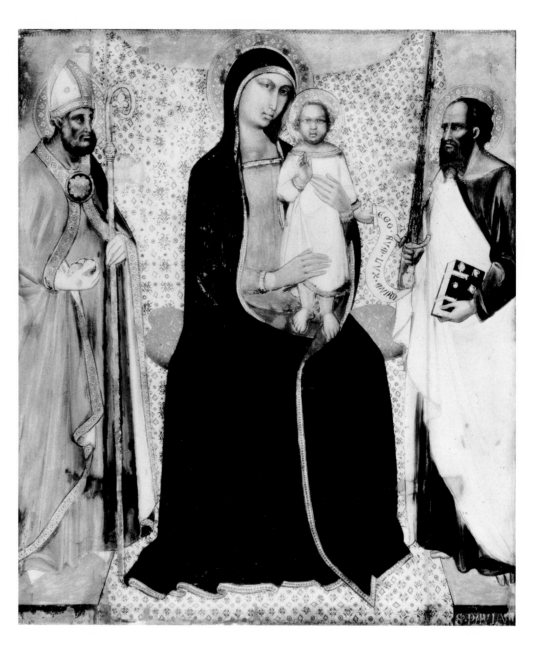

FIGURE 43
Infrared photograph.

possibility was suggested by Mario Modestini in conversation). Saint Nicholas's attribute, the balls of gold, also appears to be mordant gilding, but the gilding there remains largely intact. The blade of the sword that Saint Paul holds appears originally to have been silver leaf. Today this is almost all missing, and what remains is very badly corroded.

Punchwork decorates the picture border along the top edge. It also delineates the figures' halos and the borders of some of their clothes. The same punches have been used throughout: quatrefoils (two sizes), circles (three sizes), tiny pointed punches, and a slightly larger rounded punch. Halos are inscribed with a sharply pointed instrument (see FIG. 30).

Egg tempera paints have been applied in the traditional manner. Flesh has been under-painted with terre verte, which is more visible today because of abrasion of the flesh color on top.

It is not unusual for a painting of this age to have suffered over time. One change that was discussed in the technical introduction to Italian panel painting (pp. 39–40) is the

discoloration of the Virgin's robe. The construction of the robe is quite interesting. The bottom layer is black paint, and above that is a layer of paint containing mainly azurite. The azurite particles have remained blue, but it is the surrounding medium, now mixed with dirt and varnish, that has darkened (see FIG. 42). Coupled with the fact that the azurite layer has been abraded, exposing the black underlayer to a greater degree, the robe is now almost entirely black to our unaided eyes.

Overall, the surface paint has had its share of wear. The cloth of honor, a bright vermilion with decorative patterns of green and white outlined in black, was once glazed with what appears to be a red lake, which would have given the folds rich shadows. The crimson color is still visible along the upper part of the cloth. Similarly, garments have lost some of the darker shadows that would have given more form to folds and the body underneath.

In figure 40, which shows the painting before treatment, discolored restorations of paint loss can easily be discerned. These discolored patches are located in the cloth backdrop and in the garments of the two saints. The names of the saints at left and right have been mostly lost. In fact, it is impossible to read the name of the saint on the left, who has been identified as Nicholas.

The paint surface was covered with several discolored varnish layers (see FIG. 40). The more recent layers could be easily removed with normal cleaning solvents. There were, however, residues nearer the paint surface that required more painstaking removal with stronger solvents or by mechanical means.

In the recent conservation of the panel, losses of paint and gesso were filled with traditional gesso. The fills were toned with watercolor and then glazed with resin colors. The technique used for the restoration of the losses is *tratteggio*. Developed in Italy, *tratteggio* uses primary and secondary colors applied in parallel lines to fill in losses. At a distance the colors are blended by our eyes, but up close the striations of paint become obvious. This type of restoration can be more or less visible. For this panel it was done so as to be almost unnoticeable. Finally, the painting was varnished with a natural resin to saturate colors so that they appear rich once again.

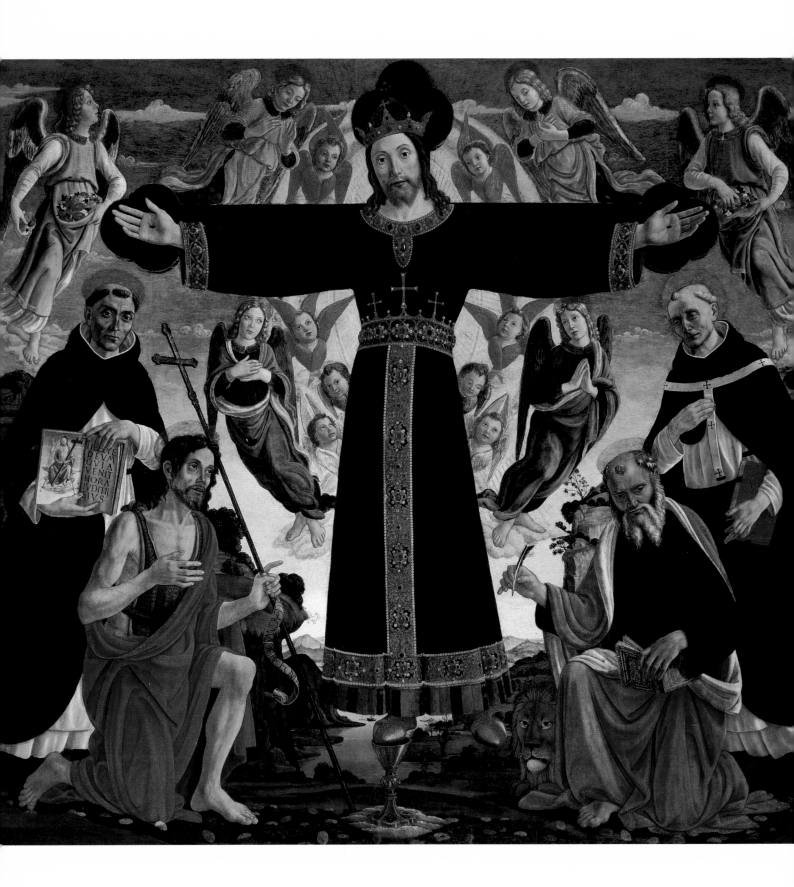

Master of the Fiesole *Epiphany*

Christ on the Cross with Saints Vincent Ferrer, John the Baptist, Mark, and Antoninus

The central image in this panel is not a Crucifixion (FIG. 45). Although there is a cross, it is an elegant construction with trilobate terminals, in rich blue edged with gold, whose shaft disappears behind the body of Christ and does not reach the ground. The nail holes are clearly apparent in his hands, but the nails are not there to fix him to the cross. Instead, he hovers in front of it, seeming to balance gracefully on a sacramental chalice of gold and enamel, which in turn rests on a tiny cloud formation. Christ wears an imperial crown, a rich silk robe with borders and a belt of gold, jewels, and pearls, and silver shoes with a gold cross-shaped pattern. Behind him is a mandorla of light and angels. In the upper corners of the panel, at each end of the cross-arm, two angels take handfuls of flower petals from a supply in the laps of their tunics.

Four saints flank the figure of Christ. At the left is the great preacher Vincent Ferrer in the habit of the Dominican Order, holding an illuminated manuscript depicting the Christ of the Last Judgment and inscribed with a shortened form of a verse from the Book of Revelation (14:7): "Fear God, for the hour of his judgment has come." In front of him kneels John the Baptist, dressed in camel skins and a red cloak; he holds in his left hand a cross on a long staff and a scroll: "Behold the Lamb of God. Behold [him] who...."

The older man kneeling on the other side of the cross may be identified by the lion and the act of writing in a book as Mark the Evangelist. The fourth figure, at far right, is Antoninus, former archbishop of Florence, wearing a Dominican habit and the narrow white pallium of his archiepiscopal office. On the ground around the figures are flower petals that have been scattered by the angels. A hilly landscape with a wide, meandering river extends into a mountainous distance.

The panel probably would have been displayed as it is now, in a tabernacle frame of the type that is still extant on altarpieces in situ in Florence, especially in the church of Santo Spirito (see FIG. 8 for another example). It is possible that there was a predella, in the form of painted scenes on the lower horizontal zone of the frame. The scenes depicted might have included episodes from the lives of the four saints or devotional scenes such as a Pietà.[1]

In the 1568 edition of the life of Cosimo Rosselli, Giorgio Vasari wrote of a panel painted by the artist for the chapel of the "tessitori di drappo" (cloth weavers) in the church of San Marco in Florence. It depicted "the Holy Cross in the middle, and on the sides Saint Mark, Saint John the Evangelist, Saint Antoninus, archbishop of Florence, and other

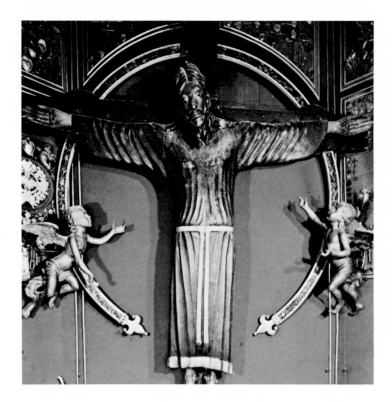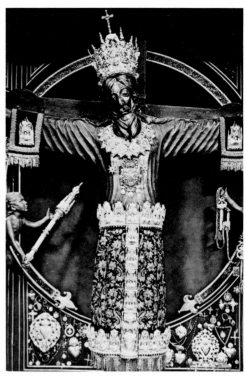

FIGURE 46
Volto Santo, probably eleventh century, polychromed wood, Lucca Cathedral.

FIGURE 47
Volto Santo with added crown and robes.

figures."[2] Although Vasari's list of saints was neither complete nor completely correct, it has nearly always been accepted that the painting described is the altarpiece now attributed to the Master of the Fiesole *Epiphany* in the Los Angeles County Museum of Art.[3]

The altarpiece was commissioned by the silk weavers' guild—the *tessitori di drappi serici*—for whom the choice of subject was significant. The silk weavers had come to Florence from Lucca,[4] where the most famous religious image was a much-venerated wooden crucifix known as the *Volto Santo* (Holy face), which had made the cathedral of Lucca a goal for centuries of European pilgrims (FIG. 46). Probably for the same reason the guild's confraternity was known as the Compagnia della Santa Croce (Company of the Holy Cross).[5]

As a central image the artist sought—in fact, must have been instructed by the terms of the contract—to replicate not only the Lucca *Volto Santo* but also the rich trappings of the crown and jeweled robe with which the faithful adorned the wooden figure (FIG. 47). The guild members no doubt appreciated the sumptuous quality of Christ's painted silk robe, the original of which their guild brothers in Lucca had probably always supplied for the wooden image. Perhaps the multicolored fringe at the hem served as a sample card for available colors of their luxury wares. In depicting the altered image the painter thus transformed the iconography of the original crucifix, turning a suffering Christ into *Christus Rex*, Christ the King.

The *Volto Santo* of Lucca was, according to tradition, carved by Nicodemus, an influential Pharisee who defended Jesus and helped take his body down from the cross and prepare it for burial (John 3:1–10, 8:50–52, 19:39).[6] As legend has it, Nicodemus meditated so long on the Crucifixion that he was divinely enabled to carve the image of Christ's face exactly as it appeared when he was on the cross; thus the image was included among those extremely revered icons known as *acheiropoietic*, or "not made by hands."[7] There are

several accounts of how the image miraculously made its way from the east, where it was in danger from the eighth-century iconoclasts, to the harbor of Luni, near Lucca, where it was supposedly discovered in the late eighth century.

Judging by stylistic evidence, many art historians believe the wooden image now in the cathedral in Lucca to be a thirteenth-century copy of an earlier reliquary.[8] The earliest extant painted reproduction of the *Volto Santo* dates from 1134, and the written accounts of the crucifix are all from the twelfth century. Much visual and written evidence supports a date before the mid-eleventh century for the original figure. By 1050 Abbot Leofstan of Bury Saint Edmunds had brought back a "copy" (whether carved or painted is not specified) of the *Volto Santo* from his pilgrimage to Lucca; in 1070 a hospice for pilgrims was being constructed in the city, suggesting that it had become an important pilgrimage destination; and records indicate that the fame of the image had spread all over Europe by then: King William Rufus (ruled 1087–1100), the successor in England to William the Conqueror, used to swear by the "holy face of Lucca."[9] The twelfth-century accounts, it must be pointed out, claim to repeat a history by Leobinus of Lucca written earlier, possibly in the late eighth or early ninth century; it is thus possible that the current image was the replacement for a much older one.

The imagery of the chalice under Christ's right foot in the Los Angeles altarpiece comes also from the Lucca *Volto Santo*. At least as far back as the thirteenth century a chalice was placed under the right foot of the wooden crucifix; some suggest it was put there for a functional purpose, to support a gold or silver shoe that for some reason, either miraculous or practical, kept falling off. As Clairece Black pointed out, however, it was unlikely that a sacred vessel would be employed for something that a nail would easily fix;[10] for this reason, the presence of the chalice should rather be explained iconographically. From the ninth century onward, images of the Crucifixion often included a figure usually identified as the Church (*Ecclesia*) or, later, an angel who held a chalice below the spear wound on Christ's right side, collecting the water and blood that spurted from the wound; a later variant developed in which the chalice itself was held or placed at the base of the cross. These representations all referred to the salvation in Christ's blood shed on the cross and consumed during the Eucharist.[11] In the case of the Los Angeles altarpiece the priest would have elevated the Host (the chalice was not elevated in the liturgy of this period) in front of the painted chalice, emphasizing the transubstantiation of the sacramental bread and wine into Christ's body and blood.

Perhaps because of this iconographical feature, the painting was identified in a mid-nineteenth-century exhibition in Manchester as *The Sacrifice of the Mass*.[12] It is unlikely that anyone in England would have associated the panel with an old wooden statue in what was then a seldom-visited Tuscan town. By 1893, however, the central image had been recognized as the *Volto Santo* of Lucca.[13]

While there is no difficulty in identifying Saint John the Baptist, the patron saint of Florence, by his appearance and attributes of cross and inscription (although Vasari recorded him as John the Evangelist), the other three saints proved less immediately

recognizable. In the Solly sale of 1847 (CAT. NO. 12, Provenance) the saints were identified as Dominic, John the Baptist, Jerome, and Peter Martyr;[14] this is understandable, given the fact that in the nineteenth and early twentieth centuries art historians routinely assumed that all Dominican saints, despite their attributes, were the most prominent figures of their order: Dominic himself, Thomas Aquinas, and Peter Martyr.[15] By the time the panel was exhibited at Burlington House in London in 1875 Saint Antoninus had been recognized as "Antonio, Archbishop of Florence," and by 1893 all the saints were finally correctly identified.[16]

The confusion by some observers of Saint Mark with Saint Jerome was also understandable, since they share the attributes of a lion and a book.[17] Jerome, however, is usually depicted in the garb either of a penitent or a cardinal. Mark, as the author of one of the Gospels, is often shown, as he is here, in the act of writing (there is also an ancient tradition that he was the apostle Peter's secretary). Also, Mark has significance as the patron saint of the church for which the altarpiece was commissioned, while Jerome has no obvious connection.

While the Dominican saints proved a puzzle to later viewers, few worshipers in San Marco would have mistaken Saint Vincent Ferrer or the Blessed Antoninus, whose rayed halo signifies that he had not been canonized when the painting was executed (a conventional halo was added after his canonization in 1523). If only by process of elimination Florentines would have known that the Dominicans represented here were not Dominic or Peter Martyr, who had a chapel or altar elsewhere in the church, or the great theologian Thomas Aquinas, to whom the altar next to that of the silk weavers' guild was dedicated.

The Spaniard Vincent Ferrer (1350–1419) was extremely popular in northern Italy even though he probably never penetrated farther south or east than Lombardy. His frequent miracles of healing, his care of the sick, his conversion of many Jews and Moors, and his attempts to heal the schism in the papacy generated much admiration during his lifetime and a strong movement for his canonization after his death. Vincent believed that he was called to preach repentance—indeed, he believed himself to be the angel of the Book of Revelation—and his legendary sermons were usually on the subject of the Last Judgment. In art, therefore, he is often shown pointing upward to a vision of the resurrected Christ or an angel blowing the last trumpet, and he often holds an open book with an inscription from the Book of Revelation (14:7) that he had quoted in his sermons: "Fear God, and give glory to him, for the hour of his judgment is come." In the Los Angeles altarpiece Vincent's vision has been transformed into a manuscript illumination of the Christ of the Last Judgment seated on a throne and borne up by angelic trumpeters; on the right folio of the book Vincent displays to the viewer is a slightly condensed version of the phrase from the Book of Revelation.

Antonio Pierozzi (1389–1459), a Florentine patrician by birth, established the monastery of San Marco in 1436 with fellow Observant Dominican monks from Fiesole, and as its prior, with the patronage of Cosimo de' Medici, turned it into a flourishing and powerful community. A frail, saintly, and learned man, the author of many theological and instructional works, he was forced to accept the position of archbishop of Florence in 1446 by Pope

Eugenius IV, who recognized his abilities as an administrator. Antoninus's conscientious pastoral work endeared him to his people, who used the diminutive form of his name ("little Anthony"), by which he was canonized, and his judgment that money earned by the investment of capital was not subject to the proscription of usury certainly won him the loyalty of the merchants of his see. The cross-shaped strip, or pallium, which identifies him as an archbishop, is his only attribute besides the ubiquitous book, but he would have been easily recognizable to the worshipers in San Marco, having lived recently enough to be remembered by many of them. It should be assumed that his face is a true likeness, which, given his expression, was probably taken from his death mask.

The angels surrounding the figure of Christ are of the highest ranks of the hierarchy of heaven: within the golden light of the mandorla are the six-winged seraphim and four-winged cherubim, who spend eternity in perpetual adoration of God. Glimpses of these angelic courtiers were rarely accorded to humans, and their presence here emphasizes the miraculous nature of the vision. Appropriately closer to us are the lowest of the nine angelic orders, the "ordinary" angels, depicted here scattering flowers, who come to earth to serve as God's messengers.

The location in which Vasari saw the altarpiece was in fact not a "cappella" or chapel in the sense of a recessed space but the first altar along the left wall of the nave after the transept. This was not the panel's earliest location in the church, however. During the renovations carried out by the sculptor and architect Michelozzo from 1437 to 1442, at the expense of Cosimo de' Medici, a one-story wall was erected across the nave to separate areas for men and women.[18] As an important Dominican foundation San Marco was primarily a preaching church; therefore, public participation in the liturgy was not appropriate, nor was sight of the high altar necessary (even the men in the front of the nave could see only a glimpse of it through a narrow opening into the monks' choir). What was required was space in which the faithful could assemble to hear the sermons. There were seats provided in the women's section, where they could listen in comfort and without distraction.

Documents record the presence of two altars on this half-wall facing the women's area of the nave: the altar of the Ricci family, dedicated to Saint Thomas Aquinas, was to the right of center, therefore the altar of the silk weavers must have been to the left (FIG. 48).[19] Thus, after the Los Angeles altarpiece had been installed in the 1490s, it would have been one of two images immediately visible to any worshiper entering by the main doors of the church. This would include not just Florentine women but anyone who entered the church when a sermon was not in progress or who came to pray at one of the four altars in the back of the nave.

The position of this altar on the left of the nave, halfway down its length, is significant in itself—this was (and is) the exact location of the newly constructed freestanding tabernacle (1482–84) by Matteo Civitali in Lucca Cathedral containing the *Volto Santo*; the site would thus have enormous resonance for the transplanted Lucchesi weavers. The unusual placement of both images, I believe, refers to the traditional site of the Crucifixion itself: in the Church of the Holy Sepulcher in Jerusalem, to which city many Florentines journeyed,

FIGURE 48

Plan of the church of San Marco, Florence, after renovations by Michelozzo in 1437–42 (by the author after M. Ferrara in Teubner 1979).

A. Monks' choir and high altar
B. Wall separating choir from nave
C. Men's section of nave
D. Low transverse wall
E. Women's section of nave
F. Main entrance
G. Altar of Saint Thomas Aquinas
H. Probable original position of altar of the Holy Cross with altarpiece by the Master of the Fiesole *Epiphany*
I. Later (and current) location of the altar of the Holy Cross after the renovations of 1563–65

the position of Golgotha is halfway down the nave on the left side (this positioning is obscured by the location of the current entrance in the left transept).

The presence and postures of the saints depicted are of great importance in understanding the message that was intended to be conveyed by this altarpiece. It is a message of repentance, very much in keeping with the penitential nature of the Dominican order itself, which advocated fasting, abstinence, poverty, penance, public confession of faults, and the use of the discipline.[20] The order also had a special devotion to the crucified Christ and to his blood, as is expressed in the many images by Fra Angelico and others in the monastery of San Marco that depict a Dominican saint or monk kneeling at the base of the cross as Christ's blood flows down the shaft.

Since one of the primary functions of the Dominicans was the spiritual direction of the lay population of the cities of Italy, it is appropriate that Vincent Ferrer serves here as the *festaiuolo*, the "master of ceremonies," who makes contact with the viewer in order to direct our attention to what is truly significant. Rather than pointing to Christ, which would be the usual duty of a *festaiuolo*, he holds up the manuscript that identifies him as the prophet of the Last Judgment, the preacher whose every sermon was an urgent call to repentance. It is likewise important to note that much of the theological writing of Antoninus had to do with the sacrament of penance.[21] In the composition the outstretched hands of Christ seem to rest over the heads of the two Dominicans as if in benediction of what they represent. And repentance is at the very heart of the message brought by John the Baptist as he prepared the way for the ministry of Christ. While Christ's open arms and benevolent gaze invite worshipers to come to him and partake of the sacrament that signifies salvation, it is John, Antoninus, and especially Vincent who remind them that only through acknowledgment of their sin and repentance are they worthy to do so.

The Dominican reformer Savonarola (1452–1498), prior of the monastery of San Marco from 1491 to 1498, is popularly perceived as an enemy of art. His sermons demonstrate, however, that, in the words of Anthony Blunt, "though [he] feared the evil effects which might come from the wrong kind of art, he had the greatest faith in the good which

could be done by the right kind," and in one of his sermons he declared that pictures in churches should be for the instruction of children and women.[22] It thus cannot be a coincidence that this altarpiece appears in the women's section of the church of the monastery of which Savonarola himself was prior. The didactic character of the altarpiece is surely heightened by its location. Marcia B. Hall noted that "the core of Savonarola's apostolate [was] Christ's sacrificial death to bring about our redemption through repentance."[23] Given the strong penitential character of the painting and its stylistic elements, it is likely that it was commissioned during his priorate, 1491–98, and, given his awareness of the importance of art in the Florentine community,[24] it would not be unreasonable to suppose that he had a part in determining its iconography.

The wall separating the men's and women's areas of the nave of the church of San Marco remained in place until renovations of 1563–65 (although it was temporarily removed in 1517 to accommodate the crowds who came to witness the visit of the Medici pope Leo X on the feast of the Epiphany); when the wall was finally taken down, the two altars were moved to the walls of the nave.[25] From 1582 to 1589 the nave walls were rebuilt so that the altars were set into the uniform, evenly spaced aedicules that are still extant. By the autumn of 1591 the silk weavers' guild had already entered into discussions with the artist Ludovico Cardi, known as Cigoli, who was working elsewhere in the church, to provide a new painting for their altar.[26] Given the horizontal format of the Los Angeles altarpiece, it would not have fit into the new, vertically oriented aedicule; this is probably what prompted the guild members to commission a more "modern" work. Cigoli's altarpiece, dated 1594 and depicting *Heraclius Carrying the Cross*, is still in place in the church of San Marco.[27]

The Los Angeles altarpiece must have been taken down in 1582 or slightly after that, when the renovation of the nave walls began. Presumably it was taken off the premises at that time: in 1684 Ferdinando Leopoldo del Migliore reported that the "panel by Cosimo Rosselli" could be seen in the guild's rooms near Santa Maria Nuova, and in 1736 Sebastiano Loddi reported that it was still there.[28]

By the mid-nineteenth century the altarpiece was in England, where it passed through a series of private collections (see CAT. NO. 12, Provenance). In the later 1930s its English owner took it back to Italy to be installed in his villa in Mignano. Believed lost in the Allied bombing of 1943, the panel was discovered nearly fifty years later in a crate in the family's house in Switzerland; it had spent the war in a warehouse in Livorno, where it had been sent for safekeeping.

Not one document mentioning the "altar of the Holy Cross" in San Marco provides the name of the artist. Although he was identified as Cosimo Rosselli by Vasari, this observation was not made until after the 1550 edition, in fact, since Vasari mentions a "chapel"— a term that he also employed to designate altars against walls—it is clear he did not see the panel until after it was moved to the nave wall during the renovations of 1563–65. His attribution was no doubt based on hearsay, tradition, or his own observations on the style of the panel. He knew that Rosselli had worked in Lucca Cathedral, where he would have had ample opportunity to see the *Volto Santo* in situ—especially since he painted frescoes

depicting Nicodemus carving the crucifix and its voyage to Italy[29]—so it would have been a logical assumption. While there are some similarities of style between Rosselli and this painter, these similarities occur only in some works, such as the figure of Saint John the Baptist in an altarpiece from the monastery of the Annunziata in Florence.[30] The anonymous painter is consistently finer than Rosselli, who, while achieving a more finished surface, often painted compositions in which beautiful and complex drapery folds dominate stiff and awkwardly proportioned figures.

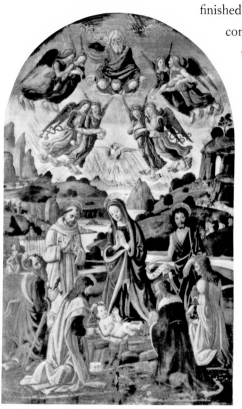

In 1967 Everett Fahy published a list of works he believed to be by the artist who painted an *Adoration of the Magi with Saints Paul, Francis, and John the Baptist*, now in the monastery church of San Francesco in Fiesole, and thus known as the Fiesole *Epiphany* (FIG. 49).[31] Anna Padoa Rizzo added more works to this list, including the Los Angeles altarpiece.[32] Like the latter panel, the Fiesole *Epiphany*, which came originally from the convent of the Murate in Florence,[33] had previously been attributed to the school of Cosimo Rosselli. But while Rosselli's striking *Adoration of the Child* in the Barber Institute, Birmingham, probably served as a compositional model for the Fiesole composition, the style is quite different.

The Master's style is characterized by strong contours and a bright, saturated palette, by compositions in which many elements are carefully arranged to achieve a balance, if not an outright symmetry. The figures are well-proportioned, the flesh and the underlying bone structure being finely modeled with light and shadow, the highlights of the flesh particularly showing a luminosity equal to the finest modeling by Domenico Ghirlandaio, as in the *Funeral of Saint Francis* (1483/86), in the Sassetti Chapel, Santa Trinità, Florence, and reminiscent of similar passages in the paintings of Sandro Botticelli and Filippino Lippi. The drapery is substantial, arranged in heavy, rounded folds flattening onto the ground; there is often a distinctive oval arrangement of the folds over a knee or leg, as here over the right legs of Vincent Ferrer and John the Baptist. Many of the works have an extensive landscape featuring a meandering river or lake, gentle wooded hills, high outcroppings of rock, and mountains fading into the distance.

The faces of the Master's saints and mortals are direct and individualized, many manifesting a heavy-lidded intensity of expression, while the countenances of Christ, the Virgin, and their attendant angels are often idealized to the point of blandness. Mina Bacci referred to the face of Christ in the Los Angeles altarpiece as a "pale ghost" (*smunta larva*), but as she herself pointed out in reference to another image of the *Volto Santo* attributed to Piero di Cosimo, concessions must be made when an artist is reproducing a holy image that must be immediately recognizable to the viewer.[34] And to a worshiper of the late fifteenth

century the formality of the *Christus Rex* imagery and the penitential message were balanced by the accessibility of the kindly face of Christ.

Raimond van Marle attributed the Fiesole *Epiphany* to a follower of Domenico Ghirlandaio, Fra Guglielmo, a monk of the Gesuati who died in 1487, probably too early to have executed it, although his style has similarities.[35] While this provides no additional evidence for the identity of the Master of the Fiesole *Epiphany*, it does correctly locate him in the circle of Ghirlandaio. In fact, he seems to have been one of the artists employed to paint the lunettes of the Oratorio di San Martino dei Buonomini, Florence, which has been most convincingly identified as a project of the entire workshop, with Ghirlandaio directing.[36] In the *Dream of Saint Martin*, formerly given by some to Davide Ghirlandaio, the drapery, landscape, strong contours, and figural and facial types, especially the angels and Christ, seem to be by the same hand, perhaps a bit less experienced, of the Master of the Fiesole *Epiphany*.[37]

Another work that may be closely associated in style with the Los Angeles panel and the Fiesole *Epiphany* is a *Coronation of the Virgin*, now in the Galleria dell'Accademia, Florence; this painting was published as recently as 1992 with an attribution to a follower of Cosimo Rosselli.[38] Because of the presence of a beautifully observed giraffe in the left background of the *Epiphany*, Padoa Rizzo dated that panel after 1487, when the first giraffe arrived in Florence, and suggested a range of 1485–95 for the three works.[39] Judging from the artist's increased facility of technique and composition, and a sophistication of style, I would judge the Los Angeles altarpiece to be the latest of the three, executed some years after the *Epiphany*.

Fahy suggested that the Master of the Fiesole *Epiphany* might be Filippo di Giuliano, who for many years shared a workshop with Jacopo del Sellaio and is recorded in 1483 as working as part of Ghirlandaio's team on the decoration of the Sala dei Gigli in the Palazzo Vecchio.[40] Unfortunately, no extant works can be attributed to Filippo, and since we have no indication of his style, there is no evidence to support this possibility. Although the angels in the Los Angeles altarpiece have an affinity with figures by Sellaio, we cannot assume that he and Filippo shared a style simply because they shared a space.

There is a clear correspondence between the style of the Master of the Fiesole *Epiphany* and that of the painter and miniaturist Gherardo di Giovanni del Fora (1445–1497). Indeed, Fahy ascribed the Los Angeles altarpiece to Gherardo when it was rediscovered,[41] and a small panel depicting Saints Sebastian and Roch auctioned in New York in 1993 as by the Master of the Fiesole *Epiphany* appeared soon after on the Italian art market attributed to Gherardo.[42] He is sometimes called a follower of Ghirlandaio, although there is little documentary evidence for his participation in Ghirlandaio's decorative campaigns. He was a gifted miniaturist who was also successful in large-scale works, many of which have been erroneously attributed to Cosimo Rosselli at one time or another.[43]

Especially in the cases of the Fiesole *Epiphany*, the *Coronation of the Virgin*, and the Los Angeles altarpiece, it should be noted that the brilliant color, decorative compositional arrangement, and *horror vacui* of the panels are hallmarks of a manuscript illuminator.

In Gherardo's *Triumph of Chastity* in the Galleria Sabauda, Turin, and *Virgin Adoring the Child* from the Hertz Collection, now in the Galleria Nazionale, Rome, both of which include extensive landscapes, the trees and the distinctive strip of minutely observed plants in the foreground areas are identical to those elements in the Los Angeles altarpiece.[44]

A work attributed to Gherardo that is particularly similar is an altarpiece depicting the *Madonna and Child with Saints Francis, Louis of Toulouse, John the Baptist, and Mary Magdalen* now in the Galleria dell'Accademia, Florence (inv. 1890, no. 9149). It is of unknown provenance but the saints suggest a Franciscan establishment in Florence. Although much of the lower part of the panel has been overpainted, making it impossible to see the original treatment of the drapery, similarities can be seen in the facial types and features, the hands, the method of shading flesh, a strong contour line, and even a similar, if less sumptuous, border on the robes of Louis of Toulouse.

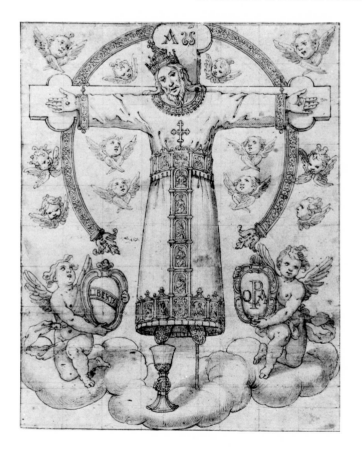

As Padoa Rizzo pointed out, many of the commissions of the Master of the Fiesole *Epiphany* can be linked to the Dominicans of San Marco.[45] It is interesting to note that according to the tax rolls of 1480 Gherardo and his brother Monte were living in a house in the Piazza San Marco.[46] Vasari also mentioned that Gherardo painted a lunette, no longer identifiable, above an altar in San Marco.[47]

Many other images of the *Volto Santo* are known, from medieval crucifixes replicating the Lucca sculpture, to nineteenth-century pilgrims' relics. Only a few of them are related in time and geography to the Los Angeles altarpiece. One of these is a problematic painting in the Szépmüvészeti Múzeum, Budapest, attributed to a number of artists and schools but most recently given to Piero di Cosimo.[48] Although Bacci mentions the "lost" altarpiece— which she accepts as a work by Piero's master, Cosimo Rosselli—and the Lucca frescoes by Rosselli as further evidence that the Budapest *Volto Santo* is by Piero, it is clear from the inclusion of the added "aureole" that the artist used the wooden image as his source and not the painting now in Los Angeles. Another image of this type is a sixteenth-century drawing in the Metropolitan Museum of Art, New York (inv. no. 61.211), attributed to an anonymous Tuscan artist (FIG. 50).

A painting of the *Volto Santo* in the Misericordia, San Gimignano, depicts the image being adored by two kneeling, hooded penitents. Lisa Venturini attributes the work to Sebastiano Mainardi and dates it to the first decade of the sixteenth century.[49] The image lacks the aureole, and in face, hair, and jeweled robe is very close to the Los Angeles altarpiece, and thus may have been derived from it.

Far more closely related is a drawing in the Uffizi currently attributed to Filippino Lippi, but the nature of the relationship is still open to speculation (FIG. 51).[50] The drawing also depicts a crowned and robed Christ on a cross with trilobate terminals, which is here supported by two angels; the chalice is below his right foot, and he is adored by two kneeling saints, John the Baptist and an older bearded man with an open book.

FIGURE 51
Attributed to Filippino Lippi (Florence, c. 1457–1504), *Mystic Representation of the Crucifixion with Saint John the Baptist and Another Saint*, 1490s, ink and brown wash, with traces of black chalk, on white paper, Galleria degli Uffizi, Gabinetto dei Disegni e Stampe, Florence.

In the composition and the poses of the figures, the two representations are nearly identical, except, of course, for the elimination in the drawing of the other figures. The other differences are slight and in the details: Christ wears the triple tiara associated with the papacy, the bottom of the cross is visible, and the angels actually bear the crosspiece rather than hovering beside it.

Several authorities, including Bernard Berenson and Alfred Scharf, suggested that this must be Lippi's sketch for a work, unexecuted or no longer extant, for Lucca, since it is clearly a representation of the *Volto Santo*.[51] Unlike the painting attributed to Piero di Cosimo and the drawing in the Metropolitan Museum, however, it does not reproduce the aureole added behind the Lucca *Volto Santo*, and is thus more likely to be a sketch for, or a copy after, another image. And the presence of the patron saint of Florence in the place of honor eliminates the possibility that this was a commission for Lucca.

All authorities date this drawing to the 1490s, which would immediately precede or coincide with the period in which the Los Angeles panel itself was executed, and it seems impossible that it had no connection with it. Padoa Rizzo suggested that it might have been drawn by an artist in Rosselli's circle, perhaps even as a trial piece for the commission.[52] This is only one of many possibilities. If the drawing preceded the painting, the drawing itself may be by the Master of the Fiesole *Epiphany*, whose painting style shares characteristics with that of Filippino. Or could Filippino initially have been considered for the commission, which was then carried out by another artist—in which case what might have been the working relationship between the two artists?

The most finished area of the drawing is the left side of a tabernacle frame, which features a channeled pilaster with an elegant Corinthian capital; the rest of the frame is also precisely indicated. Is this then perhaps a sketch to be submitted for the approval of a patron, not for the altarpiece but for the frame in which the previously commissioned altarpiece would be displayed? The drawing of the figures is primarily an outline, as if a preexisting composition was being sketched, perhaps from memory, to indicate the approximate composition.

Notes

The author wishes to recognize with gratitude the faculty, staff, and students of the Yale Institute of Sacred Music, Worship and the Arts, whose interest in the iconography of the altarpiece by the Master of the Fiesole Epiphany encouraged her to probe more deeply into the circumstances of its creation and display.

1 Francesco Pesellino's *The Trinity with Saints Mamas, James the Great, Zeno, and Jerome* (fig. 8) has four small panels illustrating a scene from the life of each of the four saints in the main altarpiece.

2 Vasari 1966–84, vol. 3 (1971), 444.

3 Raimond van Marle was the only one who believed that the so-called Rosselli San Marco altarpiece could not be the same as that formerly in the Fuller Maitland collection, because the patron saint of the church was not present (Mark had been misidentified as Jerome) and the other saints did not correspond to Vasari's list; see Van Marle 1923–36, vol. 11 (1929), 613–14 n. 3.

4 Teubner 1979, 269, doc. XXIV, no. 2. The silk workers from Lucca began to arrive in Florence in the early fourteenth century, after the conquering Florentines had imposed repressive laws on the Lucchesi for the very purpose of undermining the silk industry there; see Staley 1906, 216.

5 Interestingly, it was unusual for the iconography of an altarpiece to be linked to the altar's dedication (see Wackernagel 1981, 133); the painting over the altar dedicated to Saint Thomas Aquinas in the church of San Marco, for example, depicted the archangel Raphael. Here, however, the theme was completely consistent.

6 For the legend and iconography of the *Volto Santo*, see Black 1941, 28–31; Haußherr 1962, 132–42; Lucca 1982; Agresti/Chiusano/Amendola 1989.

7 A variant of the story states that Nicodemus carved the figure from the impression of Christ's body on his burial shroud; see Schiller 1972, 144. The *Volto Santo* was considered the equal of four other famous acheiropoietic images of Christ, all of which were then preserved in Roman churches: the Mandylion of Edessa, a portrait supposedly sent by Christ to King Abgar v of Osrhoene (San Silvestro); the Sudarium, the veil used by a woman named Veronica to wipe the sweat from Christ's face as he carried his cross through Jerusalem (San Pietro); a portrait of the Virgin and Child thought to have been painted by Saint Luke (Sancta Sanctorum, San Giovanni in Laterano); and a portrait of Christ reputedly given by Saint Peter to Senator Pudens (Santa Prassede).

8 Haußherr 1962, 134, 136.

9 Ibid., 140–41.

10 Black 1941, 31.

11 Clairece Black discusses a type of early crucifix from Lucca with a base in the shape of a chalice; see Black 1941, 27–28, 36. The veneration of the blood of Christ has always been closely connected with the *Volto Santo*, since it is itself a reliquary, once supposedly containing a vial of Christ's blood. This vial was said to have been given to the seaside town of Luni, where the image was discovered, in recompense for the crucifix being taken away to Lucca. According to another version of the story, the reliquary compartment in the *Volto Santo* contained part of the Crown of Thorns and other relics of Jesus's Passion inserted by Nicodemus himself; see Schiller 1972, 144.

12 Manchester 1857, no. 68.

13 London 1893–94, no. 71.

14 G. F. Waagen further misidentified the saint at the far right as Saint Peter; Waagen 1854, vol. 3, 4.

15 Zucker 1992, 184–85.

16 London 1875, no. 181; London 1893–94, no. 71. The erroneous identifications of the saints were published in all editions of Crowe/Cavalcaselle, however (see CAT. NO. 12, Literature), and were thus repeated in the W. Fuller Maitland sale catalogue of 1922 (see CAT. NO. 12, Provenance).

17 Mark's lion is usually winged, since it is associated with one of the four winged creatures seen in visions by the prophet Ezekiel (1:5–14) and Saint John the Evangelist (Rev. 4:6–8); here, however, only the lion's head is visible as he glares out from behind Mark's leg.

18 In many monastic churches the monks' choir was at that time also separated from the nave by a wall in which there was only a narrow opening; for the transverse division of San Marco, see Teubner 1979, especially 264, doc. XII.

19 Teubner 1979, 250, 264, doc. XII.

20 The ultimate expression of Dominican iconography, in the so-called Spanish Chapel of Santa Maria Novella, puts repentance and the act of confession at the very center, both physical and spiritual, of the fresco known as *The Triumph of the Church*, c. 1366–68, by Andrea da Firenze.

21 Antoninus's *Confessionale* is a collection of three treatises, dating 1472–75, all of which deal with the sacrament of penance.

22 Blunt 1962, 45; Wackernagel 1981, 112.

23 Hall 1990, 503.

24 Ibid., 495–503. Penitential iconography was, of course, not exclusive to the Dominicans, but it is interesting to note that one of the other great exemplars of this type, the so-called *Pala delle convertite*, painted by Botticelli for the Augustinian convent of Sant'Elisabetta delle Convertite, is dated by most authorities to the same span of time, c. 1490/94. The painting (now in the Courtauld Institute Galleries, London) was created for a convent that housed reformed prostitutes and depicts the penitent Magdalen and Saint John the Baptist flanking a vision of the Trinity with Christ on the cross; see Lightbown 1978, vol. 1, pl. 36; vol. 2, cat. no. B62.

25 Teubner 1979, 265, doc. XIV; 267, doc. XVIII; 268, doc. XX.

26 Padoa Rizzo 1989, 24, appendix.

27 San Miniato 1959, no. 13.

28 Del Migliore 1684, 217, and Loddi 1736, 269, cited in Teubner 1979, 268, doc. XXI.

29 Vasari 1966–84, vol. 3 (1971), 444.

30 Cosimo Rosselli, *Saints John the Baptist, Barbara, and Matthew*, from the convent of the Santissima Annunziata, Florence, now in the Galleria dell'Accademia, Florence, inv. 1890, no. 8635; Bonsanti 1992, 38.

31 Fahy 1967, 133–34; he added to the list in his dissertation of the following year, published in 1976: Fahy 1976, 169–70.

32 Padoa Rizzo 1989, 17–22.

33 Giglioli 1933, 171.

34 Bacci 1966, 96–97. Another painted *Volto Santo*, a small panel of c. 1410 now in the Museo Horne, Florence, has identically rendered features, including the double-pointed beard; see Meiss 1964, 38, fig. 43.

35 Van Marle 1923–36, vol. 13 (1931), 261–62; two saints ascribed by van Marle to Fra Guglielmo flanking the *Assumption of the Virgin* in a niche of the cloister of the Gesuati in Siena (fig. 179) are very similar to a fresco currently attributed to the Master of the Fiesole *Epiphany* in the Oratorio di San Martino dei Buonomini, Florence; see Florence 1992–93, 34, fig. 1.

36 Rosselli Sassatelli del Turco 1927–28, 617.

37 Nicoletta Pons in Florence 1992–93, 35.

38 Inv. 1890, no. 490; Bonsanti 1992, 41–42.

39 Padoa Rizzo 1989, 19.

40 Gaye 1839–40, vol. 1 (1839), 580; Fahy 1967, 133–34; Pons 1991, 222–24.

41 Letter of July 12, 1991; copy in the files of the Los Angeles County Museum of Art.

42 Sotheby's, New York, May 20, 1993, lot 10.

43 Fahy 1967, 128, 131; Fahy 1976, 113–25; Florence 1992–93, cat. no. 9.13.

44 In 1947 Pietro Toesca noted that these paintings were by the same hand, an artist known at that time as the Master of the *Triumph of Chastity*; see Florence 1992–93, cat. no. 9.13. Everett Fahy associated this artist with Gherardo di Giovanni in Fahy 1967, 128–33; see also Fahy 1976, 113–25.

45 Padoa Rizzo 1989, 21; she also provides the information that the Master's *Coronation of the Virgin*, now in the Accademia, was in the church of San Marco in the early nineteenth century, although its original location is not known.

46 Nicoletta Pons in Florence 1992–93, 106.

47 Vasari 1966–84, vol. 3 (1971), 473.

48 Bacci 1966, 96–97, no. 42.

49 I wish to thank Dr. Venturini for this information.

50 The drawing is catalogued as "Mystic representation of the Crucifixion with Saint John the Baptist and another saint"; Petrioli Tofani 1986, cat. no. 227 E.

51 For a history of the attribution and a summary of the literature, see Shoemaker 1975, cat. no. 88.

52 Padoa Rizzo 1989, 20.

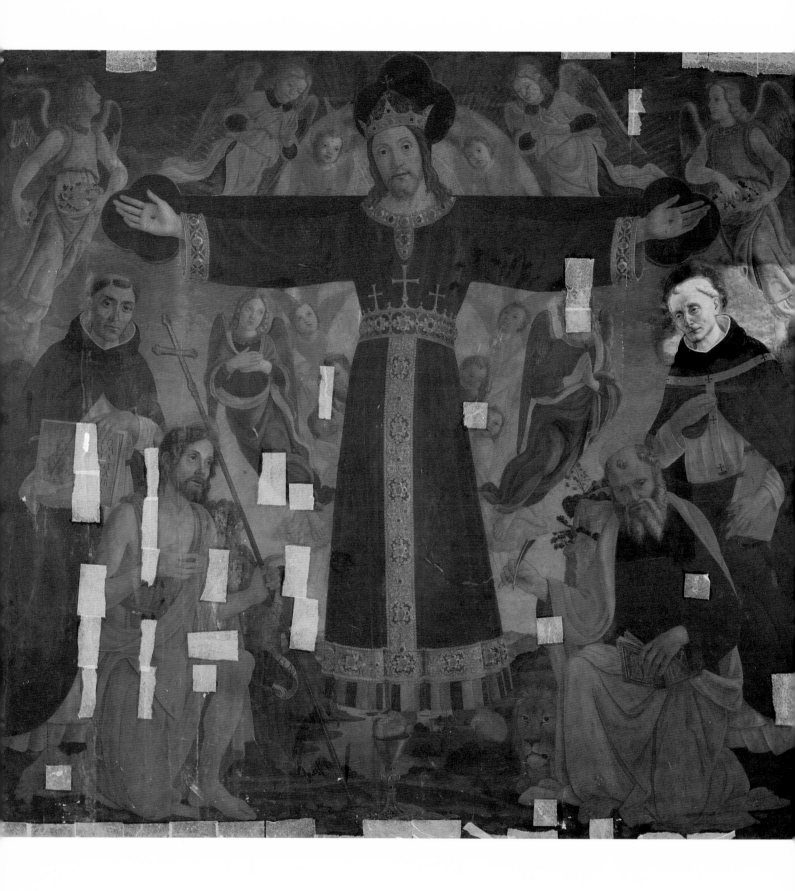

Conservation Report

JOSEPH FRONEK

When the large altarpiece *Christ on the Cross with Saints Vincent Ferrer, John the Baptist, Mark, and Antoninus* came into the museum, it was almost impossible to see the image because of thick layers of discolored varnish and black grime (FIG. 52). As many as five surface coatings separated by grime layers covered the panel. Examination of the painting with intense visible light, ultraviolet light, and infrared photography, however, gave a better idea of the condition.

Ultraviolet light gave some information about the most recent restorations (done in about the last twenty years), such as the repaint along the join to the left of Christ (FIG. 53). This newer restoration lay on top of the varnish layers, and thus in ultraviolet light it appeared dark against the fluorescing varnish. Earlier restorations were masked by the discolored varnish but were made visible by the infrared photograph.

Infrared rays successfully penetrated the varnish layers and showed very few losses and restorations (FIG. 54). Most of the repaint, which appears dark in the infrared photography, was concentrated along the top of the painting, but fortunately Christ's face was unscathed. In the infrared photograph the modeling of the visages could be read. These rays, outside the visible spectrum, even penetrated the tissue patches attached to the painting so that losses covered by the paper were visible.

Solvents were tested along the right edge to determine solubility of the surface coatings. At the same time some paint was uncovered so that the condition could be checked directly. The heads of Saints Mark and Antoninus were found to be very well preserved. By the same operation it was learned that the delicate mordant gilding decorating the very surface of the paint was still largely intact.

Cross sections, microscopic samples of paint embedded in a resin and polished to show the layer structure of the paint and varnish, confirmed the good condition of areas farther into the picture. One sample taken from the blue sky above Christ's proper left hand showed two layers of original blue paint (FIG. 55). The uppermost original layer, pigmented by relatively large chunks of ultramarine, seemed to be fairly untouched by earlier cleaning campaigns. The same could be said about the green of the landscape: a cross section taken from the lower left of the painting showed two layers of green paint in a very good state (FIG. 56).

FIGURE 52
Master of the Fiesole *Epiphany, Christ on the Cross with Saints Vincent Ferrer, John the Baptist, Mark, and Antoninus*, c. 1491/95, before treatment, with cleaning test on right edge.

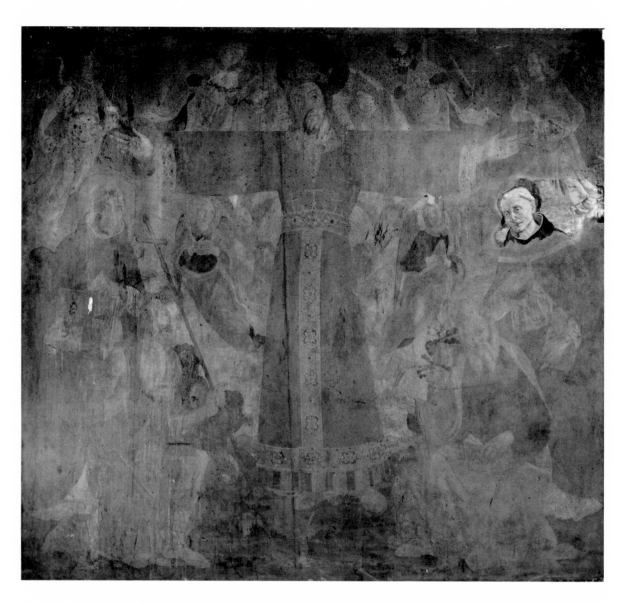

The painting is supported by a wood panel made up of approximately five planks. The panel has been thinned at some time in its history so that it is now only about 1 inch thick. Following the thinning of the wood, the panel was cradled (FIG. 57). Why this panel was thinned and cradled is rather obvious to a conservator: joins between planks had opened, and cracks and splits had developed. In addition planks had bowed, as they still are today, but to a lesser degree.

The panel's cradle was the cause of a number of problems. This restricting skeleton of wood held the panel perhaps too tightly, causing some paint to lift. So that the painting could be shipped safely from London to Los Angeles, the areas of lifting were covered with tissue paper and glue to hold the paint in place (see FIG. 52). There was another problem with regard to this cradle: the horizontal and vertical members of the cradle are fairly thin and consequently the cradle is too light for the panel. It is therefore necessary to handle the painting very carefully or else it will torque.

On top of the wood panel there are several layers of gesso, and in cross section one can see a distinction between the coarser and finer layers, the *gesso grosso* and *gesso sottile*

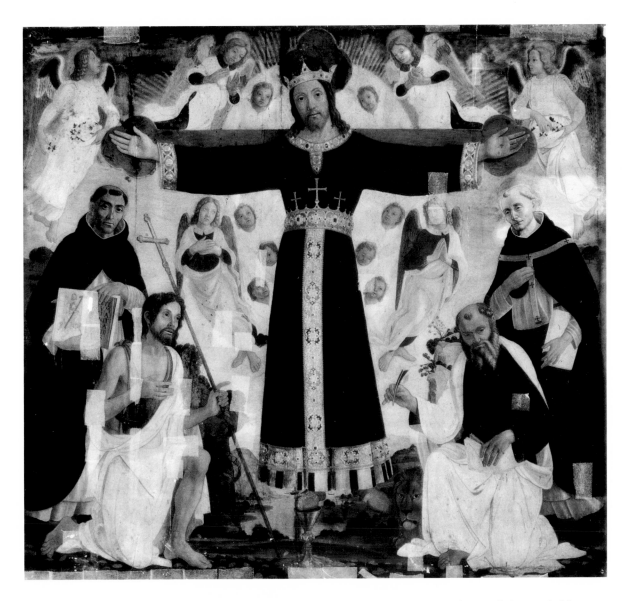

FIGURE 54
Infrared photograph.

mentioned in Cennino Cennini's *Il libro dell'arte* (see FIG. 56). A layer of glue probably covers the panel, but this could not be determined from the cross sections, since only a part of the earliest (that is, the first or lowest) layer of gesso could be extracted and nothing below that. No cloth covers the panel, a step that Cennini recommended for stabilizing a composite support.

Infrared photography revealed an underdrawing on the white gesso ground that is particularly visible in the drapes of Saints John the Baptist and Mark (see FIG. 54). The material used for the underdrawing, probably charcoal, can be distinquished in one of the cross sections, that of the green in the landscape. It lies directly on top of the ground and appears as a dark hairline (see FIG. 56). The drawing is not incised.

From the same cross section we can see that a thin layer, which appears to be a natural resinlike material, covers the ground and drawing. This layer could be similar, or analogous, to a sizing layer to make the ground less absorbent. At the same time, this layer would isolate the drawing. Over the "size" there is a yellow pigmented layer with a proteinaceous

binding component. These two layers were found on all cross sections taken from various parts of the picture; therefore, this seems to be an overall treatment of the ground. (Richard Wolbers categorized the various coating layers using the following stains: triphenyl tetrazolium chloride; rhodamine isothiocyanate; and rhodamine 123.)

The painting of the figures followed the traditional manner as described by Cennini for egg tempera. The figure of Saint Antoninus, for example, was painted in strokes or hatching clearly visible even to the unaided eye. The flesh was underpainted with terre verte, now slightly more visible than it was originally. In contrast, the sky was very thickly painted, and hatching is not evident. Analysis by staining methods of the media used for the blue sky resulted in an interesting finding: the media for the sky seems to be egg tempera and oil. Whether or not these media are found in separate layers or mixed cannot be determined from the present analyses.

While egg tempera was the medium of choice for the working up of the forms, glazes of oil may have been used to deepen shadows and create modeling more subtle than tempera could achieve. This appears to be most true for the angels' blue robes and for the red robe of Saint Mark. The gray habits of the two Dominicans are actually less successfully modeled than those just noted. In fact, the gray garments of the monks are a bit abraded. Deep black tones were at some time worn from the gray underlayer.

The pigments in the painting are not out of the ordinary, except for the fact that ultramarine was used for the expanse of the blue sky. Such an elaborate use of this precious pigment would have been very costly.

Two areas of the painting were particularly problematic with regard to the cleaning, and the solution of these problems required some discussion and analysis. The halo of Saint Antoninus was a muddy orange color set frontally, very unlike the halos of the other figures, which are disks made up of gold strips and dots set in perspective (FIG. 58). Examination with magnification showed that there were gold rays emanating from behind Antoninus's head, underneath the crudely painted halo; and a cross section of paint from the halo showed varnish and dirt layers present between the earlier rays and the later halo. Since Antoninus was not canonized until 1523, it has been suggested that the halo was added after his canonization. The hastily applied paint of the halo almost totally obscured the golden rays, which denote someone who has been beatified. It is a great fortune that these wisps of gold, a part of the original painting, were not scraped away before repainting.

FIGURE 55
Cross section from blue sky, magnification of 250x:
A. Overpaint and varnish layers
B. Blue (ultramarine and lead white)
C. Blue underlayer (ultramarine and lead white)
D. Ground

FIGURE 56
Cross section from green of landscape, magnification of 250x:
A. Varnish layers
B. Two green paint layers containing green earth and lead white
C. Drawing
D. Ground

FIGURE 57
Reverse of panel showing cradle.

The other problematic area of the picture was the upper part of the sky, which was broadly overpainted. Infrared photographs successfully showed some of this overpaint (see FIG. 54), but it was also identifiable when viewing with a warm intense light. The cross section from the sky (see FIG. 55) showed the thin blue-green restoration covering what appeared to be an intact layer of original paint. With cleaning it was found that some of the upper layer of original paint had been abraded, but the majority of the area was still intact.

The painting was varnished at least four times, and below the varnish layer there is a layer of what has been analyzed as a polysaccharide of some sort. This is a rather odd finding, but a plant gum may have been applied overall to consolidate paint and perhaps to protect the paint film during the operation of cradling. Subsequent to the structural treatment, the coating may have been only partially removed or even just allowed to stay so that it would continue to hold any loose paint. Under normal viewing conditions this film appears grayish, and it was very difficult to remove.

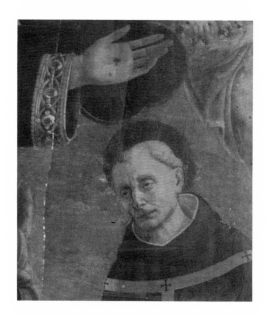

Prior to the application of the gum layers, the painting was probably cleaned. Some patches of an older surface coating lay below the gum layer. This would certainly suggest that the painting had been varnished previously, though not necessarily by the artist.

After the painting was cleaned in the museum, it was given an isolating coat of thin varnish. Losses were filled with gesso and then toned with a water-based paint. A natural resin varnish was brushed onto the surface to saturate colors and even out the paints. Final inpainting was completed with resin colors so that the losses are not obvious and do not interfere with the viewing of the picture.

Scientific Report

JOHN TWILLEY

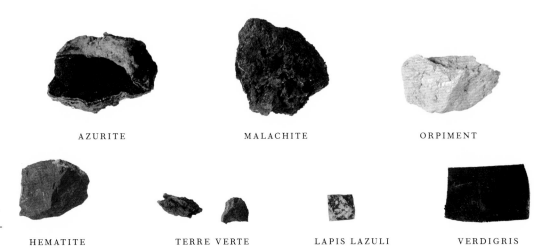

AZURITE

MALACHITE

ORPIMENT

FIGURE 59
Mineral pigments representative of those used in the fifteenth century and man-made verdigris.

HEMATITE

TERRE VERTE

LAPIS LAZULI

VERDIGRIS

Conservation treatment of Italian panel paintings is attended by complications imposed by prior restorations and the aging of the painting materials, aging of both the original paints and those of restorers. Considerable effort is expended by conservators today to differentiate subsequent applications of paint from the original, often damaged and fragmentary, image. Obtaining as much advance information as possible about the nature of all materials to be encountered in the painting and their behavior toward the broad range of cleaning formulations available today is a highly important part of conservation practice. This approach has brought significant improvements to the restoration of paintings that help the practitioner to avoid the damaging effects associated with the limited range of harsh materials available to an earlier age. Joseph Fronek has reported the observations made by conservators treating the *Christ on the Cross* with a variety of visual and scientific examination aids. Here an account will be given of a related phase of work, the analysis of the materials of the artist and, in particular, the analysis of the materials that posed difficulties during the conservation treatment process.

Conservation research work in support of such a treatment takes the form of numerous chemical microanalyses, the results of which disclose the paint composition and lead to an interpretation of the alteration phenomena affecting the painting. A few of the many issues that arose during treatment of the tabernacle will serve to illustrate the nature of this work.

FIGURE 60
Copper resinate green from a fifteenth-century Spanish poly-chromed knight effigy in the museum's collection (M.49.23.16) viewed at a magnification of 800x.

FIGURE 61
Terre verte from the painting's landscape, magnification of 800x.

The traditional use of mineral pigments throughout late antiquity and the medieval period had restricted the decorative palette to a small number of reliable materials (FIG. 59). By the fifteenth century the use of thinly pigmented, oil-based paint layers (into which light penetrated deeply) was firmly established as a means of accentuating the illusion of depth. Semitransparent, man-made pigments came to be used for the richest of these glazes and often incorporated less-stable colorants such as the dyes that provide color in lake pigments (used here in the red robes of Saints Mark and John the Baptist) and a green substance called copper resinate. This latter material results from dissolving verdigris, copper corrosion produced in the presence of vinegar, into a resin similar to those used in the final varnishing of a painting. Copper resinate is capable of a beautiful gemlike transparency (FIG. 60) but suffers from instability to light and to the harsh alkalis often used in the restoration of paintings centuries ago. Its deterioration takes the form of darkening to a reddish brown color that cannot be reversed. The great obscuring effect of the multiple layers of darkened varnish made it impossible to judge whether this pigment might be present in the tabernacle. If it were, extreme caution would be necessary to remove the darkened resin varnish without also removing this resin-containing colorant.

Analysis of the pigments proceeded in concert with the cleaning. Techniques that measured the optical properties, chemical composition, and crystal structure of the green pigments[1] demonstrated that the principal green pigment of the painting was a high-quality celadonite (FIG. 61), a green marine clay known to the artists of the day as terre verte. Those areas of the painting that exhibited brown foliage, particularly the distant landscape beneath the figure of Christ, were observed to contain particles of brown "earth" pigments quite distinct from a degraded copper resinate. If copper resinate was used by the Master of the Fiesole *Epiphany* in this painting, neither it nor its degradation products have survived earlier cleanings. The stability of the terre verte toward the cleaning procedures of today could be assured.

Darker passages in the painting were so obscured by the discolored varnish that their color could not be discerned even under intense light. One such area was the cross, which was, oddly, indistinguishable in color from the black robe of Christ. In order to understand

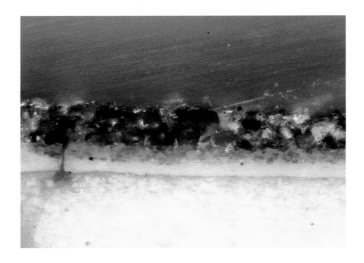
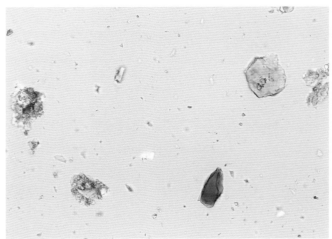

FIGURE 62
Cross section of paint layers from the cross, magnification of 800x. Top to bottom: discolored varnish, ultramarine, azurite mixed with lead white, gesso.

FIGURE 63
Azurite and lazurite (ultramarine) from the first and second layers of the cross, respectively. The color saturation of the ultramarine particles varies from pale to dark, magnification of 800x.

the original color and to differentiate any possible overpaint, a sample was taken for cross-sectioning. The microscopic section revealed two distinctive layers of blue: the first paler and more reflective of light, the second deep blue and gemlike (FIG. 62). Clearly the function of the first is to reflect light through the second, while that of the second is to impart depth of color.

The identities of the two blue pigments were established by the technique of polarized-light microscopy applied to the individual particles of pigment. In figure 63 the slightly green color of azurite, used with lead white in the first layer, is distinguished from the darker, bluer shade of the isotropic pigment ultramarine, used alone in the upper layer. In the same way, the identity of Prussian blue, a component of old restorations to the sky, was ascertained. In the cross the first layer is a continuation of the sky. Atop this the form of the cross was created by the much more costly and rare ultramarine with its enamel-like blue.[2] Neither azurite nor ultramarine alone would have achieved the rich effect that the artist desired. This ultramarine example is of very high quality: deep in color, carefully freed of white impurities, and ground to a consistently coarse particle size, providing a saturated color.

In addition to the differentiation of original materials from restorations there were complications to the cleaning process itself that led to further tests. After the removal of old varnishes with solvent formulations tailored to the characteristics of aged resin varnishes, a gray, insoluble residue remained in some areas, which was quite disfiguring (FIG. 64). When this residue failed to respond to alternative cleaning measures, samples were taken from several areas for chemical analysis. The results disclosed that the residue contained a substantial quantity of inorganic material in the form of gypsum, a little calcium carbonate at some locations, and a starchlike polysaccharide. None of these is soluble in the sort of materials used to remove aged varnish. Unfortunately the sort of solvents that would be effective in their removal were judged to pose unacceptable risks to the painting surface. This necessitated that the conservator undertake a much more laborious process of manual cleaning.

The question of the origin of this residue remains with us. The polysaccharide may be a residue from a prior treatment, as has been postulated above by Joseph Fronek. Such an

adhesive would have been an aqueous one; the consequent dampening, and others that may have occurred over the years, may have been instrumental in bringing the gypsum to the surface through the minute aging cracks in the paint. The ground, or gesso layer, applied to prepare the panel for painting, presents an abundant reservoir of this slightly soluble material. The residue alone may have been much less apparent following an earlier cleaning. Were it not for the presence of grime bound in this residue today, it would be less apparent.

Our investigation and the treatment of *Christ on the Cross with Saints Vincent Ferrer, John the Baptist, Mark, and Antoninus* have revealed a master of fifteenth-century painting technique working with exceptional materials and in full command of their potential.

Notes

1 Polarized-light microscopy, Fourier transform infrared spectroscopy, and X-ray diffraction, respectively.

2 Ultramarine, isolated from the semiprecious stone lapis lazuli by a laborious process, was only available to European artists of the time by trade with Afghanistan along the famous "Silk Route," which led ultimately to China. The commissioners of this painting (the Silk Guild) may be presumed to have had excellent access to this route of commerce.

*Catalogue of
Italian Panel Paintings
of the Early Renaissance
in the Collection*

Bartolo di Fredi

SIENA, C. 1330–1409/10

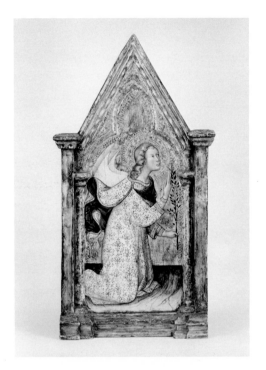
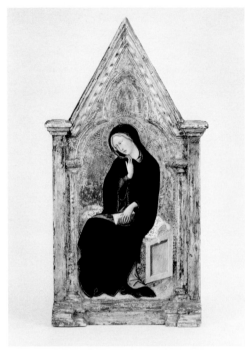

1

**The Angel of the
Annunciation** (pinnacle from
the Coronation Altarpiece)
1383/88
Tempera on panel
57.2 x 28.9 cm (22½ x 11⅜ in.)
Mr. and Mrs. Allan C. Balch
Collection
M.44.2.1
COLOR FIG. 20

2

The Virgin Annunciate
(pinnacle from the Coronation
Altarpiece)
1383/88
Tempera on panel
57.2 x 28.6 cm (22½ x 11¼ in.)
Mr. and Mrs. Allan C. Balch
Collection
M.44.2.2
COLOR FIG. 20

*Conservation Notes were written
by Joseph Fronek, Virginia
Rasmussen, and Shelley Svoboda.*

Bartolo di Fredi was one of the most innovative of the generation of Sienese artists to come to prominence after the bubonic plague of 1348. Although the influence of his predecessors is clear in his work—particularly the grace of Simone Martini and the spatial acuity of the Lorenzetti brothers—he transformed his models with a novel use of strong color, attention to detail, imaginative, vivid compositions, and expressive faces. He was held in great regard in Siena, where he was elected to high political office and commissioned to execute major altarpieces and other important works in the city and the surrounding regions, including Montalcino, Pienza, San Gimignano, and Volterra.

These small panels, which taken together depict the Annunciation of the incarnation of Christ by the archangel Gabriel to the Virgin Mary, are from a large altarpiece commissioned from Bartolo di Fredi for the church of San Francesco in Montalcino, a hill town close to Siena. The altarpiece is dated 1388, but the commission might have been received as early as 1383 (Van Os 1985, 59). According to the reconstruction of the altarpiece suggested by Gaudenz Freuler (1985, 25), the two panels were the pinnacles of wings illustrating scenes from the life of Mary that flanked a central image of the Coronation of the Virgin (now in the Museo Civico, Montalcino; the wings are in the Pinacoteca Nazionale, Siena).

PROVENANCE
Possibly Palazzo Saracini, Siena.
Private collection, Russia.
Edward Hutton, London.
A. Gore.
Knoedler's, London and
 New York, until 1927.
Allan C. Balch, Los Angeles,
 1927–44.
Donated to the Los Angeles
 County Museum, 1944.

EXHIBITED
Possibly exhibited in San Diego
 1936.
Los Angeles 1944, cat. nos. 1–2.

LITERATURE
Perkins 1927, 203–4.
McKinney 1944a, 12.
McKinney 1944b, 8, 10, pls. 7–8.
Los Angeles 1945, 10.
Bush 1947, 225, 258–61,
 figs. 65–66.
Feinblatt [1948?], 16–17, fig. 10.
Wescher 1954, cat. no. 3.
Bush 1963, 3–12, cover, figs. 3–4.
Los Angeles 1965, 58–59.
Berenson 1968, vol. 1, 29.
Carli 1972, 16 (erroneously
 identified as an Assumption).
Fredericksen/Zeri 1972, 16,
 302, 591.
Mallory/Moran 1972, 14–15,
 figs. 3–4.
Los Angeles 1977, 58.
De Benedictis 1979, 80–81.
Carli 1981, 238.
Freuler 1985, 23, 26, figs. 4, 15.
Van Os 1985, 59, 63, figs. 32–33.
Los Angeles 1987, 15.
Günther 1993, 268.
Harpring 1993, 102–3, 154,
 cat. no. 19.

The figures of Gabriel and Mary are clearly based on the famous *Annunciation* of 1333 by Simone Martini (Galleria degli Uffizi, Florence), which in Bartolo's day was over the altar of Saint Ansanus in the cathedral of Siena. The reverent, courtly pose of the kneeling archangel, the apprehensive, shrinking curve of the maiden, and the gestures of both figures are nearly identical, as are the faces of the two Virgins. Bartolo's bodies, however, seem more substantial under the draperies, and the decorative elements in his composition—particularly the drapery folds and borders—are more subdued and less arbitrary in their placement. Bartolo has continued a Sienese practice of depicting Gabriel with an olive branch rather than the more traditional lily, which was the symbol of the rival city of Florence.

Conservation Notes

The wood supports of *The Angel of the Annunciation* and *The Virgin Annunciate* measure approximately ¾ of an inch thick. The frames are engaged and gilded. The panels have been cradled. In both works the design of the composition is laid in with incised lines, faintly visible around the outside of the figures. The gilded background features a trefoil border of *pastiglia*, or raised gesso molding, decorated with delicate punchwork. The paint is estimated to be egg tempera, but glazes are also evident. Flesh is underpainted with terre verte, visible in areas of shadow. The decoration of the wings and the garment of the angel as well as the bench cushion upon which the Virgin sits are developed with the technique of sgraffito. The forms are outlined in black paint. The paintings are well preserved, and while some abrasion is evident, the details of execution in the faces and the decorative patterns of the garments are intact. The Virgin's blue gown has darkened. The gold backgrounds reveal a degree of wear, as does the frame. VR

Jacopo Bellini

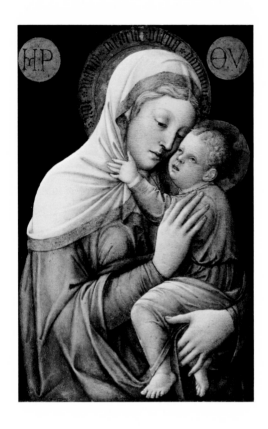

3

Virgin and Child

c. 1465
Oil on panel
69.7 x 47 cm (27⁷⁄₁₆ x 18½ in.)
Gift of the Ahmanson
Foundation
M.85.223
COLOR FIG. 11

INSCRIPTIONS
*In the roundels at upper left
and right:*
M.P; Θ.V
(for MHTHP ΘEO, Mother
of God)
On Mary's halo:
·AVE·MARIA·GRATIA·PLENA·
DOMINUS·TE[CUM]
(Hail Mary, full of grace, the
Lord [is] with you)

Jacopo Bellini is the literal or spiritual
father of the great painters of Renaissance
Venice, his sons Gentile and Giovanni,
his son-in-law Andrea Mantegna, and,
through Giovanni, Giorgione and Titian
(Eisler 1989a). He received at least some
of his training from the peripatetic Gentile
da Fabriano, to whom he may have been
apprenticed when the latter was in Venice
in 1408–14; in 1423 he was recorded in
Gentile's household in Florence. In Ferrara
in 1441 he bested Pisanello in a competition
for the commission for the portrait of the
ruler, Lionello d'Este. A probable meeting
at the court of Mantua with architect and

theoretician Leonbattista Alberti may have
inspired Jacopo's many remarkable draw-
ings, which display a rigorous investigation
of one-point perspective and the situation
of figures in space, as well as a fascination
with nature and themes from antiquity.
By 1452 Jacopo was back in Venice, where
he was awarded many public and private
commissions. The few extant paintings by
his hand (many of his early works are lost)
show at first the influence of his master
Gentile in their essentially Gothic emphasis
on grace, linearity, and decorative surface,
but his later works display an impressive
grasp of natural form and depth of feeling.

PROVENANCE
France, private collection.
Sale, Sotheby Parke Bernet,
 Monte Carlo, June 25, 1984,
 lot 3332.
Piero Corsini, New York.
Acquired by the Los Angeles
 County Museum of Art, 1985.

LITERATURE
Boskovits 1985, 123 n. 25.
Los Angeles Times, December 25,
 1985.
Burlington Magazine 128
 (March 1986): 244, fig. 66.
Avenues to Art 1, no. 3
 (April 1986): 19.
New York Times, December 7,
 1986, sec. 2, 1, 35.
Los Angeles 1986, 6.
Sutton 1986, 388, fig. 2.
Christiansen 1987, 171, 174,
 176–77, nn. 39–40, 47, pl. V.
Joannides 1987, 5, 20 n. 10, fig. 3.
Los Angeles 1987, 16.
Eisler 1989a, 69–70, 72, cover.
Eisler 1989b, 46, 56, 298, 514,
 fig. 41.
Conisbee/Levkoff/Rand 1991,
 cat. no. 38.

Venetians frequently commissioned or purchased this type of devotional panel of the Virgin and Child for their homes, as can be seen in views of interiors by contemporary artists such as Vittore Carpaccio. This lovely painting is an example of the range of influences on Jacopo and the other artists of early Renaissance Venice. Through trade and warfare Venice had always been in contact with Constantinople, and the heritage of Byzantine art can be seen in the blank background and the corner roundels in Greek identifying Mary as the Mother of God, reminiscent of eastern icons, as well as in the tenderness and slight melancholy shared by the prescient mother and child, a level of emotional content that was an important feature of later Byzantine paintings and mosaics. The sculptural quality and the poses of the figures, however, are related to contemporary Italian art, specifically to a group of relief sculptures executed around 1425 by Donatello (Conisbee/Levkoff/Rand 1991, 149–50, fig. 38a), which Jacopo must have seen while he was living in Florence. The date of the painting is in accord with a new period in Jacopo's career, distinguished by a richness and subtlety of color and form that would profoundly influence the work of his sons.

Conservation Notes

The panel is one piece of wood (⅜ of an inch thick, probably thinned) reinforced along the perimeter of the reverse with wood strips, which are later additions. Raised gesso on the left and right sides indicates that originally there was an engaged frame. The panel once had a strip added to the right side that was painted black to match the background, but the strip was removed before the painting came into the museum.

The gilding of the halos appears to be oil mordant gilding. It was applied after the figures were painted. The paint is estimated to be egg tempera and oil. Certainly the thin translucent paint on the surface is oil, but the flesh appears to be applied with the egg tempera technique of hatching.

There is overall abrasion, and the background has been restored. There is a flame burn below the nose of the Virgin. JF

Dario di Giovanni

VENETO, c. 1420–BEFORE 1498

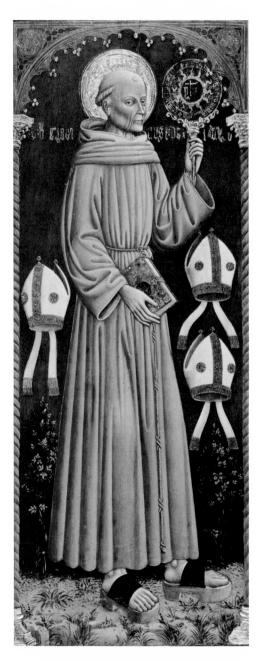

4

Saint Bernardino of Siena

c. 1470
Tempera on panel
179.1 x 71.8 cm (70½ x 28¼ in.)
Gift of Dr. Rudolph Heinemann
48.6
COLOR FIG. 10

INSCRIPTIONS
*On either side of the figure's
shoulders:*
BE[?]US[?]

Dario di Giovanni was born in Pordenone
and was a pupil of Francesco Squarcione in
Padua, for whom he worked from 1440 to
1446. Referred to in contemporary docu-
ments as a "pictor vagabundus" (wandering
painter), he spent his career in various
towns and cities of northern Italy, particu-
larly Treviso (hence his most common
appellation of Dario da Treviso) and Asolo,
where he probably worked for the exiled
queen of Cyprus, Caterina Cornaro; in
1456 he was called to the Doge's Palace in
Venice, although his work there is lost. His
painting shows the influence of Squarcione's
hard, linear style, but in composition,
color, and figure type it is also reminiscent
of the works of Venetians Jacopo Bellini
and Antonio Vivarini.

PROVENANCE
F. Kleinberger Galleries,
 New York, 1917–18.
Sale, F. Kleinberger, New York,
 January 23, 1918, lot 78.
Satinover Galleries, New York,
 1918.
Rudolph Heinemann,
 New York, until 1948.
Donated to the Los Angeles
 County Museum, 1948.

EXHIBITED
New York 1917, cat. no. 92.

LITERATURE
Valentiner 1948, 11–13, fig. 1.
Los Angeles 1950, 18, cat. no. 9.
Longhi 1954, 64.
Wescher 1954, cat. no. 13.
Berenson 1957, vol. I, 73.
Fredericksen/Zeri 1972, 63, 379,
 591.
Los Angeles 1987, 33.

Saint Bernardino (often, in English, Bernardine) was born to the noble Albizzeschi family in Siena in 1380; after nursing the sick during an outbreak of the plague, he joined the Franciscan Order in 1402. He spent his subsequent years preaching lively and often humorous sermons, criticizing greed and improper behavior and encouraging peace among feuding nobles. Despite the largely illegible inscription in this painting, Bernardino is easily identified by the disk he holds in his hand, which bears a flaming sun and the initials *yhs* (later usually *ihs*), the so-called sacred monogram, originally an abbreviation of the name Jesus in Greek (not *Iesus Hominum Salvator*, "Jesus savior of men," as was later thought). It was Bernardino's habit to invite his listeners to venerate the monogram as a symbol of the person of Christ, a practice that was in the eyes of some church authorities an idolatrous heresy, for which he was tried (and acquitted). The three bishop's miters represent his three refusals of the episcopal sees of Siena, Ferrara, and Urbino. He was canonized soon after his death in 1444.

This panel is possibly the left wing of an altarpiece, although individual figures of standing saints were also painted in this period, and it should be noted that the saint's attention is focused on the viewer and not toward a missing central element such as the Virgin and Child. Bernardino is depicted typically as a gaunt old man in a minimal, scrubby landscape suggesting the desert environment suitable to an ascetic.

The figure is very close to that of the saint in an altarpiece on canvas by Dario for the church of San Bernardino in Bassano (now in the Museo Civico, Bassano del Grappa; Bassano 1978, cat. no. 125), although the drapery of the Los Angeles panel is more stylized; both representations are related to a panel of about 1460 attributed to Jacopo and Gentile Bellini (private collection, New York; Christiansen 1987, 174–76, pl. VIII). Although Burton Fredericksen and Federigo Zeri suggested that the Los Angeles painting might be by another artist of the Veneto, details of the composition seem to confirm the attribution to Dario.

The use of raised areas of gesso covered by gold leaf, as here for elements of the disk and the architectural framework, was more popular in the earlier part of the century and suggests that Dario's patrons, who lived in the smaller cities of northern Italy, preferred a conservative, more traditional depiction of religious subject matter.

Conservation Notes

This painting has probably not been restored since the early part of the twentieth century. Since the background is abraded, it has been toned. The flesh and dress have survived fairly well. The panel once had an engaged frame. The raised edges of gesso along the perimeter of the panel are intact. The panel has been cradled. JF

Niccolò di Pietro Gerini

FLORENCE, ACTIVE 1368–1415/16

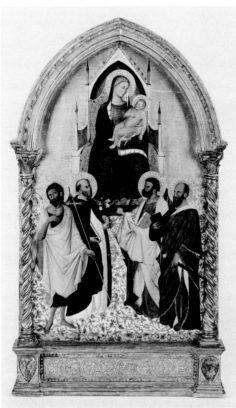

5

Virgin and Child with Saints John the Baptist, Dominic, Peter, and Paul

1375/85
Tempera on panel
81.3 x 49.5 cm (32 x 19½ in.)
Gift of Alexander M. and
Florence E. Bing
48.1

COLOR FIG. 9

When this painting was acquired by the museum in 1947, it was attributed to Andrea di Giusto and thereafter given to an anonymous Florentine of the later fourteenth century. As a result of careful observation and research during a recent restoration, paintings conservator Shelley Svoboda noted the similarity of the panel to many works attributed to Niccolò di Pietro Gerini, to whom it is now attributed.

Although Niccolò is traditionally thought to have studied with Taddeo Gaddi, documents suggest that he was apprenticed to Orcagna, which would explain his

decade-long (1370–80) professional association with Orcagna's youngest brother, Jacopo di Cione. Niccolò enrolled in the painters' guild of Florence as an independent master in 1368 and very soon received commissions for major altarpieces. He executed fresco cycles in Pisa and Prato as well as joining Gaddi in the fresco decoration of the enormous sacristy of Santa Croce in Florence.

His style is related to that of the Cione family, particularly Jacopo, but his oeuvre is characterized by a distinctive figure type: elongated bodies posed in Gothic curves but enveloped by substantial drapery falling in natural folds often generated by the gestures of the figures themselves. The faces of the men are dark and gaunt, the women of a more conventional loveliness. He also had a penchant for bright, unusual colors used in unexpected and striking combinations.

Gerini's workshop produced a large number of altarpieces; in this he was assisted by Lorenzo di Niccolò—probably not his son, as previously thought, but a pupil—and other young painters.

The saints in this small panel are easily identified by their clothing and attributes: the disheveled man in a skin tunic holding a reed cross is John the Baptist, patron saint of the city of Florence; next to him in a Dominican habit and holding a lily is

PROVENANCE
Private collection, Rome,
 before 1920 until at least 1925.
Private collection, France.
Alexander and Florence Bing
 collection, New York, until
 1947.
Donated to the Los Angeles
 County Museum, 1947
 (as Andrea di Giusto).

EXHIBITED
Vancouver 1953
 (as Andrea di Giusto).

LITERATURE
Van Marle 1923–36, vol. 9
 (1927), 244, 246, fig. 158
 (as Andrea di Giusto).
Los Angeles 1950, 18, cat. no. 7
 (as Andrea di Giusto).
Longhi 1954, 64.
Wescher 1954, cat. no. 9
 (as Andrea di Giusto).
Fredericksen/Zeri 1972, 218,
 317, 390, 412, 438, 441, 591
 (as Florentine).
Los Angeles 1987, 104
 (as Florentine).

Saint Dominic. On the other side of the Virgin and Child are the apostles Peter and Paul, often found together, the former identifiable by his keys ("of the kingdom"), the latter by his sword ("of the spirit"). Although we do not know the original location of this panel, we may surmise from the combination of saints that it was executed for a Dominican establishment in Florence, perhaps a chapel or altar dedicated to Peter and Paul in one of the city's churches. The cloth behind the standing saints is unusually elaborate in its figuration, including human figures rather than the more customary bird or animal motifs.

The works attributed to Niccolò display subtle stylistic variations, which may be explained by the artist's development or the participation of one or more workshop artists. Among the group of paintings that may be assigned to the hand that executed the Los Angeles panel are representations of the Virgin and Child with saints in the Baltimore Museum of Art, Denver Art Museum, and Philbrook Museum of Art, Tulsa; a predella panel of the *Adoration of the Magi* in the Gemäldegalerie, Berlin-Dahlem; and possibly a *Madonna and Child Enthroned with Four Saints and the Crucifixion* in the Yale University Art Gallery, currently attributed to the shop of Jacopo di Cione (Seymour 1970, cat. no. 29). The same hand appears in some larger works attributed to Jacopo, such as the *Coronation of the Virgin* in the National Gallery, London, suggesting that the Los Angeles panel was executed while Niccolò was working with Jacopo or shortly thereafter.

Conservation Notes

The structure of this painting survives fairly intact preserved in its original size and format. The support of the painting is formed by two peg-joined, 1 1/16 inches thick, vertically oriented wooden planks, upon which the engaged frame elements were added. Much of the frame has been redone, but the base is, for the most part, original. The sides and reverse of the panel were originally painted a terre-verte color.

Fabric and a thick white gesso cover the panel. An underdrawing, visible in some areas to the unaided eye, outlines the forms and drapery folds.

The gilding, over an orange bole, survives remarkably well. Relatively few and simple punches were used to create the elaborate designs, a hexagonal punch being the most common.

The paint appears to be tempera, oil, and resin. The elaborate designs of the floor and cloth of honor were created by scraping away white paint that had been applied over the gilding and then punching the exposed gold. A thick, orange-pigmented mordant was used to adhere gold detailing to the upper surface of the paint. The Virgin's robe is thinned and contains large losses. The panel's lower edge has been affected by what appears to be water damage.

A recent treatment involved the reduction of a thick, discolored varnish and darkened overpaint in addition to minor, local consolidation. A new varnish was applied, as was appropriate retouching. ss

Silvestro dei Gherarducci

FLORENCE, 1339–1399

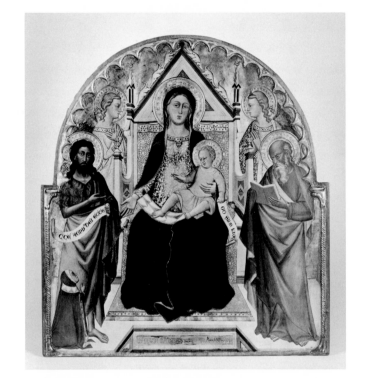

6

**Virgin and Child
Enthroned with Saints
John the Baptist and
John the Evangelist,
Angels, and a Donor**

c. 1375/85
Tempera on panel
82.6 x 78.1 cm (32½ x 30¾ in.)
Gift of the Samuel H. Kress
Foundation
M.39.1
COLOR FIG. 12

INSCRIPTIONS
*At left, on the scroll held by
John the Baptist:*
ECCE AGNU[S] DEI ECCE
(Behold the lamb of God behold)
*At right center, on the scroll held
by the Christ Child:*
[E]GO SUM LUX
(I am the light)
*At lower center, on the step below
the throne:*
S MARIA MATER D[EI] ORA
PRONOBIS
(Holy Mary mother of God pray
for us)

Silvestro dei Gherarducci entered the
Camaldolite community of Santa Maria
degli Angeli in Florence in 1347, at the age
of eight, and became a monk in 1352; a year
before his death he was elected prior of the
monastery. He was highly regarded primar-
ily as a painter of miniatures, some of which
are preserved in codices from the sup-
pressed monastery (now in the Biblioteca
Laurenziana, Florence), but he also executed
a number of larger paintings on panel.
Stylistically he was in the circle of Orcagna,
his brother Jacopo di Cione, and Giovanni
del Biondo, to whom his work was some-
times attributed. Gherarducci spent some
time in Siena, where he was influenced by
the more natural depiction of space that had
been pioneered by the Lorenzetti brothers.

Although the formula of the Virgin
and Child seated among saints and angels
is timeless, certain characteristics help to
locate this work in time and place. The
presence of John the Baptist in the place of
honor on the Virgin's right is common in
Florentine paintings, since he was the city's
patron saint, and the size of the painting
suggests that it served as the altarpiece for
a subsidiary chapel or altar in a Florentine
church. The other saint has no identifying
attribute but is probably John the Evangelist,
who is usually depicted as an older man
with a book and is often paired with the
Baptist. The latter exercises here his cus-
tomary role of *festaiuolo*, the "master of
ceremonies" so loved by the Florentines,

PROVENANCE
Contini Bonacossi, Florence,
 until 1937.
Samuel H. Kress, New York,
 1937–39.
Donated to the Los Angeles
 County Museum, 1939
 (as Giovanni del Biondo).

EXHIBITED
I. Magnin, Los Angeles/
 San Francisco, 1951.
Vancouver 1953
 (as Giovanni del Biondo).

LITERATURE
Frankfurter 1939, 10
 (as Giovanni del Biondo).
Feinblatt [1948?], 19
 (as Giovanni del Biondo).
Longhi 1954, 64.
Shorr 1954, 33, 37, fig. 5
 Florence 5 (as Master of the
 Cionesque *Humility*).
Wescher 1954, cat. no. 5
 (as Giovanni del Biondo).
Levi d'Ancona 1957, 21–22.
Berenson 1963, vol. 1, 86
 (as Giovanni del Biondo).
Shapley 1966, 38, cat. no. K1121,
 fig. 88 (as Florentine school,
 late fourteenth century).
Fredericksen/Zeri 1972, 82, 314,
 411, 418, 534, 591.
Boskovits 1975, 69, 217 n. 91,
 424, fig. 78.
Fremantle 1975, fig. 396.
Los Angeles 1987, 45.

who by gesture, gaze, and written word calls the attention of the viewer to the most important element of the composition, here, the "lamb of God," the Christ Child. Jesus bestows a blessing on the kneeling donor, who according to a medieval convention is shown in a smaller scale, and the Virgin extends a graceful hand toward the kneeling man while looking out at the viewer, perhaps to call our attention to the individual whose generosity made the altarpiece possible. From his garb the donor appears to be a civic official of some stature; from the choice of saints it is likely that his name was Giovanni, but he has not been further identified.

The heritage of Giotto and his followers can be seen in the natural fall of drapery and the suggestion of substantial form beneath the cloth; the influence of the Cione and Giovanni del Biondo is clear in the grace and rich color, while the successful location of the figures in space confirms the artist's knowledge of a type of natural perspective developed by the Sienese. While the altarpiece was in the Kress Collection, it was attributed by various scholars to the Florentine school around 1370/90; one artist specifically suggested was Giovanni del Biondo (or a follower). Mirella Levi d'Ancona first attributed the panel to Gherarducci on the basis of its stylistic similarity to a group of his miniatures. To be sure, it displays the bright colors and attention to decorative detail that are hallmarks of an illuminator.

Conservation Notes

The outer frame does not appear to be original, but the engaged, scalloped edges of the upper arch do seem consistent with the panel; they are created from shaped wooden pieces covered with gesso. The panel has been thinned and cradled. An aged split in the wood runs vertically through the Virgin's face; retouching in this area makes assessment of the original paint loss difficult. Canvas covers the panel's surface beneath the ground. The gilding remains quite intact. Sgraffito was used to decorate garments of the Virgin and the flanking angels as well as the cloth of honor. Deeper shadows of the robes were applied with glazes after the punching was done. With the exception of the glazes, the paint has the linear characteristic of egg tempera. Mordant gilding is present in all figures; in some areas the mordant is thick and pigmented and in others quite thin and transparent. There is abrasion in the areas of mordant gilding, the inscription of the foreground step, and the robe of the Virgin. The painting was surface-cleaned and revarnished in 1982. ss

Luca di Tommè

SIENA, ACTIVE 1356–89

7

Virgin and Child Enthroned with Saints Louis of Toulouse and Michael and Angels

c. 1356/61
Tempera on panel
55.2 x 26.7 cm (21¾ x 10½ in.)
Given anonymously
57.68
COLOR FIG. 36

For a summary of the life of Luca di Tommè and a discussion of his style, see pages 49–50.

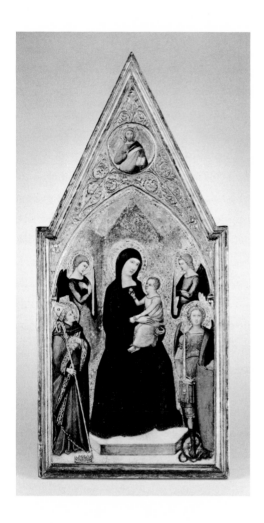

Small panels of the Virgin and Child with saints were used for private devotions in the home. Like an example by Luca of similar size in the Timken Art Gallery, San Diego (Timken 1983, cat. no. 19), this panel may have had wings, which would protect the painted surfaces when the owner was traveling. The patron would have selected saints for whom he or she had a special personal veneration, perhaps a name saint and a family patron. The young bishop saint on the left is Louis of

Toulouse (1274–1297), who was enormously popular in Italy. The great-nephew of Louis IX, the canonized king of France, the younger Louis renounced the throne of Naples and entered the Franciscan Order. Despite his desire for the simplicity of monastic life, he was consecrated bishop of Toulouse and is usually depicted in a sumptuous, jeweled cope and miter decorated with the fleur-de-lis, as here in the border, symbolizing his royal French blood. The crown he has rejected lies on the ground

PROVENANCE

Rosenberg and Stiebel,
New York, 1957.
Donated to the Los Angeles
County Museum, 1957
(as Ambrogio Lorenzetti).

LITERATURE

Gazette des Beaux-Arts 55
(January 1960): supp. p. 30,
fig. 103 (as Ambrogio
Lorenzetti).
Meiss 1963, 47–48, fig. 2.
Los Angeles 1965, 57.
Fehm 1970, 27–31, cat. no. 1.
Bolaffi 1972–76, vol. 7 (1975), 57.
Fredericksen/Zeri 1972, 113,
317, 355, 424, 433, 592.
Fehm 1973, 14, 16, 18–22, 27
n. 30, fig. 12.
Muller 1973, 12–21, figs. 1, 3–5.
Fehm 1976, 348 n. 31.
Zeri 1976, vol. 1, 41.
Fehm 1978, 159, 164 n. 17.
De Benedictis 1979, 87, fig. 69.
Maginnis 1980, 138 n. 32.
Fehm 1986, 8–9, 14–15, 20–21,
25, cat. no. 1, pl. 1.
Los Angeles 1987, 61.
London 1989–90, 12–14, fig. 1.

in front of him. The Archangel Michael, on the right, is represented in armor, the dragon under his feet a reference to his victorious campaign to expel Satan and his host from heaven (Michael's wings differentiate him from Saint George, who was also depicted in armor with a dragon). The blessing adult Christ in the roundel above, which calls to mind the multi-image large altarpieces of the period, provides another focus for the owner's devotions.

At the time of its donation to the museum the panel was attributed to Ambrogio Lorenzetti; soon afterward (1960), Gertrude Coor-Achenbach identified it as a work of Luca di Tommè (museum files). Luca's early style, of which this is an important and well-known example, is noted for its delicacy and charm of expression and pose; the softness and naturalism contrasts with the more hieratic imagery of his later, larger altarpieces (see CAT. NO. 8 and FIG. 35).

Conservation Notes

The support is a single piece of wood running vertically. It is prepared with cloth and gesso. The panel has been thinned and cradled, and the present frame is a replacement of an original engaged one. The panel has been decorated with gold leaf (punched and incised), sgraffito, mordant gilding, and gilded *pastiglia*. As in Luca's *Virgin and Child Enthroned with Saints Nicholas and Paul*, the Virgin's robe was almost completely incised before painting. The paint film has been abraded somewhat overall; the Virgin's blue mantle has lost much of the modeling, and the gold has been abraded as well. Nevertheless, forms read fairly well, and some paint on top of the gold, indicating the draped throne, still exists. VR

Luca di Tommè

SIENA, ACTIVE 1356–89

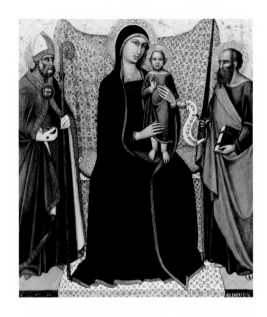

8

**Virgin and Child
Enthroned with Saints
Nicholas and Paul**

c. 1367/70
Tempera on panel
134 x 115.3 cm (52¾ x 45⅜ in.)
Gift of Samuel H. Kress
31.22
COLOR FIG. 35

INSCRIPTIONS
*On the scroll held by the
Christ Child:*
EGO·SUM·LVX·MVNDI
(I am the light of the world)
At lower left, beneath Nicholas:
....VS
At lower right, beneath Paul:
S. PAVLV...
(St. Paul)

*For a summary of the life of Luca
di Tommè, a discussion of his
style, and a detailed consideration
of this altarpiece, including conser-
vation information, see pages
49–61.*

PROVENANCE
Charles Fairfax Murray,
 Florence, by 1920 until 1929.
Contini Bonacossi, Rome, 1930.
Samuel H. Kress, New York,
 1930–31.
Donated to the Los Angeles
 County Museum, 1931.

EXHIBITED
Los Angeles 1944, cat. no. 3.
Claremont 1952–53.
Long Beach 1956.

LITERATURE
Perkins 1920, 292 n. 12.
Perkins 1929, 427.
*Los Angeles Museum Art News
 Bulletin*, May 1931, n.p.
Illustrated Daily News,
 May 13, 1931.
Los Angeles Times, May 13, 1931.
*Los Angeles Museum Art News
 Bulletin*, June 1931, n.p.
Antiquarian, June 1931, 39.
California Arts and Architecture,
 June 1931, 8.
Kress 1932–35, 5.
Feinblatt 1948[?], 18.
Longhi 1954, 64.
Wescher 1954, cat. no. 4.
Shapley 1966, vol. 1, 60, fig. 153.
Berenson 1968, vol. 1, 225.
Fehm 1970, 37, 137–38, no. 31.
Fredericksen/Zeri 1972, 113,
 318, 435, 438, 591.

Pisa 1972, 95.
Fehm 1973, 31 n. 35.
Muller 1973, 12, 15–16, 18–19;
 figs. 2, 7, 9.
Fehm 1976, 348 n. 32.
De Benedictis 1979, 87.
Siena 1979, 78.
Carli 1981, 227, fig. 258.
Fehm 1986, 41–42, 120–21,
 cat. no. 33.
Los Angeles 1987, 61.

Follower of Mariotto di Nardo

FLORENCE, ACTIVE 1394–1424

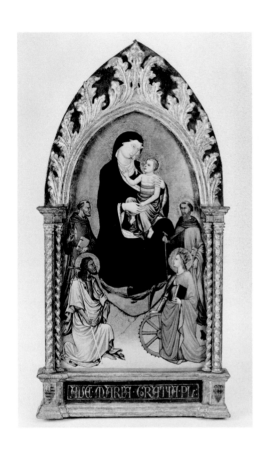

9

Virgin and Child with Saints Francis, John the Baptist, Catherine of Alexandria, and Anthony Abbot

c. 1420
Tempera on panel
86.4 x 50.2 cm (34 x 19¾ in.)
William Randolph Hearst Collection
48.5.7
COLOR FIG. 24

Mariotto was the son of a stonecutter named Nardo di Cione, not to be confused with the painter of the same name. His style has elements of the work of the earlier masters Niccolò di Pietro Gerini and Spinello Aretino; one tradition is that he was trained by Niccolò's follower Lorenzo di Niccolò. Mariotto's paintings display intensity and compositional unity that were novel for the time; probably for this reason he rapidly became the most sought-after painter in late-fourteenth- and early-fifteenth-century Florence. During his career he not only received commissions from important patrons in Tuscany but also was hired by the Malatesta rulers of Pesaro

to decorate their palace. A number of his documented works are lost, but many others can be attributed to his hand. Later in his career his treatment of forms and surfaces became overly fussy and lacked the grace and elegance of the popular late Gothic painters such as Lorenzo Monaco; his last, very conservative works were executed primarily for provincial churches.

Bernard Berenson (1930–31, 1300; 1970, 122) attributed this small altarpiece to a follower or copyist of Mariotto. The type of the affectionate infant Christ reaching toward his smiling mother is very common in the artist's oeuvre, but this group does not seem to be copied from the pose of any

extant autograph work; thus I believe it is more likely to have been executed by an assistant than a copyist. Hardness of contour, attenuation of figures, and excessive attention to surface detail—especially visible here in the mantle of John the Baptist—are hallmarks of Mariotto's later style, but the male faces and figures are not as skillfully rendered as in works by his hand. It is possible that the women, who display far more grace and mastery in their modeling than the men, are by another hand, perhaps that of Mariotto himself.

The Virgin appears to be seated on the ground and thus, despite her grandeur of scale, may be identified as a Virgin of Humility, an image that became popular in northern Italy in the fourteenth century. In contrast to the many representations of the Virgin ensconced in an elaborate, often architectural, throne, this type celebrated her humility—to the medieval church the root of all virtues—and emphasized the mystery of the Incarnation, the willingness of Christ to humble himself to become human.

Although John the Baptist is easily recognized by his appearance and cross and the fourth-century princess-savant Catherine of Alexandria by the wheel on which she was tortured, the two monastic figures have been misidentified in past literature. The plain brown robe slit to show a wound and the holes in the hands of the figure on the left easily identify him as Saint Francis of Assisi. The other monastic is the early desert hermit Anthony Abbot, who may be recognized by the tau cross he carries as a walking stick and by the creature to the lower right of the hem of his robe, which, although here resembling a frog, is meant to be the pig that traditionally accompanies him. The saints suggest that the panel was commissioned for a subsidiary altar in a Florentine Franciscan church or chapel; indeed, the humility of Christ was an important focus for the devotion of Francis and his followers.

PROVENANCE
Achille De Clemente.
Sale, American Art Association,
 New York, January 15, 1931,
 lot 495.
William Randolph Hearst,
 1931–48.
Donated to the Los Angeles
 County Museum, 1948.

LITERATURE
Salmi 1909, 179.
Berenson 1930–31, 1300, 1308.
Los Angeles 1950, 17, cat. no. 3.
Wescher 1954, cat. no. 6.
Berenson 1970, 122, fig. 204.
Fredericksen/Zeri 1972, 121,
 317, 371, 382, 395, 412, 591.
Los Angeles 1987, 64.

Conservation Notes

The panel is approximately 1½ inches thick and is constructed of two vertical planks glued together. Two lateral battens were once mounted to the back of the panel, fitted into channels cut into the wood, but these have since been removed. The upper half of the back of the panel displays extensive insect damage, and the whole of the back has been infused with wax. The bare wood around the front outer edges of the panel and raised gesso indicate there was once an engaged frame. Corners on either side indicate the shape of the small cornice pieces where the columns would have been attached. The present frame is a replacement.

The panel was prepared first with pieces of cloth glued over sections of the join to reinforce it and cover any flaws in the wood. On top of this there is a rather thick gesso layer. Incised lines fixed the image onto the ground. A faint underdrawing can be seen. The paint layer was applied after the background was gilded. The medium is estimated to be egg tempera; however, there is also evidence of glazes. Certain details such as the decorative borders of the garments were rendered in shell gold. Discolored remnants of what may be an original surface coating, possibly glair, exist in some areas of the foreground.

The paint was thinly applied, and, while generally well preserved, some abrasion exists. The coarsely ground blue azurite paint film of the Virgin's robe has darkened considerably. There is a large loss in the cloudlike forms under the Virgin. Glazes, particularly in areas of red and pink color in the garments of Saints John the Baptist and Catherine, are largely missing, and the shell gold, except for the hem of the Virgin's gown, has deteriorated. The painting was recently cleaned and restored. VR

Martino di Bartolomeo

SIENA, ACTIVE 1389–1434/35

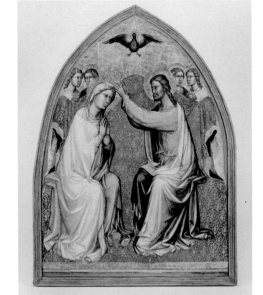

IO

Coronation of the Virgin

c. 1425
Tempera on panel
88.4 x 66 cm (34¹³/₁₆ x 26 in.)
William Randolph Hearst
Collection
49.17.6
COLOR FIG. 19

Martino was the son of the Sienese gold-smith Bartolomeo di Biagio. His first important works were executed outside his home city: miniatures in choir books in the cathedral in Lucca, after 1391, and a series of frescoes in San Giovanni Battista in Cascina, near Pisa, signed and dated 1398. He subsequently established himself in Pisa until 1405, and during his last few years there he collaborated with Giovanni di Pietro da Napoli on several altarpieces. When Martino returned to Siena he was given commissions in both the cathedral and the Palazzo Pubblico; he held a number of public offices and acquired a considerable amount of property. Besides his frescoes and panels, he is known to have applied polychrome decoration to many important wood sculptures, including an Annunciation group by Jacopo della Quercia. Although Martino's early style

was dry, he seems to have been influenced by the realism and volumetric modeling of the paintings of Giovanni di Pietro and of the sculpture he painted.

When the *Coronation of the Virgin* was acquired by the museum, it was surmounted by spandrels depicting worshiping angels; the *Coronation* panel had been expanded and an angel added at either side to accom-modate the spandrels. Despite the obvious differences in style and date between the two components, the pastiche was attrib-uted to the late-fourteenth-century Florentine Agnolo Gaddi. The spandrels were subsequently identified as the work of Ugolino di Nerio (see CAT. NO. 17), and in 1955 the *Coronation* was attributed to Martino by Philip Pouncey (written communication).

Although scenes of the crowned Virgin, either alone or with Christ, are known from the sixth century, the theme of the Coronation itself, depicting Mary's glorifi-cation in heaven by her son after her death and assumption, did not occur in literature or art until the twelfth century. It was a common subject in the early Renaissance, sometimes as an independent image and sometimes as one part of a complex altar-piece. In this panel the dove of the Holy Spirit hovers as Jesus crowns his mother with the triple tiara usually associated with a pope or emperor. Both these associations may have resonance here: as *Regina Coeli* (Queen of heaven) Mary certainly deserved a crown as elaborate as that

PROVENANCE
Private collection near Ludlow,
England, until 1948.
Sale, Christie's, London,
May 28, 1948, lot 114
(as Agnolo Gaddi).
Mallett, London, 1948.
William Randolph Hearst, 1949.
Donated to the Los Angeles
County Museum, 1949.

EXHIBITED
Vancouver 1953.
Riverside 1971.
Santa Barbara 1980–81.

LITERATURE
Los Angeles 1950, 17, cat. no. 2
(as Florentine).
Wescher 1954, 9 (as a
"minor Florentine master").
Coor-Achenbach 1955, 158 n. 24
(as Florentine).
Berenson 1968, vol. 1, 246,
pl. 439.
Fredericksen/Zeri 1972, 91, 122,
309, 592 (also attributed to
Giovanni di Pietro da Napoli).
Neri Lusanna 1981, 331, 338
n. 17, 339–40 n. 19, fig. 18.
Los Angeles 1987, 65.

of any mortal emperor, and as the personification of the Church she was linked by the tiara to the head of the Church on earth, the pope. It is usual for both Christ and the Virgin to wear elaborate mantles in the *Coronation*; here, the sumptuous cloth of honor is a backdrop for their plain robes, which may reflect the austerity of a monastic order for whose church the painting was commissioned.

Enrica Neri Lusanna cited an eighteenth-century Sienese manuscript by G. G. Carli describing an altarpiece, signed by Martino di Bartolomeo and dated 1425, in the church of Sant'Antonio in Fontebranda. The center of the altarpiece was a polychromed wood sculpture of the hermit saint Anthony Abbot (now in the church of San Domenico, Siena) by Francesco di Valdambrino, which had been painted by Martino. Above the niche containing the statue was a "bel Quadretto di Gesù Cristo, che corona la Vergine, con Angeli" (beautiful little painting of Jesus Christ crowning the Virgin, with angels). Neri Lusanna proposed that this was the panel now in Los Angeles. The date of 1425 would put it later in Martino's career than had previously been thought—it had been compared with frescoes of 1408—but the artist's conservative style and compositions make difficult the dating of his work after he had returned from Pisa. The natural fall of the drapery and the skillful modeling of extremely three-dimensional forms with light and shadow, however, suggest an awareness of significant artistic developments in the second and third decades of the fifteenth century.

Conservation Notes

The panel is approximately 1 inch thick and composed of three vertical planks joined by dowels, which are visible in an X-radiograph (FIG. 26). The panel was cut down; in fact, the shape of the arched top is slightly asymmetrical. The X-radiograph reveals that the upper corners have been removed, taking away some of the dowel on each side. The frame is a modern addition, consisting of wood strips nailed into the panel. The panel has a split through the central section and splits along one of the joins, which were repaired in a recent treatment.

The panel was prepared with scraps of cloth glued over joins or imperfections, and a rather thin gesso layer was applied over this. The design of the composition was transferred to the panel using incised lines and then drawing. The background is gilded, and the halos of the figures are tooled with simple punched designs. The paint medium is estimated to be egg tempera. While most colors are well preserved, the blue dove representing the Holy Spirit has darkened and the violet of the Virgin's robe has faded. The pattern of background drapery was created using the technique of sgraffito, and although there is evidence of the use of glazes here, little of it remains.

The painting received recent conservation treatment to remove discolored varnish and old restorations. VR

Master of the Bargello Judgment of Paris

FLORENCE, ACTIVE EARLY FIFTEENTH CENTURY

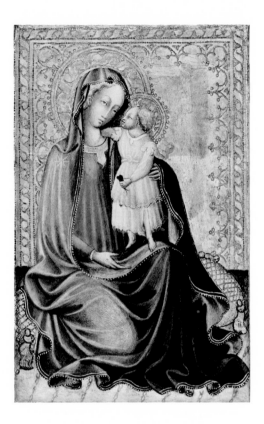

I I

Virgin of Humility

c. 1425
Tempera on panel
26.7 x 17.1 cm (10½ x 6¾ in.)
Gift of Robert Lehman
47.11.1
COLOR FIG. 16

This painting was originally attributed to the so-called Master of the Innocenti *Coronation* (later called the Master of the Straus *Madonna*), a follower of Lorenzo Monaco active in Florence around 1430–40. In 1954 Roberto Longhi reattributed the panel to the Master of the Bargello *Judgment of Paris*, a northern Italian artist active in Tuscany; the artist is also known as the Master of the Carrand Tondo, since the above-mentioned *Judgment of Paris* is a tondo in the Bargello's Collezione Carrand (Fremantle 1975, cat. no. 1270). An attempt to identify this artist as Cecchino da Verona, known to have been working in Siena in 1432, has not produced sufficient evidence.

The Virgin seated on a cushion on the ground emphasizes the humility of the young mother (see CAT. NO. 9); the star on the right shoulder of her mantle refers to her title *Stella Maris* (Star of the sea). Her elaborately dressed little son reaches up with his right arm to embrace her neck; in his left hand he clutches a goldfinch, a bird with complex associations. At the simplest level, the goldfinch was a favorite children's pet; it also symbolized, as did any bird, the soul released by death from its imprisonment in the body, a pagan symbol appropriated by the early Christians.

PROVENANCE
H. Wendland estate, Paris.
Robert Lehman, New York,
 until 1947.
Donated to the Los Angeles
 County Museum, 1947.

EXHIBITED
Long Beach 1956.
Santa Ana 1957–58.

LITERATURE
Feinblatt [1948?], 20–21
 (as Master of the Innocenti
 Coronation).
Los Angeles 1950, 18, cat. no. 5
 (as Master of the Innocenti
 Coronation).
Longhi 1954, 64.
Wescher 1954, cat. no. 11
 (as Master of the Innocenti
 Coronation).
Fredericksen/Zeri 1972, 126,
 331, 591.
Los Angeles 1987, 66.

Finally, according to legend, a finch had swooped to pull a thorn from the brow of the crucified Christ and was splashed with a drop of his blood; from that day every finch bore this red spot. The appearance of the bird in the hand of the infant Christ thus served as a reminder of his inevitable Passion.

Because of its small size and the absence of accompanying saints, this painting may have been a "ready-made" panel produced without commission for the open market. In its execution, however, it is certainly superior to the works of the so-called *madonnieri*, mediocre artists who turned out devotional images of the Virgin and Child for those not wealthy enough to commission a master. The artist's grace and delicacy identifies him as a late proponent of the International Gothic style epitomized earlier in Florence by Lorenzo Monaco; the fluid, looping drapery folds and the method of highlighting are particularly close to Lorenzo's manner. Among the Master's contemporaries, he is closest to Masolino and Giovanni dal Ponte. A *Virgin and Child Enthroned* formerly in the collection of Samuel Courtauld, London, is by the same hand, and a *Virgin and Child Enthroned with Saints Peter Martyr and Francis* in the Fogg Art Museum, Harvard University, displays many stylistic similarities.

Conservation Notes

This panel is a vertically oriented plank of wood that has been cradled. The engaged frame is most probably not original. The panel itself remains in very good condition, as do the areas of paint and gilding. The intricate designs in the background punchwork appear to be the result of two punching tools, one consisting of a single dot and the other a circle of six dots. The forms are inscribed where the paint abuts the gold ground. Some underdrawing is visible to the unaided eye, notably in the figure of Christ. The very linear paint application would appear to be consistent with egg tempera; it is exceptionally well preserved. Paint in the flesh areas remains thick, retaining its original three-dimensional modeling. Black line-work delineates the gilt cushion under the Virgin; this is lightly abraded. A thin area of paint loss exists along the lower edge. Fairly extensive and well-preserved mordant gilding details the garments of the figures; a thin and transparent mordant was used. The painting was cleaned in 1980. JF

Master of the Fiesole Epiphany

FLORENCE, ACTIVE c. 1480–1500

12

Christ on the Cross with Saints Vincent Ferrer, John the Baptist, Mark, and Antoninus

c. 1491/95
Tempera and possibly oil
on panel
186.1 x 203.8 cm (73¼ x 80¼ in.)
Gift of the Ahmanson
Foundation
M.91.242
COLOR FIG. 45

INSCRIPTIONS
*On the book held by Saint
Vincent Ferrer:*
TI[M]ETE DEVM QVIA VENIT
HORA IVDITIJ EIVS.
(Fear God, for the hour of his
judgment has come)
*On the scroll held by John
the Baptist:*
ECCE AGNVS DEI ECCE QVI...
(Behold the Lamb of God,
behold [him] who...)

*For a detailed consideration of
this altarpiece, especially its
iconography and original location,
a discussion of the possible identity
of the Master of the Fiesole
Epiphany, and conservation
information, see pages 63–86.*

PROVENANCE
San Marco, Florence,
 until c. 1582.
Compagnia della Santa Croce,
 parish of San Michele
 Bisdomini, Florence, until
 after 1736.
Edward Solly; sale,
 Christie & Manson, London,
 May 8, 1847, lot 13.
W. Fuller Maitland,
 Stansted House, Essex, by
 1854; sale, Christie, Manson &
 Woods, London, July 14,
 1922, lot 69 (1,650 guineas).
Leopold Hirsch, London;
 sale, Christie, Manson &
 Woods, London, May 11,
 1934, lot 132 (280 guineas).
J. Howard.
Francis Howard, Mignano,
 by 1943.
Private collection.
Acquired by the Los Angeles
 County Museum of Art, 1991.

EXHIBITED
Manchester 1857, no. 68.
London 1875, no. 181.
London 1893–94, no. 71.

LITERATURE
Del Migliore 1684, 217.
Loddi 1736, 269.
Richa 1754–62, vol. 7 (1758),
 139.
Waagen 1854, vol. 3, 4.
Crowe/Cavalcaselle 1864–66,
 vol. 2 (1864), 524.
Vasari 1878–85, vol. 3, 187 n. 2.
Crowe/Cavalcaselle 1903–14,
 vol. 4 (1911), 370.
Künstler-Lexikon 1904–14,
 vol. 15 (1910), 184.
Reinach 1905–23, vol. 1 (1905),
 no. 435.
Vasari 1906, vol. 3, 187 n. 3.
Crowe/Cavalcaselle 1908–9,
 vol. 2 (1909), 492.
Crutwell 1908, 145.
Kunstchronik 33 (1921–22), 780.

Van Marle 1923–36, vol. 11
 (1929), 613–14 n. 3.
Colnaghi [1928], 233.
Art Prices Current, n.s. 13, August
 1933–August 1934, no. 4840.
Carfax 1934, 182, 184–85.
Gronau 1935, 35.
Paatz 1940–54, vol. 3 (1952),
 45, 80 n. 273.
San Miniato 1959, 56.
Bacci 1966, 97.
Vasari 1966–84, vol. 3, 444.
Pigler 1968, vol. 1, 541.
Shoemaker 1975, 314.
Bénézit 1976, vol. 9, 100.
Teubner 1979, 257 n. 56.
Padoa Rizzo 1989, 17–24, fig. 1.

Neri di Bicci

FLORENCE, 1419–1492

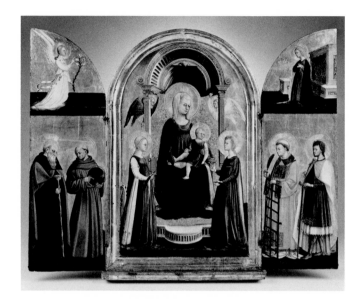

I3

Virgin and Child Enthroned with Saints and the Annunciation (triptych)

c. 1440/50
Tempera on panel
73.5 x 89 cm open (28¹⁵⁄₁₆ x 35 in.)
Gift of Varya and Hans Cohn in honor of the museum's twenty-fifth anniversary
M.91.15
COLOR FIG. 17

Neri di Bicci, the son and grandson of painters Bicci di Lorenzo and Lorenzo di Bicci, was an enormously prolific artist in Florence in the third quarter of the fifteenth century. Trained at first by his father, Neri was most certainly influenced by Fra Angelico. Although art historians have also claimed to see the impact on Neri of the work of many of the major artists working in Florence at mid-century, Neri's style is actually quite distinctive and recognizable. At its best, as in this triptych, it is graceful, well drawn, and beautifully colored; it can also be unoriginal and awkward. The *retardataire* quality of his work is often noted, but it is clear from his many commissions and financial success that there was a large segment of the population that preferred religious paintings of a conservative type. Neri's *Libro di ricordanze* (journal) for the years 1453–75, which preserves a wealth of information about an artist's life and

practices, indicates, for example, that a surprising number of patrons requested a supposedly archaic gold ground.

The Los Angeles triptych is small enough to have been easily portable; it could even be taken on journeys for its owner's private devotions. Although the floral decoration of the outer wings (see FIG. 7) was heavily repainted in the seventeenth or eighteenth century, probably because of wear, the closed wings kept the interior surface in excellent condition.

The Virgin and Child sit on a niche-like throne that demonstrates a knowledge of the classical vocabulary of early Renaissance architecture. The inverted scallop shell above the Virgin's head, frequently perceived as an attribute of Venus, was appropriated by humanists for the immaculately conceived Virgin and appeared in many paintings by Neri and

other artists. The whole construction forms a canopy over the mother and child, a parallel to the baldachin that would protect an altar and the consecrated host (the altar and host are symbols of Mary and Jesus, respectively). The Christ Child, holding a pear, emblematic of his love for the world, twists to look at Saint Lucy, a third-century Sicilian maiden carrying an oil lamp (her name is derived from the Latin *lux*, "light"); her counterpart is the fourth-century princess Catherine of Alexandria with the iron-studded wheel on which she was to be tortured. Both young women lost their lives because they refused to give up their religion, thus they carry the palm of martyrdom.

On the left wing are the desert hermit Anthony Abbot with his tau-cross walking stick and his little pig (see CAT. NO. 9) and the Franciscan preacher Bernardino of Siena with a disk inscribed with the monogram of Christ (see CAT. NO. 4). On the right wing is Lawrence, a third-century deacon martyred not so much for his faith as for his distribution of the wealth of the church to the poor instead of turning it over to the civil authorities. He can be recognized by his dalmatic (the traditional vestment of the deacon) and the gridiron on which he was roasted to death. The saint at the far right has been previously mistaken for Paul or Proculus; his long sword, youth, and elegant dress identify him as Julian the Hospitaler, a wealthy young man who accidentally killed his parents and atoned for his sin by a lifetime of caring for travelers, particularly those who were ill or in trouble.

The scene of the Annunciation, here divided between the two wings, was often represented in a split format in altarpieces (see CAT. NOS. 1–2); the distance gave resonance to the concept of the Holy Spirit traveling from the Father to accomplish the conception of the Son.

PROVENANCE

King Frederick William IV of
 Prussia (reigned 1840–61).
Count Ingenheim, Silesia.
Art market, Munich, c. 1925/26.
A. S. Drey, New York, by 1932.
Rosenberg and Stiebel,
 New York, until 1945.
Varya and Hans Cohn,
 Los Angeles, 1945–91.
Donated to the Los Angeles
 County Museum of Art, 1991.

EXHIBITED

Los Angeles County Museum
 of Art, 1957.
Santa Barbara 1980–81,
 cat. no. 23, pl. VII.
Los Angeles 1990–91.

LITERATURE

Van Marle 1923–36, vol. 10
 (1928), 543.
Burrows 1931, 109, 111.
Morsell 1932, 9.
Drey 1933, 66–67.
Die Weltkunst, December 18,
 1938.
Cohn 1991, 310–11.

The figure types, their grace and small scale, are reminiscent of the style of Neri's father, and this is certainly an early work. Neri painted several hundred small devotional paintings during his career, some of which were "ready-made" panels sent to dealers in Rome and the Marches. A small altarpiece with six saints, however, would certainly have been a commission from a specific patron who venerated those individuals. Although it is not possible to determine for whom the triptych was painted, the saints on the right wing bear names very popular among the Medici family—in Italian, Lorenzo and Giuliano.

Conservation Notes

The condition of the triptych is very good, and the support has never been thinned. Each section is constructed of only one plank of wood; the central panel is surrounded with an engaged molding. The gold leaf, punched and inscribed, is in an excellent state.

Paint layers have fared quite well. The azurite blue robe of the Virgin has been damaged, however, and the floor of each scene, a mixture containing green verditer, has turned brown. The dresses of Saint Lucy and the Christ Child, primarily green verditer, are now dull. The disk held by Saint Bernardino of Siena has been much damaged. The cloth behind the Virgin was probably once glazed with color. The outer surface of the wings was later painted with a marble pattern, which covered the original floral design. This earlier design has been uncovered and restored. The painting itself was recently cleaned and restored. JF

Paolo Veneziano
VENICE, ACTIVE c. 1333–BEFORE 1362

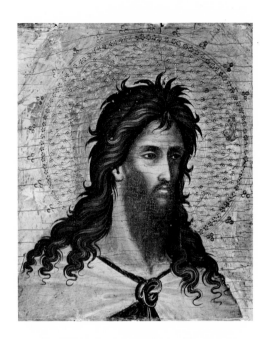

14

Saint John the Baptist
(fragment)
c. 1355/60
Tempera on panel
21 x 17.8 cm (8¼ x 7 in.)
Gift of Robert Lehman
47.11.2
COLOR FIG. 2

Paolo Veneziano is the founder of a distinctly Venetian school of painting; his followers included his sons Luca and Giovanni and his pupil Lorenzo, to whom many of his works were once attributed. Paolo's earliest dated work is an altarpiece of 1333 for the church of San Lorenzo in Vicenza, and his latest is a *Coronation of the Virgin* of 1358, signed with his son Giovanni (Frick Collection, New York). In 1345 he and his sons painted an altarpiece depicting scenes from the life of Saint Mark as a ferial cover for the Pala d'Oro, the spectacular gold altar in the basilica of San Marco, and he was also commissioned to execute an altarpiece, now lost, in the Doge's Palace.

Several of Paolo's extant works are large, double- or triple-registered polyptychs with many full- or half-length figures of saints flanking a central image. This small panel is probably a fragment from one such dismantled and unknown polyptych. Even in a bust-length format John the Baptist is recognizable by his unkempt hair, untrimmed beard, and tunic of skins visible under his mantle. Both the facial type and manner of painting demonstrate the extraordinarily strong influence in Venice of Byzantine art. The punchwork in the halo—groups of three circles connected by fine, scrolling tendrils—is a hallmark of Paolo's workshop; the sinuous grace of this motif and the calligraphic energy of the individual curls of hair are reminders of the Gothic taste that gave Paolo's work a quality distinct from much Italo-Byzantine art.

PROVENANCE
Robert Lehman, New York,
 until 1947.
Donated to the Los Angeles
 County Museum, 1947.

LITERATURE
Venturi 1945, 11.
Feinblatt [1948?], 19
 (as Lorenzo Veneziano).
Los Angeles 1950, 17, cat. no. A1
 (as Lorenzo Veneziano).
Di Carpegna 1951, 65 n. 7.
Wescher 1954, cat. no. 2.
Berenson 1957, vol. 1, 128, pl. 7.
Pallucchini 1964, 51.
Muraro 1970, 63, 113, fig. 44
 (as "workshop of
 Paolo da Venezia").
Fredericksen/Zeri 1972, 158,
 411, 591.
Los Angeles 1987, 75.

John the Baptist is prominent among the saints in several of the artist's largest polyptychs, such as that in San Giacomo Maggiore, Bologna, and another in the Pinacoteca of San Severino, where he occupies a position close to the central image. The Los Angeles panel is most similar to the full-length figure of the Baptist in a group of four saints once attributed to Lorenzo, now in the Pinacoteca in Brescia, and to another full-length Baptist from a disassembled altarpiece, now in the Yale University Art Gallery. The face of Christ in the Frick *Coronation* of 1358 provides the closest stylistic similarities to the Los Angeles panel, a circumstance that suggests a date close to the end of Paolo's life.

Conservation Notes

This panel is a fragment from a larger composition. The wooden panel is split vertically with the grain direction, just left of the head. The upper-left corner has lost bole and gilding, exposing the gesso below. The gilding, which is fairly well preserved, carries delicate inscribed lines and punchwork for the halo. The paint survives well also and appears to be egg tempera. The robe is decorated with mordant gilding. The mordant for the gilding is quite thin and transparent. ss

Bernardo Rosselli

FLORENCE, 1450–1526

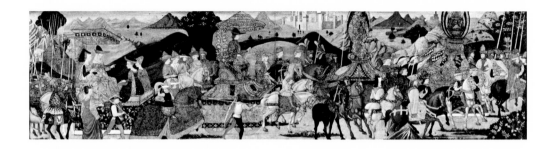

15

The Triumph of Alexander the Great

c. 1485
Tempera on panel
42.9 x 155.3 cm (16⅞ x 61⅛ in.)
Phil Berg Collection
M.71.73.371
COLOR FIG. 14

This detached panel from a *cassone*, an elaborate linen or clothes chest that was a traditional betrothal or marriage gift in Renaissance Italy, has been attributed to several artists. Bernard Berenson (verbal communication) assigned it to a painter to whom he had given the name of Master of the Jarves *Cassoni*, referring to several similar panels in the collection of James Jackson Jarves, Florence (now in the Yale University Art Gallery), and suggested that the artist was in the workshop of Domenico Veneziano. Other art historians speculated that the Master might be identified with Apollonio di Giovanni, a Florentine artist who, with Marco del Buono, had a thriving workshop that specialized in the production of *cassone* and other decorative panels. Everett Fahy renamed him the Master of the Whittemore *Madonna*, after a work in the Fogg Art Museum, Harvard University, and later attributed much of the artist's work,

including the Los Angeles panel, to Bernardo di Stefano Rosselli, one of the many Florentine artists trained in the workshop of Neri di Bicci. He was employed on the decoration of the Sala de' Signori in the Palazzo Vecchio between 1488 and 1490. Whoever the artist, his was a hand suited for such decorative painting: he lavished far more attention on the armor, costumes, and trappings than on the figures, their faces, or the landscape.

The theme of the triumph was based on ancient Roman processions awarded to victorious generals. The artists of the fifteenth century utilized the theme to flatter a contemporary ruler, praise a virtuous hero of the past, or, most popularly, present an allegory of such concepts as Love, Chastity, Fame, or Death, inspired by the fourteenth-century *Trionfi* of the poet Petrarch. In composition many of these scenes are reminiscent of Greek and Roman

PROVENANCE
Harold I. Pratt, New York.
Wildenstein & Company,
 New York, by 1947.
Phil Berg, Los Angeles.
Donated to the Los Angeles
 County Museum of Art, 1971
 (as Master of the Jarves
 Cassoni).

EXHIBITED
New York 1947, cat. no. 9
 (as Master of the Jarves
 Cassoni).
Los Angeles 1971, cat. no. 298
 (as Master of the Jarves
 Cassoni).

LITERATURE
New York Times, January 19, 1947.
Los Angeles 1987, 68
 (as Master of the Whittemore
 Madonna).

relief carvings of processions; the Los Angeles panel is no exception: other than a column of soldiers coming from the left background, the action is parallel to the picture plane and very much in the foreground.

There are several *cassone* panels that illustrate the same scene as the Los Angeles panel: a procession of men and women on foot and on horseback, some wearing armor, others sumptuous clothing, headed by an altar with its sacred fire, followed by a statue of a winged deity, a man seated on a triumphal car in solitary splendor, and finally a cart in which most or all of the passengers are women. Fortunately, in the panel that was recorded in 1923 in the possession of Conte Carlo Cinughi of Siena (Schubring 1923, cat. nos. 158–59), the major elements bore inscriptions: the altar is SACRIFICIUM (sacrifice), the statue APPOLLO [sic], the distinguished older man DARI REX (King Darius), and the two women MATER ET USOR DARI (Mother and wife of Darius). Although there are three Persian kings named Darius, this one is probably Darius Kodomannos, who was defeated by Alexander the Great at the battle of Issus in 333 B.C.; the battle itself was a popular theme for *cassone* panels.

While the Cinughi panel may depict the procession of Darius to the battlefield, the Los Angeles panel is considerably different. The statue is not the lyre-playing Apollo, the solitary man is extremely young, and there are four women in the cart. This last element provides a clue:

during the battle of Issus the wounded Darius fled the field, leaving his mother, wife, and two daughters to the mercy of the victor, who treated them with honor and courtesy, an incident that was often recounted as proof of Alexander's high moral principles. Although the Los Angeles panel has long been titled *The Triumph of Darius*, the scene is probably the triumph of the young Alexander, with his four noble hostages shown riding behind him in the elegance merited by their royal blood. Such scenes, however, were not meant to be historically accurate but to capture the color and magnificence of a ceremonial occasion and to delight the eye with its splendor and variety.

There remains the problem of the identity of the statue, a winged figure in armor standing on a dragon, at right of center, who would appear to be the archangel Michael. If an angel seems out of place in a "pagan" triumph, it should be noted that angels, in the role of divine messengers or agents, were common to all ancient religions. In fact, Michael had his origins in Persian religion, which recognized gods of light and of darkness; in his struggle with Satan (the dragon) Michael represented the victory of the forces of light.

Conservation Notes

The panel measures approximately 1⅛ inches in thickness. At some point it was cut in half and subsequently rejoined and reinforced with additions on the back. Original pegged wooden inserts exist along two rows in the panel, and while it is uncertain what purpose they would have served, it is assumed that the pegs functioned as part of the internal structure of the chest. The additions on the back of the panel included a layer of wood veneer and a wooden cradle. Neither of these additions was warranted, and they were in fact causing paint to flake; they have been removed. Strips of frame molding that had been glued and nailed to the edges of the panel at a later date were also removed. A margin of bare wood around the edges of the panel marks where the actual engaged frame of the chest would have been attached. Part of the keyhole of the chest is also visible, located at the top center. The panel has a slight outward bow, and the X-radiograph reveals several minor splits in the wood.

The thick gesso layer was applied directly to the wood. Incised lines on the surface indicate that the complex design of the composition was transferred to the panel from a cartoon. The paint layer appears to be egg tempera that was thinly applied, and there is evidence that glazes were also employed. Gold and silver leaf were used extensively. The small figures were painted delicately in detail, and outlines were used to strengthen the forms.

The paint layer is in good condition but shows an expected degree of miscellaneous damage related to the *cassone*'s utilitarian use. While many of the faces and details of the landscape are well preserved, the silver leaf is now largely missing and the gold is extensively abraded.

Recently, areas of lifting paint were consolidated, and the painting was cleaned and restored. The wood support was also treated to mend cracks. VR

Gherardo di Jacopo di Neri Starnina

FLORENCE, ACTIVE 1378–1409/13

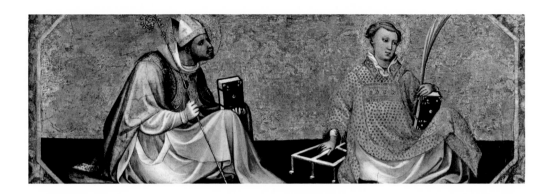

16

**A Bishop Saint and Saint
Lawrence** (predella panel)
c. 1404/7
Tempera on panel
16.5 x 42.5 cm (6½ x 16¾ in.)
Gift of Dr. Ernest Tross
47.23
COLOR FIG. 6

Starnina was possibly trained in the work-shop of Agnolo Gaddi; he joined the painters' guild in 1387. He spent more than five years in Spain, working in Toledo around 1395 and then moving to Valencia sometime before July 1398. He returned to Florence after the middle of 1401. In 1404 he completed the fresco decoration of a chapel in Santa Maria del Carmine, and in 1409 he was commissioned to execute frescoes in the Confraternity of the Annunciation in Empoli; extant fragments of these two cycles are the only works that can be documented as by his hand. Art historians have sought to reconstruct his oeuvre from among works attributed to Agnolo Gaddi and his school and a group of paintings still in Toledo. There is still some debate as to whether the stylistically similar Master of the Bambino Vispo ("lively child," after his energetic infant Christ) was a Spanish collaborator of Starnina's (perhaps Miguel Alcañiz) or in fact the artist himself, the latter view being now generally accepted. Starnina also had a definite stylistic affinity with Lorenzo Monaco, as can be seen in his graceful

curves of drapery (reminiscent also of the work of Lorenzo Ghiberti), intense colors, and brilliant white highlighting.

This panel is the left section of a pre-della that formed the base for an altarpiece. The third-century saint Lawrence can be easily identified at the right by his dalmatic (the traditional vestment of a deacon), his palm of martyrdom, and the gridiron on which he was killed (see CAT. NO. 13). Various attempts to identify the bishop saint on the left have not been conclusive. Bernard Berenson called him Augustine, which was a common (and often erro-neous) assumption when a bishop had no specific attributes. In the early literature he was identified as Bishop Sixtus II of Rome, who was martyred a few days before Lawrence, his deacon, but the figure is without a palm branch, and Sixtus was nor-mally depicted wearing the papal tiara, since as bishop of Rome, he was in fact the pope. Cornelia Syre suggested he was Hugh of Lincoln (1140–1200), because of his garb, which she believed is Carthusian, and because that saint was on the right wing of an altarpiece by Starnina dedicated

to Saint Lawrence, once in the cathedral of Florence and now dispersed among several museums. Although Wescher suggested that the predella was from that disassembled altar, the original predella was later located in the Colonna collection in Rome; this predella would have been too long for the extant altarpiece. Most recent are suggestions (Chiarelli 1984, vol. 1, 93) that the bishop is Hugh of Grenoble (1052–1132), a friend and advisor of Saint Bruno, the founder of the Carthusian order, and that the predella was part of a polyptych on one of the side altars of the Certosa (Carthusian monastery) of Galluzzo, outside Florence (Vasari 1906, vol. 1, 506–7).[*]

Fortunately, although the predella was cut in three sections, the other two are extant and identifiable. The center panel, recorded in a private collection in Paris, depicts the dead Christ held upright in the tomb by an angel, flanked by seated figures of the weeping Virgin and the mourning Saint John (Berenson 1970, 146–47, fig. 254). Roberto Longhi (1939–40, 184) believed it was by a Spanish assistant; as Burton Fredericksen noted (museum files), "Its quality is somewhat lower than that of the other two parts, and it seems perhaps also closer to the Valencian tradition."

The right section of the predella, currently on the art market, depicts another easily recognizable deacon saint, Stephen, the first Christian to be martyred for his faith, carrying the stones that caused his death. Accompanying him is an unidentified monastic saint in white robes that may denote a Benedictine, Camaldolite, or Carthusian; his identification in an auction catalogue (Christie's, New York, November 4, 1986, lot 189) as Bruno, the founder of the Carthusian order, is certainly plausible and would suggest that the Los Angeles bishop is indeed his friend Hugh of Grenoble.

An interesting reference to the predella is found in an album of drawings (Biblioteca Ambrosiana, Milan, vol. F.214 inf.), almost all of which are copies from the later 1430s of contemporary works of art or antiquities in Italy; the sheets are by various artists in the circle of Gentile da Fabriano and Pisanello. On one sheet are copies of all the figures from the center panel of the predella and the Saint Lawrence from the Los Angeles panel (Schmitt 1968, pl. LXII no. 1 and pl. LXIII no. 3); Annegrit

PROVENANCE
Contessa Barberini, Florence.
Dr. Ernest Tross, Denver and
 Los Angeles, until 1947.
Donated to the Los Angeles
 County Museum, 1947.

LITERATURE
Feinblatt [1948?], 21.
Los Angeles 1950, 18, cat. no. 4.
Longhi 1954, 64.
Wescher 1954, cat. no. 10.
Berenson 1963, vol. 1, 140,
 pl. 472.
Schmitt 1968, 119, 121, pl. LXIII
 no. 4.
Fredericksen/Zeri 1972, 125,
 422, 591.
Frinta 1973, 361.
Syre 1979, 83–88, fig. 106.
Chiarelli 1984, vol. 1, 93.
Los Angeles 1987, 92.
Boskovits 1988, 26, 30, 48 n. 68,
 fig. 25.
Lurie 1989, 373, no. 9A.

Schmitt attributed this sheet to Pisanello himself, although that is not unanimously accepted. As Fredericksen pointed out (museum files), the existence of this sheet suggests that the predella was in Italy, probably in Florence, the location of most of the other works copied in the album, and that it was part of a work important enough to be prominently displayed.

There are other works by Starnina that show an interest in the deacon saints: a panel with Stephen and Lawrence was recorded in the Maitland Griggs collection, New York (Van Marle 1923–36, vol. 9 [1927], 192, 198), and two altarpiece wings depicting Stephen and the deacon Vincent of Saragossa are in the Museum of Fine Arts, Boston (Murphy 1985, 179). The left wing of the disassembled Saint Lawrence altarpiece mentioned above, with Lawrence, Mary Magdalen, and the donor, Cardinal Accaiuoli, is in the Bodemuseum, Berlin.

I am grateful to Luisa Morozzi for bringing this information to my attention.

Conservation Notes

The panel is constructed from a horizontally oriented plank of wood that is approximately 9/16 of an inch thick. The composition remains intact; it is bordered on the top and bottom edges with the raised gesso of a now-missing engaged frame. The left and right sides are bordered with remnants of *pastiglia*. The panel has never been cradled or thinned.

The basic composition was placed onto the panel with a light, inscribed line. Gold leaf covers much of the panel's surface, including the background; it forms the base of Saint Lawrence's robe and is covered there by a transparent glaze. The decorative trim on the garments of the bishop saint are done with mordant gilding. Though the gold of the background is noticeably disturbed by abrasion, that in the saints' garments survives very well. The paint appears to be egg tempera; it is in very good condition with no sizable losses in the figures. Gold details on the surfaces of the figures were adhered by thick mordants of differing hues; they also remain in good condition. ss

Ugolino di Nerio
SIENA, ACTIVE 1317– c. 1327

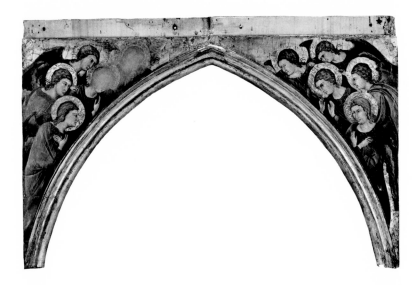

17

Worshiping Angels

c. 1320/25
Tempera on panel
44.5 x 74.9 cm (17½ x 29½ in.)
William Randolph Hearst
Collection
49.17.40
COLOR FIG. 21

Ugolino was the son and brother of Sienese painters, whom he surpassed in fame to the point of being commissioned to execute the high altarpiece of the great Franciscan church of Santa Croce in the rival city of Florence, where he also apparently worked in Orsanmichele and Santa Maria Novella. He returned to his native city in the later 1320s; the last reference to him in documents is in 1327, but he seems to have lived some time after that, possibly until 1349. Stylistically Ugolino was a follower of Duccio; in composition, style, and iconography his work is often derived from Duccio's *Maestà* (1308/11), which was then on the high altar of the cathedral of Siena. In the grace of Ugolino's figures and the lyricism of his work can be seen a link to the Gothic elegance of Simone Martini; his colors, rich but subtle, are distinctive. His later work was characterized by a greater plasticity in the figures and by more complex compositions.

The only authenticated work by Ugolino is the high altarpiece of Santa Croce, of which this panel is a fragment; in 1955 Gertrude Coor-Achenbach convincingly identified the Los Angeles spandrels as those that surmounted the central image of the Virgin and Child, which is now lost. The altarpiece, which was probably commissioned by the Alamanni family, was still in place when it was recorded by Giorgio Vasari in 1550 (Vasari 1906, vol. 1, 454), but after 1566 it was removed from the high altar. It was kept intact on the premises until the early nineteenth century, when those sections that were still in good condition were sold to an unnamed Englishman, perhaps William Young Ottley, in whose collection many of the panels were later found. A drawing from the late eighteenth century by William Séroux d'Agincourt (Loyrette 1978, pl. 22) shows that the panel with the Virgin and Child was already deteriorating,

PROVENANCE
Santa Croce, Florence,
 until about 1790.
Possibly William Young Ottley,
 London, until at least 1835.
William Randolph Hearst,
 Los Angeles, until 1949.
Donated to the Los Angeles
 County Museum, 1949
 (as "follower of Duccio").

LITERATURE
Los Angeles 1950, 17, cat. no. 2
 (as "school of Duccio,
 about 1300").
Longhi 1954, 64
 ("very close to Duccio").
Wescher 1954, cat. no. 1
 (as "follower of Duccio,
 c. 1300").
Coor-Achenbach 1955, 156, 158,
 fig. 7.
Davies 1961, 535, 537 n. 11.
Williamstown 1962, 8–9.
Berenson 1968, vol. 1, 438.
Fredericksen/Zeri 1972, 207,
 353, 592.
Bolaffi 1972–76, vol. 11 (1976),
 197.
Loyrette 1978, 18, no. 1, fig. 1,
 pls. 22–23.
Gardner von Teuffel 1979, 48
 n. 69, 50, 56 n. 82, figs. 27–28.
Stubblebine 1979, vol. 1, 164–
 66, 168 n. 10; vol. 2, fig. 401.
Carli 1981, 74.
Christiansen 1982, fig. 20.
Gordon/Reeve 1984, 40,
 figs. 3–4.
Los Angeles 1987, 97.
London 1989, 102, 111, fig. 60.
Boskovits 1990, 222.

but it was taken to England anyway, probably because it was the central image and because Ugolino's signature was below it: a "fragment" of the Virgin and Child—probably fragmentary in the sense of condition rather than shape—was noted in Ottley's collection in 1835. Whether or not the central panel was accompanied by the spandrels is not mentioned; neither of the two sections appeared in sales of the collection in 1847 or 1850 (Davies 1961, 533–36). Paint losses on the Los Angeles panel suggest that it may have been one of the sections of the altarpiece that was left behind in Italy.

Narrower spandrels of pairs of adoring angels by the same hand surmounted the half-figures of saints that were once on either side of the central images; the smaller spandrels are now in the Gemäldegalerie, Berlin-Dahlem, and the National Gallery, London. These and the Los Angeles panels show an extraordinary range of colors, perhaps due to Ugolino's use of glazes, which allowed a more subtle modulation of hues.

Conservation Notes

These two small spandrels (about ⅜ of an inch thick) are nailed to a heavier board (about 2 inches thick) that once formed the central tier of the Santa Croce altarpiece. The wood for both supports is poplar. The Virgin and Child, which would have been painted directly on the heavier support, was roughly chiseled out along the arch of the spandrels. One inch of the main panel extends above the spandrels, which are separated at the apex of the arch. A dowel hole exists at each side (lower part), and one hole has remnants of a dowel. The carved molding along the arch is original, attached with nails. The main panel and the spandrels were the same width, which has remained unchanged.

The preparation is a gesso ground into which the design has been incised. Flesh is underpainted with terre verte, and the preparation for gilding is a red bole. Halos are decorated with incising.

The right spandrel is in pristine condition. The left one, however, has serious losses: two angel heads are totally lost. Since it is impossible to know the original appearance of these two figures, they have been restored with a technique known as *tratteggio* that does not attempt to reconstruct the design. The upper part of the head of the angel on the far left is also badly damaged, but enough of the original paint remained so that invisible reconstruction was possible. VR

Marco Zoppo
BOLOGNA AND VENICE, 1433–1478

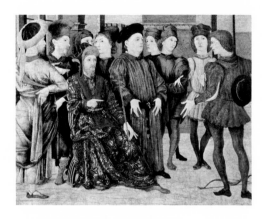

18

Scene of Judgment

(fragment from a *cassone* panel
with *Shooting at Father's Corpse*)
c. 1462
Tempera on panel
52.1 x 69.9 cm (20½ x 27½ in.)
Gift of Howard Ahmanson, Jr.
M.81.259.1
COLOR FIG. 22

Marco di Ruggero, better known as Marco
Zoppo, was born near Bologna. Between
1453 and 1455 he was adopted by the
Paduan painter Francesco Squarcione,
whose hard, linear style influenced his own
work, as it had that of an earlier adoptee,
Andrea Mantegna. Like Mantegna, Zoppo
fled to Venice, breaking his contractual
obligation to Squarcione. After a brief stay
in Bologna, from 1461 to 1463, he returned
to Venice, where he remained until his
death. Zoppo's style is an interesting mix-
ture of Gothic elegance and Renaissance
naturalism, a combination that could be
seen in different proportions in the work of
many northern Italian artists earlier in the
century, such as Jacopo Bellini. The influ-
ence of Squarcione and Mantegna is clear
in Zoppo's hard contours and fascination
with antiquity. Although his figures rarely
betray strong feelings, the attenuation of
form, sharpness of contour, and clarity of
environment give his works an emotional
edge and explain his association with the
intense, idiosyncratic style of the painters
of Ferrara.

This is the left half of a panel that prob-
ably formed the side of a *cassone*, a marriage
chest (see CAT. NO. 15). The right half, now
in a private collection in Florence (FIG. 23),
depicts a young man shooting an arrow at
an old man tied to a column, while another
young man holding a bow looks back at
the group in the Los Angeles panel. The
subject of the painting was erroneously
identified first as the martyrdom of Saint
Sebastian and then of Saint Christopher, in
which one of the arrows shot at the saint
by his executioners turned back and struck
the king who ordered his death. Wolfgang
Stechow identified the composition cor-
rectly as the illustration of a little-known
story from the Babylonian Talmud, in
which Rabbi Bnaha discovered the legiti-
mate son among the ten sons of a deceased
man by ordering the claimants to knock on
the grave until the corpse arose; the rabbi
awarded the inheritance to the one son who
refused to disturb his father's rest. In later
centuries the story was altered to a far
more gruesome incident in which the
corpse was exhumed and the sons ordered
to pierce the body with arrows or lances.
The judge was sometimes transformed into
the wise King Solomon, as he perhaps is in
the Los Angeles panel, since he wears a
crown. The scene was found in fourteenth-
and fifteenth-century illuminated Bibles as
an illustration of the Book of Proverbs,
which represented the wisdom of Solomon
himself (Stechow 1942, 215–19). In this
painting, asked to identify the rightful

PROVENANCE
Erich Gallery, New York,
 by 1940.
Duveen Brothers, New York,
 by 1959.
Howard Ahmanson, Los Angeles.
Mrs. Denis Sullivan,
 Newport Beach.
Howard Ahmanson, Jr.,
 Los Angeles.
Donated to the Los Angeles
 County Museum of Art, 1981.

EXHIBITED
Possibly the Columbus Gallery
 of Fine Arts.

LITERATURE
Stechow 1955, 55–56, fig. 1.
Ruhmer 1966, 36, 63, fig. 32.
Longhi 1968, 139–40, 184–85,
 figs. 327, 329.
Armstrong 1976, 137–39,
 348–49, cat. no. 4B, 451,
 fig. 10.
Armstrong 1981.
Los Angeles 1987, 102.
Conisbee/Levkoff/Rand 1991,
 cat. no. 20.

heir to the dead man's fortune, the king indicates the young man at the right of this panel (who would be at the center of the composition), who refused to desecrate his father's corpse and whose gesture—he is on one panel, his hand on the other— expresses dismay at his brothers' actions. The narrative was popular in the fifteenth and sixteenth centuries as an example of filial piety, an appropriate theme for a *cassone*, pairs of which were often gifts from the parents of a betrothed couple or the commission of the prospective bridegroom. Another *cassone* painted with this theme was attributed by Paul Schubring (1923, cat. no. 125) to a Bolognese artist of the late fifteenth century.

It is possible that the panel is from one of three pairs of *cassoni* Zoppo is known to have executed around 1462, two pairs for Barbara of Brandenburg, the marchioness of Mantua, and another pair for an unidentified lady of Bologna. Lilian Armstrong (1981) made an intriguing case for the former patron, pointing out that the formal betrothal of Barbara's son Federigo Gonzaga to Margherita of Bavaria took place earlier in the same month in which Barbara wrote to Zoppo to inquire about the progress on the four *cassoni*. Federigo's rebellious behavior over the betrothal may have been commemorated in the choice of a subject that demonstrated both exemplary and reprehensible behavior in sons.

The panel is typical of Zoppo's style in the dispassionate faces of the participants, the heads disproportionately large for the bodies, the elongated limbs, and the elegant hands, which make delicate gestures with long, tapering fingers. The king's rich brocaded robe is painted with great skill. The

corpse is almost identical to the figure of Saint Jerome in a *Virgin and Child with Four Saints* of 1471 painted for the church of San Giovanni Evangelista in Pesaro and now in the Bodemuseum, Berlin.

Armstrong noted the similarity of the figure in the turban on the left of the Los Angeles panel and the "good son" on the right to figures in two highly finished drawings by Zoppo now bound in a volume preserved in the British Museum, London (Dodgson 1923, fols. 12r, 22r). The drawings are not studies for the paintings; the twenty-six sheets in the volume seem to have been created as independent works and kept by the artist as a repertoire of models for his compositions.

A "restoration" of the panel in Florence, in which the head of the young man at the left was repainted so he looked at the corpse and not in the opposite direction, suggests that the original panel was deliberately cut and "doctored," so that the owner would have two paintings to sell.

Conservation Notes

The panel measures less than ½ an inch in thickness and is cradled on the reverse. Pronounced splits, visible through the center of the panel, have been repaired in the past. There is an underdrawing on the gesso ground that can be seen with the help of infrared reflectography. The paint is estimated to be egg tempera, over which oil glazes have been applied. The paint layer, especially the faces on the left and right sides, is abraded. Miscellaneous damage exists from utilitarian use. Certain elements are, however, well preserved, such as the decorative pattern of the king's garment. The panel was recently cleaned and restored. VR

Bibliography

AGRESTI/CHIUSANO/
AMENDOLA 1989.
Giuliano Agresti, Italo Alighiero
Chiusano, and Amelio
Amendola. *Volto Santo*. Lucca:
Rugani Edizioni d'Arte, 1989.

ARMSTRONG 1976.
Lilian Armstrong. *The Paintings
and Drawings of Marco Zoppo*.
New York: Garland Publishing,
1976.

ARMSTRONG 1981.
Lilian Armstrong. "Marco
Zoppo's *Shooting at Father's
Corpse*." Unpublished article,
museum files, Department of
European Painting and
Sculpture, Los Angeles County
Museum of Art.

BACCI 1966.
Mina Bacci. *Piero di Cosimo*.
Milan: Bramante, 1966.

BASSANO 1978.
Bassano del Grappa: Museo
Civico. *Il Museo Civico di
Bassano del Grappa: Dipinti dal
XIV al XX secolo*. Cat. edited by
Licisco Magagnato and Bruno
Passamani. 1978.

BÉNÉZIT 1976.
Emmanuel Bénézit. *Dictionnaire
critique et documentaire des pein-
tres, sculpteurs, dessinateurs et
graveurs*. New ed. 10 vols. Paris:
Librairie Gründ, 1976.

BERENSON 1930–31.
Bernard Berenson. "Quadri
senza casa; il Trecento
fiorentino, III." *Dedalo* 11
(1930–31): 1286–1318.

BERENSON 1957.
Bernard Berenson. *Italian
Pictures of the Renaissance:
Venetian School*. 2 vols. London:
Phaidon, 1957.

BERENSON 1963.
Bernard Berenson. *Italian
Pictures of the Renaissance:
Florentine School*. 2 vols. New
York: Phaidon/New York
Graphic Society, 1963.

BERENSON 1968.
Bernard Berenson. *Italian
Pictures of the Renaissance:
Central and Northern Italian
Schools*. Rev. and enl. ed. 3 vols.
London: Phaidon, 1968.

BERENSON 1970.
Bernard Berenson. *Homeless
Paintings of the Renaissance*.
Edited by Hanna Kiel.
Bloomington: Indiana
University Press, 1970.

BLACK 1941.
Clairece Black. "The Origin of
the Lucchese Cross Form."
Marsyas 1 (1941): 27–40.

BLUNT 1962.
Anthony Blunt. *Artistic Theory in
Italy, 1450–1600*. Oxford:
Oxford University Press, 1962.

BOLAFFI 1972–76.
*Dizionario enciclopedico Bolaffi
dei pittori e degli incisori italiani
dall'XI al XX secolo*. 11 vols.
Turin: Giulio Bolaffi, 1972–76.

BONSANTI 1992.
Giorgio Bonsanti. *The Galleria
della Accademia, Florence: Guide
to the Gallery and Complete Cata-
logue*. Boston: G. K. Hall, 1992.

BOSKOVITS 1975.
Miklós Boskovits. *Pittura
fiorentina alla vigilia del
Rinascimento, 1370–1400*.
Florence: Edam, 1975.

BOSKOVITS 1985.
Miklós Boskovits. "Per Jacopo
Bellini pittore (Postilla ad un
colloquio)." *Paragone* 36
(January/March/May 1985):
113–23.

BOSKOVITS 1988.
Miklós Boskovits. "Arte lom-
barda del primo Quattrocento:
Un riesame." In *Arte lombarda
fra gotico e Rinascimento*, 9–49.
Milan: Fabbri, 1988.

BOSKOVITS 1990.
Miklós Boskovits, with Serena
Padovani. *The Thyssen-
Bornemisza Collection: Early
Italian Painting 1290–1470*.
Translated by Françoise
Pouncey Chiarini. London:
Sotheby's Publications, 1990.

BURCKHARDT 1988.
Jacob Burckhardt. *The Altarpiece
in Renaissance Italy*. Edited and
translated by Peter Humfrey.
Cambridge: Cambridge
University Press, 1988.

BURROWS 1931.
Carlyle Burrows. "Letter from
New York." *Apollo* 13 (February
1931): 109–11.

BUSH 1947.
Lucile E. Bush. "Bartolo di
Fredi." Ph.D. diss., Columbia
University, New York, 1947.

BUSH 1963.
Lucile E. Bush. "Pinnacles from
a Polyptych." *Los Angeles
County Museum of Art Bulletin*
15, no. 2 (1963): 3–12.

CARFAX 1934.
Andrew Carfax. "Treasures of
the Leopold Hirsch
Collections." *The Connoisseur* 93
(March 1934): 182–87.

CARLI 1972.
Enzo Carli. *Montalcino: Museo Civico, Museo Diocesano d'Arte Sacra.* Bologna: Calderini, 1972.

CARLI 1981.
Enzo Carli. *La pittura senese del trecento.* Milan: Electa, 1981.

DI CARPEGNA 1951.
Naldo di Carpegna. "La 'Coperta' della Pala d'Oro di Paolo Veneziano." *Bollettino d'arte* 36 (1951): 55–66.

CENNINI 1960.
Cennino d'Andrea Cennini. *The Craftsman's Handbook.* Translated by Daniel V. Thompson, Jr. New York: Dover Publications, 1960.

CHIARELLI 1984.
Caterina Chiarelli. *Le attività artistiche e il patrimonio librario della Certosa di Firenze.* 2 vols. Salzburg: Analecta Cartusiana, Institut für Anglistik und Amerikanistik, Universität Salzburg, 1984.

CHRISTIANSEN 1982.
Keith Christiansen. "Fourteenth-Century Italian Altarpieces." *The Metropolitan Museum of Art Bulletin* n.s. 40, no. 1 (summer 1982): 3–56.

CHRISTIANSEN 1987.
Keith Christiansen. "Venetian Painting of the Early Quattrocento." *Apollo* 125 (March 1987): 166–77.

CLAREMONT 1952–53.
Claremont, California: Scripps College. *Scripps Christmas Exhibition.* 1952–53.

COHN 1991.
By Judgment of the Eye: The Varya and Hans Cohn Collection. Edited by Nancy Thomas and Constantina Oldknow. Los Angeles: privately published, 1991.

COLNAGHI [1928].
Dominic Ellis Colnaghi. *A Dictionary of Florentine Painters from the 13th to the 17th Centuries.* Edited by P. G. Konody and Selwyn Brinton. London: John Lane, n.d. [1928].

CONISBEE/LEVKOFF/RAND 1991.
Philip Conisbee, Mary L. Levkoff, and Richard Rand. *The Ahmanson Gifts: European Masterpieces in the Collection of the Los Angeles County Museum of Art.* Los Angeles: Los Angeles County Museum of Art, 1991.

COOR-ACHENBACH 1955.
Gertrude Coor-Achenbach. "Contributions to the Study of Ugolino di Nerio's Art." *The Art Bulletin* 37, no. 3 (September 1955): 153–65.

CROWE/CAVALCASELLE 1864–66.
Joseph Archer Crowe and Giovanni Battista Cavalcaselle. *A History of Painting in Italy, from the Second to the Fourteenth Century.* 3 vols. London: John Murray, 1864–66.

CROWE/CAVALCASELLE 1903–14.
Joseph Archer Crowe and Giovanni Battista Cavalcaselle. *A History of Painting in Italy, Umbria, Florence and Siena, from the Second to the Sixteenth Century.* Edited by Langton Douglas and Tancred Borenius. 6 vols. London: John Murray, 1903–14.

CROWE/CAVALCASELLE 1908–9.
Joseph Archer Crowe and Giovanni Battista Cavalcaselle. *A New History of Painting in Italy from the II to the XVI Century.* Edited by Edward Hutton. 3 vols. London: J. M. Dent/New York: E. P. Dutton, 1908–9.

CRUTWELL 1908.
Maud Crutwell. *A Guide to the Paintings in the Churches and Minor Museums of Florence.* London: J. M. Dent, 1908.

DAVIES 1961.
Martin Davies. *National Gallery Catalogues: The Earlier Italian Schools.* 2d ed. London: National Gallery, 1961.

DE BENEDICTIS 1979.
Cristina De Benedictis. *La pittura senese 1330–1370.* Florence: Salimbeni, 1979.

DODGSON 1923.
Campbell Dodgson. *A Book of Drawings Formerly Ascribed to Mantegna.* London: British Museum, 1923.

DREY 1933.
"Drey Galleries Re-open." *The Connoisseur* 91 (January 1933): 66–67.

EISLER 1989A.
Colin Eisler. "The Father of Us All." *Art and Antiques* 6, no. 10 (December 1989): 69–73.

EISLER 1989B.
Colin Eisler. *The Genius of Jacopo Bellini: The Complete Paintings and Drawings.* New York: Abrams, 1989.

FAHY 1967.
Everett Fahy. "Some Early Italian Pictures in the Gambier-Parry Collection." *The Burlington Magazine* 109 (March 1967): 128–39.

FAHY 1976.
Everett Fahy. *Some Followers of Domenico Ghirlandaio*. New York: Garland Publishing, 1976.

FEHM 1970.
Sherwood A. Fehm, Jr. "Luca di Tommè." Ph.D. diss., Yale University, 1970.

FEHM 1973.
Sherwood A. Fehm, Jr. *The Collaboration of Niccolò Tegliacci and Luca di Tommè*. Malibu: J. Paul Getty Museum, 1973.

FEHM 1976.
Sherwood A. Fehm, Jr. "Luca di Tommè's Influence on Three Sienese Masters: The Master of the Magdalen Legend, the Master of the Panzano Triptych, and the Master of the Pietà." *Mitteilungen des Kunsthistorischen Institutes in Florenz* 20, no. 3 (1976): 333–50.

FEHM 1978.
Sherwood A. Fehm, Jr. "Attributional Problems Surrounding Luca di Tommè." In *Essays Presented to Myron P. Gilmore*, vol. 2, 155–65. 2 vols. Florence: La Nuova Italia, 1978.

FEHM 1986.
Sherwood A. Fehm, Jr. *Luca di Tommè: A Sienese Fourteenth-Century Painter*. Carbondale: Southern Illinois University Press, 1986.

FEINBLATT [1948?].
Ebria Feinblatt. *The Gothic Room*. Los Angeles: Los Angeles County Museum of Art, n.d. [1948?].

FERGUSON 1961.
George Wells Ferguson. *Signs and Symbols in Christian Art*. New York: Oxford University Press, 1961.

FLORENCE 1992–93.
Florence: Palazzo Strozzi. *Maestri e botteghe: Pittura a Firenze alla fine del Quattrocento*. Exh. cat. 1992–93.

FRANKFURTER 1939.
Alfred M. Frankfurter. "Kress Gifts to Eight Cities: Italian Paintings of Three Centuries in the South and West." *Art News* 37, no. 18 (January 28, 1939): 10.

FREDERICKSEN/ZERI 1972.
Burton B. Fredericksen and Federico Zeri. *Census of Pre-Nineteenth-Century Italian Paintings in North American Public Collections*. Cambridge: Harvard University Press, 1972.

FREMANTLE 1975.
Richard Fremantle. *Florentine Gothic Painters from Giotto to Masaccio: A Guide to Painting in and near Florence, 1300 to 1450*. London: Martin Secker and Warburg, 1975.

FREULER 1985.
Gaudenz Freuler. "Bartolo di Fredis Altar für die Annunziata-Kapelle in S. Francesco in Montalcino." *Pantheon* 43 (1985): 21–39.

FRINTA 1973.
Mojmír S. Frinta. "Evidence of the Italian Influence on Catalan Panel Painting of the Fourteenth Century." *Actas del XXIII Congreso Internacional de historia del arte* 1 (1973).

GARDNER VON TEUFFEL 1979.
Christa Gardner von Teuffel. "The Buttressed Altarpiece: A Forgotten Aspect of Tuscan Fourteenth-Century Altarpiece Design." *Jahrbuch der Berliner Museen* 21 (1979): 21–65.

GARDNER VON TEUFFEL 1983.
Christa Gardner von Teuffel. "From Polyptych to Pala: Some Structural Considerations." In *La pittura nel XIV e XV secolo: Il contributo dell'analisi tecnica alla storia dell'arte*, 324–27. Atti del XXIV Congresso internazionale di storia dell'arte, September 10–18, 1979. Edited by Henk W. van Os and J. R. J. van Asperen de Boer. Bologna: CLUEB, 1983.

GAYE 1839–40.
Giovanni Gaye. *Carteggio inediti dei secoli XIV, XV, XVI*. 3 vols. Florence: Giuseppe Molini, 1939–40; reprint Turin: Bottega d'Erasmo, 1968.

GETTENS/STOUT 1966.
Rutherford J. Gettens and George L. Stout. *Painting Materials: A Short Encyclopaedia*. New York: Dover Publications, 1966.

GIGLIOLI 1933.
Odoardo H. Giglioli. *Catalogo delle cose d'arte e di antichità d'Italia: Fiesole*. Rome: Libreria dello Stato, 1933.

GIGLIOLI 1935.
Odoardo H. Giglioli. *Le scuole pittoriche della Toscana (sec. XIV–XV)*. Bergamo: Istituto italiano d'arti grafiche, 1935.

GIOTTO TO DÜRER 1991.
Jill Dunkerton, Susan Foister, Dillian Gordon, and Nicholas Penny. *Giotto to Dürer: Early Renaissance Painting in the National Gallery*. New Haven: Yale University Press; London: National Gallery Publications, 1991.

GOFFEN 1989.
Rona Goffen. *Giovanni Bellini*. New Haven: Yale University Press, 1989.

GORDON/REEVE 1984.
Dillian Gordon and Anthony Reeve. "Three Newly Acquired Panels from the Altarpiece for Santa Croce by Ugolino di Nerio."*National Gallery Technical Bulletin* 8 (1984): 36–52.

GRONAU 1935.
Georg Gronau. "Cosimo Rosselli." In Thieme/Becker 1907–50, vol. 29 (1935): 34–36.

GÜNTHER 1993.
Susanne Günther. "Bartolo di Fredi." In *Allgemeines Künstlerlexikon: Die bildenden Künstler aller Zeiten und Völken*, vol. 7 (1993), 268. Munich/Leipzig: K. G. Saur, 1992.

HALL 1990.
Marcia B. Hall. "Savonarola's Preaching and the Patronage of Art." In *Christianity and the Renaissance: Image and Religious Imagination in the Quattrocento*, 493–522. Syracuse: Syracuse University Press, 1990.

HARPRING 1993.
Patricia Harpring. *The Sienese Trecento Painter Bartolo di Fredi*. Rutherford, N. J.: Fairleigh Dickinson University Press, 1993.

HAUßHERR 1962.
Reiner Haußherr. "Das Imervardkreuz und der Volto-Santo-Typ." *Zeitschrift für Kunstwissenschaft* 16, nos. 3/4 (1962): 129–70.

JOANNIDES 1987.
Paul Joannides. "Masaccio, Masolino and 'Minor' Sculpture." *Paragone*, no. 451 (September 1987): 3–24.

KRESS 1932–35.
An Exhibition of Italian Paintings Lent by Mr. Samuel H. Kress of New York to Museums, Colleges and Art Associations. Exh. cat. N.d. [1932–35].

KÜNSTLER-LEXIKON 1904–14.
Neues allgemeines Künstler-Lexikon. 25 vols. Linz: Zentraldruckerei, 1904–14.

LEVI D'ANCONA 1957.
Mirella Levi d'Ancona. "Don Silvestro dei Gherarducci e il 'Maestro delle Canzoni.'" *Rivista d'arte* 32 (1957): 3–37.

LIGHTBOWN 1978.
Ronald Lightbown. *Sandro Botticelli*. 2 vols. Berkeley: University of California Press, 1978.

LODDI 1736.
Sebastiano Loddi. *Notizie de' soggetti e cose più memorabili del convento di S. Marco dell'Ordine de' Predicatori*. Manuscript of 1736 in the monastery library of Santa Sabina, Rome; nineteenth-century copy in archives of San Marco, Florence.

LONDON 1875.
London: Burlington House. *Exhibition of Works by the Old Masters, and by Deceased Masters of the British School [Winter Exhibition]*. Exh. cat. 1875.

LONDON 1893–94.
London: New Gallery. *Exhibition of Early Italian Art from 1330 to 1550*. Exh. cat. 1893–94.

LONDON 1989.
London: National Gallery Publications. *Art in the Making: Italian Painting before 1400*. Exh. cat. by David Bomford, Jill Dunkerton, Dillian Gordon, and Ashok Roy. 1989.

LONDON 1989–90.
London: P. & D. Colnaghi. *Master Paintings 1350–1800*. Exh. cat. 1989–90.

LONG BEACH 1956.
Long Beach, California: City of Long Beach Municipal Art Center. *Religious Art*. 1956.

LONGHI 1939–40.
Roberto Longhi. "Fatti di Masolino e di Masaccio." *Critica d'arte* 4–5 (1939–40), pt. 2: 145–91.

LONGHI 1954.
Roberto Longhi. Review of *Los Angeles County Museum: A Catalogue of Italian, French and Spanish Paintings*. *Paragone*, no. 59 (November 1954): 64.

LONGHI 1968.
Roberto Longhi. *Officina ferrarese, 1934; Ampliamenti nell'officina ferrarese (1940); Nuovi ampliamenti (1940–55)*. Florence: Sansoni, 1968.

LOS ANGELES 1944.
Los Angeles: Los Angeles
County Museum. *The Balch
Collection and Old Masters from
Los Angeles Collections Assembled
in Memory of Mr. and Mrs. Allan
C. Balch.* Exh. cat. 1944.

LOS ANGELES 1945.
"Gifts and Bequests to the Los
Angeles County Museum during
the Year 1944." *Los Angeles
County Museum Quarterly* 4, nos.
3–4 (Fall–Winter 1945): 10–13.

LOS ANGELES 1950.
"Acquisitions of the Art
Division of the Los Angeles
County Museum, 1946–1950."
*Los Angeles County Museum
Bulletin of the Art Division* 3,
no. 2 (Summer 1950): 3–23.

LOS ANGELES 1965.
Los Angeles: Los Angeles
County Museum of Art.
*Illustrated Handbook of the Los
Angeles County Museum of Art.*
1965.

LOS ANGELES 1971.
Los Angeles: Los Angeles
County Museum of Art. *Man
Came This Way: Objects from the
Phil Berg Collection.* Exh. cat. by
Phil Berg. 1971.

LOS ANGELES 1977.
Los Angeles: Los Angeles
County Museum of Art. *Los
Angeles County Museum of Art
Handbook.* 1977.

LOS ANGELES 1986.
Los Angeles: Los Angeles
County Museum of Art. "Recent
Acquisition: Madonna and
Child." *Member's Calendar* 24,
no. 3 (March 1986): 6.

LOS ANGELES 1987.
Scott Schaefer and Peter Fusco,
with Paula-Teresa Wiens.
*European Painting and Sculpture
in the Los Angeles County Museum
of Art.* Los Angeles: Los Angeles
County Museum of Art, 1987.

LOS ANGELES 1990–91.
Los Angeles: Los Angeles
County Museum of Art. *As
Many Worlds As There Are: 25th
Anniversary Gifts.* 1990–91.

LOYRETTE 1978.
Henri Loyrette. "Une source
pour la reconstruction du polyp-
tyque d'Ugolino da Siena à
Santa Croce." *Paragone*, no. 343
(September 1978): 15–23.

LUCCA 1982.
Lucca: Santi Giovanni e
Reparata. *Il Volto Santo: Storia e
culto.* Exh. cat. by Clara
Baracchini and Maria Teresa
Filieri. 1982.

LURIE 1989.
Ann T. Lurie. "In Search of a
Valencian Madonna by
Starnina." *The Bulletin of The
Cleveland Museum of Art* 76, no.
10 (December 1989): 334–73.

MAGINNIS 1980.
Hayden B. J. Maginnis. "The
So-Called Dijon Master."
Zeitschrift für Kunstgeschichte 43,
no. 2 (1980): 121–38.

MALLORY/MORAN 1972.
Michael Mallory and Gordon
Moran. "Yale's *Virgin of the
Annunciation* from the Circle of
Bartolo di Fredi." *Yale
University Art Gallery Bulletin*
34, no. 1 (November 1972):
10–15.

MANCHESTER 1857.
Manchester: Museum of
Ornamental Art. *Art Treasures of
the United Kingdom Collected at
Manchester in 1857.* Exh. cat.
1857.

VAN MARLE 1923–36.
Raimond van Marle. *The
Development of the Italian Schools
of Painting.* 18 vols. The Hague:
Martinus Nijhoff, 1923–36.

MCKINNEY 1944A.
Roland McKinney. "The Balch
Art: Rich Gift for California."
Art News 43, no. 17 (December
15–31, 1944): 11–12.

MCKINNEY 1944B.
Roland McKinney. "Old Masters
in the Balch Collection." *Los
Angeles County Museum
Quarterly* 4, nos. 1–2
(Spring–Summer 1944): 2–10.

MEISS 1963.
Millard Meiss. "Notes on Three
Linked Sienese Styles." *The Art
Bulletin* 45, no. 1 (March 1963):
47–48.

MEISS 1964
Millard Meiss. *Painting in
Florence and Siena after the Black
Death: The Arts, Religion, and
Society in the Mid-Fourteenth
Century.* Rev. ed. New York:
Harper and Row, 1964.

MERRIFIELD 1849.
Mary P. Merrifield. *Original
Treatises Dating from the XIIth to
the XVIII Centuries on the Arts of
Painting.* 2 vols. London, 1849;
reprint New York: Dover
Publications, 1967.

DEL MIGLIORE 1684.
Ferdinando Leopoldo del
Migliore. *Firenze città nobilissima
illustrata.* Florence: Stella, 1684.

MORSELL 1932.
Mary Morsell. "Show of Italian Primitives Held at Drey Gallery." *Art News* 31, no. 8 (November 19, 1932): 3, 9.

MULLER 1973.
Norman E. Muller. "Observations on the Painting Technique of Luca di Tommè." *Los Angeles County Museum of Art Bulletin* 19, no. 2 (1973): 12–21.

MURARO 1970.
Michelangelo Muraro. *Paolo da Venezia*. University Park: Pennsylvania State University Press, 1970.

MURPHY 1985.
Alexandra R. Murphy. *European Paintings in the Museum of Fine Arts, Boston: An Illustrated Summary Catalogue*. Boston: Museum of Fine Arts, 1985.

NERI LUSANNA 1981.
Enrica Neri Lusanna. "Un episodio di collaborazione tra scultori e pittori nella Siena del primo Quattrocento: La 'Madonna del Magnificat' di Sant'Agostino." *Mitteilungen des Kunsthistorischen Institutes in Florenz* 25, no. 3 (1981): 325–40.

NEW YORK 1917.
New York: F. Kleinberger Galleries. *Loan Exhibition of Italian Primitives in Aid of the American War Relief*. Exh. cat. by Osvald Sirén and Maurice W. Brockwell. 1917.

NEW YORK 1947.
New York: Wildenstein & Company. *Italian Paintings*. Exh. cat. 1947.

NEW YORK 1990.
New York: The Metropolitan Museum of Art. *Italian Renaissance Frames*. Exh. cat. by Timothy J. Newbery, George Bisacca, and Laurence B. Kanter. 1990.

VAN OS 1984.
Henk W. van Os. *Sienese Altarpieces, 1215–1460: Form, Content, Function*. Vol. 1: *1215–1344*. Groningen: Bouma's Boekhuis, 1984.

VAN OS 1985.
Henk W. van Os. "Tradition and Innovation in Some Altarpieces by Bartolo di Fredi." *The Art Bulletin* 67, no. 1 (March 1985): 50–66.

PAATZ 1940–54.
Walter and Elisabeth Paatz. *Die Kirchen von Florenz*. 6 vols. Frankfurt am Main: Klostermann, 1940–54.

PADOA RIZZO 1989.
Anna Padoa Rizzo. "L'altare della Compagnia dei Tessitori in San Marco a Firenze: Dalla cerchia di Cosimo Rosselli al Cigoli." *Antichità viva* 28, no. 4 (1989): 17–24.

PALLUCCHINI 1964.
Rodolfo Pallucchini. *La pittura veneziana del Trecento*. Venice: Istituto per la Collaborazione Culturale, 1964.

PERKINS 1920.
F. Mason Perkins. "Some Sienese Pictures in American Collections: Part Two." *Art in America* 8, no. 6 (October 1920): 272–92.

PERKINS 1927.
F. Mason Perkins. "Two Sienese Pictures of the 'Annunciation.'" *Apollo* 6 (November 1927): 201–4.

PERKINS 1929.
F. Mason Perkins. "Luca di Tommè." In Thieme/Becker 1907–50, vol. 23 (1929): 427.

PETRIOLI TOFANI 1986.
Annamaria Petrioli Tofani. *Gabinetto Disegni e Stampe degli Uffizi: Inventario. 1. Disegni esposti*. Florence: Leo S. Olschki, 1986.

PIGLER 1968.
A. Pigler. *Katalog der Galerie Alter Meister* [Budapest]. 2 vols. Tübingen: Ernst Wasmuth, 1968.

PISA 1972.
Pisa: Museo Nazionale di San Matteo. *Mostra del Restauro*. Exh. cat. 1972.

PONS 1991.
Nicoletta Pons. "Zanobi di Giovanni e le compagnie di pittori." *Rivista d'arte*, ser. 4, 7 (1991): 221–27.

REINACH 1905–23.
Salomon Reinach. *Répertoire de peintures du moyen âge et de la renaissance (1280–1580)*. 6 vols. Paris: E. Leroux, 1905–23.

RICHA 1754–62.
Giuseppe Richa. *Notizie istoriche delle chiese fiorentine*. 10 vols. Florence: Vivarini, 1754–62.

RIVERSIDE 1971.
Riverside, California: University of California Art Gallery. *Early Italian Renaissance*. 1971.

ROSSELLI SASSATELLI DEL TURCO 1927–28.
Tommaso Rosselli Sassatelli del Turco. "La chiesetta di San Martino dei Buonomini a Firenze." *Dedalo* 8 (1927–28): 610–32.

RUHMER 1966.
Eberhard Ruhmer. *Marco Zoppo.* Vicenza: Neri Pozza, 1966.

SALMI 1909.
Mario Salmi. "Spigolatura d'arte toscana." *L'Arte* 7 (1909).

SAN MINIATO 1959.
San Miniato: Accademia degli Euteleti. *Mostra del Cigoli e del suo ambiente.* Exh. cat. 1959.

SANTA ANA 1957–58.
Santa Ana, California: Charles W. Bowers Memorial Museum. *Eighth Annual Madonna Festival.* 1957–58.

SANTA BARBARA 1980–81.
Santa Barbara: University of California, Santa Barbara, Art Museum. *In Her Image: The Great Goddess in Indian Asia and the Madonna in Christian Culture.* Exh. cat. by Gerald James Larson, Pratapaditya Pal, and Rebecca P. Gowen. 1980–81.

SCHILLER 1972.
Gertrud Schiller. *Iconography of Christian Art.* Translated by Janet Seligman. 2 vols. London: Lund Humphries, 1972.

SCHMITT 1968.
Annegrit Schmitt. "Ein Musterblatt des Pisanello." In *Festschrift Ulrich Middeldorf,* 119–23. 2 vols. Berlin: Walter de Gruyter, 1968.

SCHUBRING 1923.
Paul Schubring. *Cassoni: Truhen und Truhenbilder der italienischen Frührenaissance. Ein Beitrag zur Profanmalerei im Quattrocento.* 2 vols. Leipzig: Karl W. Hiersemann, 1923.

SEYMOUR 1970.
Charles Seymour, Jr. *Early Italian Paintings in the Yale University Art Gallery.* New Haven: Yale University Press, 1970.

SHAPLEY 1966.
Fern Rusk Shapley. *Paintings from the Samuel H. Kress Collection: Italian Schools, XIII–XV Century.* 2 vols. London: Phaidon, 1966.

SHOEMAKER 1975.
Innis Howe Shoemaker. "Filippino Lippi as a Draughtsman." Ph.D. diss., Columbia University, 1975.

SHORR 1954.
Dorothy C. Shorr. *The Christ Child in Devotional Images in Italy during the XIV Century.* New York: George Wittenborn, 1954.

SIENA 1979.
Siena: Pinacoteca Nazionale. *Mostra di opere d'arte restaurate nelle provincie di Siena e Grosseto.* Exh. cat. 1979.

STALEY 1906.
Edgcumbe Staley. *The Guilds of Florence.* London: Methuen / Chicago: A. C. McClurg, 1906.

STECHOW 1942.
Wolfgang Stechow. "Shooting at Father's Corpse." *The Art Bulletin* 24, no. 1 (March 1942): 213–25.

STECHOW 1955.
Wolfgang Stechow. "Shooting at Father's Corpse: A Note on the Hazards of Faulty Iconography." *The Art Bulletin* 37, no. 1 (March 1955): 55–56.

STRASBURG 1966.
The Strasburg Manuscript: A Medieval Painters' Handbook. Translated by Viola and Rosamund Borradaik. New York: Transatlantic Arts, 1966.

STUBBLEBINE 1979.
James H. Stubblebine. *Duccio di Buoninsegna and His School.* 2 vols. Princeton: Princeton University Press, 1979.

SUTTON 1986.
Denys Sutton. "Los Angeles and Aesthetic Sensations." *Apollo* 124 (November 1986): 384–89.

SYRE 1979.
Cornelia Syre. *Studien zum "Maestro del Bambino Vispo" und Starnina.* Bonn: Rudolf Habelt, 1979.

TEUBNER 1979.
Hans Teubner. "San Marco in Florenz: Umbauten vor 1500. Ein Beitrag zum Werk des Michelozzo." *Mitteilungen des Kunsthistorischen Institutes in Florenz* 23, no. 3 (1979): 239–72.

THIEME / BECKER 1907–50.
Ulrich Thieme, Felix Becker, and Hans Vollmer, eds. *Allgemeines Lexikon der bildenden Künstler vor der Antike bis zur Gegenwart.* 37 vols. Leipzig: E. A. Seemann, 1907–50.

THOMPSON 1956.
Daniel V. Thompson, Jr. *The Materials and Techniques of Medieval Painting.* New York: Dover Publications, 1956.

TIMKEN 1983.
Timken Art Gallery: European and American Works of Art in the Putnam Foundation Collection. San Diego: Putnam Foundation, 1983.

VALENTINER 1948.
W. R. Valentiner. "A Portrait of S. Bernardino of Siena." *Los Angeles County Museum Bulletin of the Art Division* 2, nos. 1–2 (Summer 1948): 11–13.

VANCOUVER 1953.
Vancouver: Vancouver Art
Gallery. *Italian Renaissance
Exhibition*. 1953.

VASARI 1878–85.
Giorgio Vasari. *Le opere*. Edited
and annotated by Gaetano
Milanesi. 9 vols. Florence:
Sansoni, 1878–85.

VASARI 1906.
Giorgio Vasari. *Le opere*. Edited
and annotated by Gaetano
Milanesi. 2d ed. 9 vols. Florence:
Sansoni, 1906.

VASARI 1960.
Giorgio Vasari. *Vasari on
Technique: Being the Introduction
to the Three Arts of Design,
Architecture, Sculpture, and
Painting, Prefixed to the Lives of
the Most Excellent Painters,
Sculptors, and Architects*.
Translated by Louisa S.
Maclehose; edited by G. Baldwin
Brown. New York: Dover
Publications, 1960.

VASARI 1966–84.
Giorgio Vasari. *Le vite de' più
eccellenti pittori scultori e architet-
tori*. Edited by Rosanna Bettarini
and Paola Barocchi. 5 vols.
Florence: Sansoni, 1966–84.

VENTURI 1945.
Lionello Venturi. *The Rabinowitz
Collection*. New York: The Twin
Editions, 1945.

VORAGINE 1969.
Jacobus de Voragine. *The Golden
Legend*. Translated by Granger
Ryan and Helmut Ripperger.
New York: Arno Press, 1969.

WAAGEN 1854.
Gustav Friedrich Waagen.
*Treasures of Art in Great Britain,
Being an Account of the Chief
Collections of Paintings,
Drawings, Sculptures, Illuminated
MSS., &c., &c*. 3 vols. London:
John Murray, 1854.

WACKERNAGEL 1981.
Martin Wackernagel. *The World
of the Florentine Renaissance
Artist: Projects and Patrons,
Workshop and Art Market*.
Translated by Alison Luchs.
Princeton: Princeton University
Press, 1981. Original German
edition published in 1938.

WESCHER 1954.
[Paul Wescher, with Ebria
Feinblatt.] *Los Angeles County
Museum Catalogue of Paintings I:
A Catalogue of Italian, French,
and Spanish Paintings XIV–XVIII
Century*. Los Angeles: Los
Angeles County Museum, 1954.

WILLIAMSTOWN 1962.
Williamstown, Massachusetts:
Sterling and Francine Clark Art
Institute. *Heptaptych Ugolino da
Siena*. Exh. cat. by John Pope-
Hennessy. 1962.

ZERI 1976.
Federico Zeri. *Italian Paintings
in the Walters Art Gallery*. 2 vols.
Baltimore: Walters Art Gallery,
1976.

ZUCKER 1992.
Mark J. Zucker. "Problems in
Dominican Iconography: The
Case of St. Vincent Ferrer."
Artibus et Historiae 13, no. 25
(1992): 181–93.

Index